THE MAP AS ART

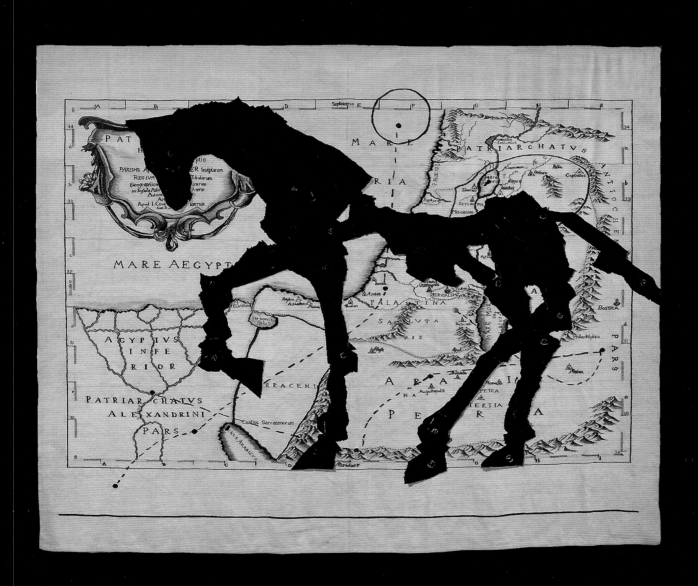

INDIA

YANGON
(RANGOON)

ANDAMAN AND NICOBAR ISLANDS

PONDICHERRY

CHENNAI

CHIANG

BAY OF BENGAL

BEIK ARCHIPELAGO

KRUNG THEP-PHRA NAKHON

MYANMAR (BURMA)

THAILAND

LAOS

HANOI

VIETNAM

BANGKOK

CAMBODIA

PHILIPPINES

MANILA

SOUTH CHINA SEA

CELEBES SEA

ANDAMAN SEA

SRI LANKA

EYE OF TSUNAMI

CEYLON

PADANG

BENGKULU

THIRUVANANTHAPURAM

KOCHI

INDIAN OCEAN

SOUTHEAST ASIA

GULF OF THAILAND

STRAIT OF MALACCA

MALAYSIA

SINGAPORE

BRUNEI

KALIMANTAN

SULAWESI

JAVA SEA

CERAM SEA

BANDA SEA

INDONESIA

JAVA JAWA

BALI

FLORES SEA

SAVU SEA

PAPUA NEW GUINEA

EAST TIMOR

INDIAN OCEAN

SUMATRA

THE TSUNAMI: DECEMBER 26, 2004, 9.3 ON THE RICHTER SCALE.

THE MAP AS ART

CONTEMPORARY ARTISTS EXPLORE CARTOGRAPHY

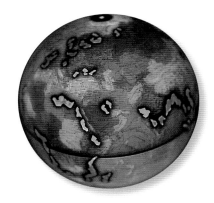

KATHARINE HARMON

with essays by GAYLE CLEMANS

PRINCETON ARCHITECTURAL PRESS

NEW YORK

Published by
Princeton Architectural Press
37 East Seventh Street
New York, New York 10003

Visit our website at www.papress.com.

Project Editor: Clare Jacobson
Copy Editors: Dorothy Ball and Becca Casbon
Designer: Jane Jeszeck, Jigsaw/www.jigsawseattle.com

Special thanks to: Nettie Aljian, Sara Bader, Nicola Bednarek,
Janet Behning, Carina Cha, Penny (Yuen Pik) Chu,
Russell Fernandez, Pete Fitzpatrick, Wendy Fuller, Jan Haux,
Aileen Kwun, Nancy Eklund Later, Linda Lee, Aaron Lim,
Laurie Manfra, John Myers, Katharine Myers, Lauren Nelson
Packard, Jennifer Thompson, Paul Wagner, Joseph Weston,
and Deb Wood of Princeton Architectural Press
—Kevin C. Lippert, publisher

ISBN 978-1-56898-972-3

The Library of Congress has catalogued the hardcover
edition as follows:
Harmon, Katharine A., 1960–
 The map as art : contemporary artists explore cartography
/ Katharine Harmon ; with essays by Gayle Clemans.
 255 p. : col. ill. ; 24 x 26 cm.
Includes bibliographical references.
ISBN 978-1-56898-762-0 (alk. paper)
1. Maps in art—Exhibition. 2. Cartography in art—Exhibitions.
I. Clemans, Gayle, 1968- II. Title.
N8222.M375H37 2009
760'.0449912—dc22

 2008030929

Cover

JULES DE BALINCOURT

US World Studies II, 2005

Oil and enamel on panel
48 x 68 in.
Courtesy of Zach Feuer Gallery, New York
(See also p. 59.)

Page 1

WILLIAM KENTRIDGE

The Nose (Horse), 2007

From an edition of six
Tapestry of mohair, silk, and embroidery
145.5 x 165 in.
Courtesy of Marian Goodman Gallery, New York

Refugees circle the globe, endlessly looking
for a place to call home in Kentridge's
extensive body of work (drawings, collage,
tapestry) featuring maps as backdrops. This
piece was made as part of a set design for a
Dmitri Shostakovich opera based on "The
Nose," a short story by Nikolai Gogol.

Page 2

PAULA SCHER

Tsunami, 2006

Acrylic on canvas
113.5 x 92 in.
(See also p. 163.)

Page 3

INGO GÜNTHER

115: Wetlands

From the series *Worldprocessor,* 1988–present
(ongoing)
Altered globe
(See also pp. 56-57.)

About seventy-five percent of all endangered
species are native to the world's wetlands.

Facing page

ALEKSANDRA MIR

The Tower of London

Porto Vecchio/Cagliari/Palermo

Lago Artificiale

Page 6, L to R

Jones High School

Red Hook

*Kennington Rd./Wincott Street/
Kempsford Rd.*

Great Lawn

Indianapolis

Peking

Mississippi (also p. 7)

Thessaloniki

Cervino Matterhorn/Monte Rosa

Black Sea Odessa

Panama

Beijing

From the series *The World from Above,* 2004
Black marker on paper
Each 48 x 48 in.

In her series of over one hundred marker
drawings, Mir depicts continents, islands,
deserts, swamps, and suburban street
junctions. She draws from existing maps,
creating freehand translations meant
to resemble those produced before the
development of modern cartographic
technologies. Mir writes, "I like the idea
that a viewer who has a close relationship
to a particular site and who knows where
the roads actually lead to and from, or how
the borders became the way they are, can
complete the drawing according to his
own historical and geographical references.
This way, the maps are never finished and
appear different to everyone."

Back cover

CHRISTA DICHGANS

Peru, **2004**

Oil on canvas
55 x 39 in.
Courtesy of Contemporary Fine Arts,
Berlin
Photo by Jochen Littkemann
(See also p. 172–173.)

Flaps

STEPHEN WALTER

Havering, 2008 (details)

Archival inkjet and screen print on paper
55 x 78.75 in.
(See p. 203.)

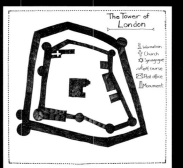

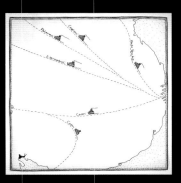

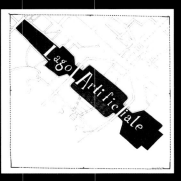

CONTENTS

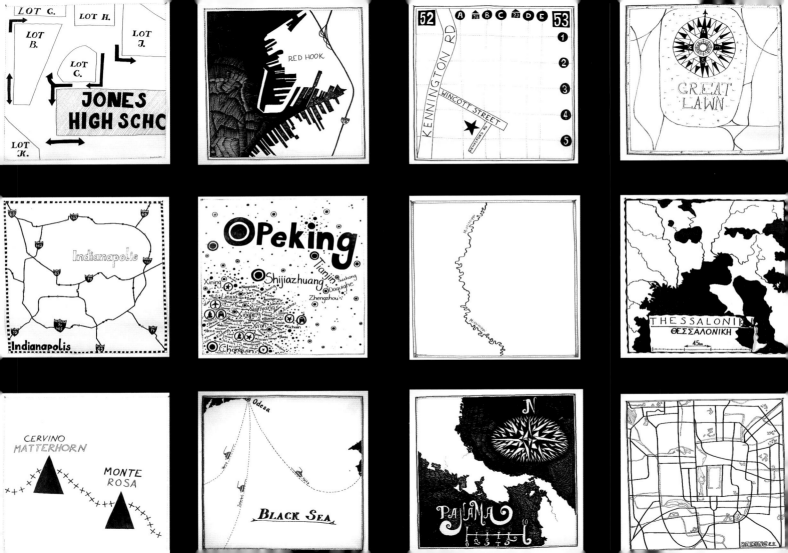

Index of Artists

FRANK BOWLING

Marcia H Travels, 1970

Acrylic on canvas
120 x 180 in.
Exhibited at the 2003 Venice Biennale
On extended loan to Chelsea and Westminster Hospital, London
Photo by Graham Mileson

INTRODUCTION

There has always been art in cartography. Maps by definition are utilitarian, of course; they bear implicit promises of routes into and out of the unknown. Yet the language of maps as developed over time is a beautiful one, filled with artistic potential.

Cartographers have long known that deploying artistic skills and techniques can enhance a map's effect, and have to varying degrees used visual creativity to make their maps more compelling. Now the relationship between maps and art has swung around; artists are using maps to further their artistic purposes. In postmodern times, with all truths suspect, artists have found in cartography a rich vein of concepts and imagery to mine. Cartographic rules give artists whole networks of assumptions to exploit and upend. In the last fifty years artists have produced much inspiring material for those who appreciate what art can tell us about maps, and how maps enhance art.

Since the 1960s there has been an exponential increase in artists working with maps, and that abundant output has in turn inspired this book. Like the growth of a small settlement into a metropolis, cartographic motifs have spread across the artistic landscape. The timeline

at left lists some of the better-known artists who have used mapping in their work, grouped by the decade in which each began; many artists continued to find inspiration in cartography over two or more decades. An ongoing succession of recent gallery and museum exhibitions and several cartographic blogs led me to map-enthused artists in North and South America, Europe, Africa, Asia, Australia, and New Zealand. Some of these artists have explored mapping in one phase of their careers; for others maps are a unifying motif throughout their work.

Is there any motif so malleable, so ripe for appropriation, as maps? They can act as shorthand for ready metaphors: seeking location and experiencing dislocation, bringing order to chaos, exploring ratios of scale, charting new terrains. Maps act as backdrops for statements about politically imposed boundaries, territoriality, and other notions of power and projection. Mapping and art movements are equally susceptible to shifting political and aesthetic winds. Like artworks, maps are selective about what they represent, and call out differences between collective knowledge and individual experience. Artists use maps to respond to social and economic globalization, and to find orientation amid cultural volatility. And some artists include maps in their artworks not for their semiotics but because they can adapt cartographic systems to their uses or because they simply are drawn to the line and shape of the map's vocabulary.

Reflecting the diversity of contemporary artistic practice, there is little that contemporary artists haven't done with maps. Artists rip, shred, slice, splice, carve, and dissect maps; they fold, pleat, trace, encase, weave, and crumple them; they burn, drown, twist, tear apart, and stitch together every kind of cartographic document imaginable. One artist mapped her sweat, a pair of artists mapped the wrinkles and folds of their skin, and another charted her every movement for weeks on end. Artists make maps of memories, mental states, and futuristic visions. There are maps in this book made from an unraveling sweater, giant green balls, and slabs of meat; I discovered more than one map made of bubble gum. I regret not seeing, in person, one of William Pope.L's maps of the United States made of thousands of rotting hot dogs.

Geographers submit to a tacit agreement to obey certain mapping conventions, to speak in a malleable but standardized visual language. Artists are free to disobey these rules. They can mock preoccupation with ownership, spheres of influence, and conventional cultural orientations and beliefs. In his celebrated series of paintings of the U.S. map created in the early sixties, Jasper Johns took a familiar icon, a form that children learn to recognize in kindergarten, and played with it as a child might. Brushstrokes soften borders, names are untethered from territories, colors come from a broader artistic palette. This is not the map that

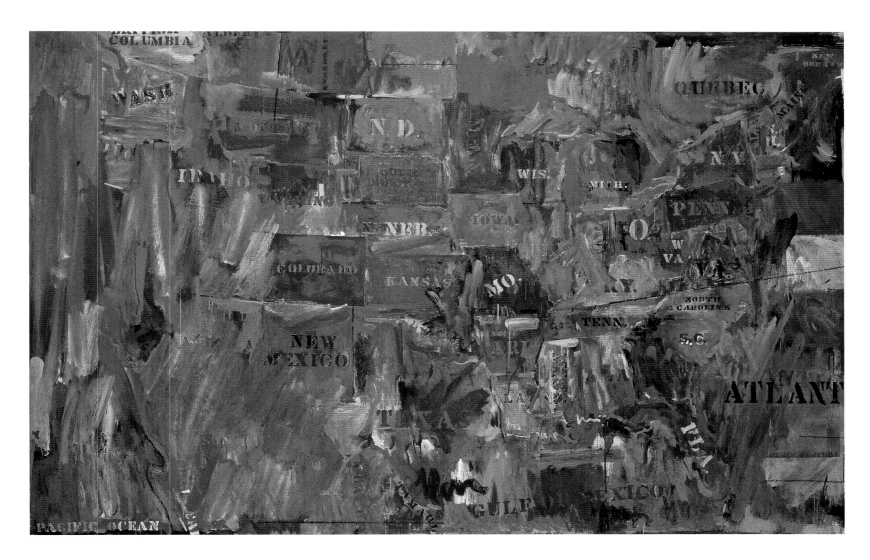

schoolchildren envision as they pledge allegiance to the United States. Why must they—or artists—inherit current cultural conditions, systems, or boundaries?

In the sixties and seventies Frank Bowling painted color-saturated maps with an even softer focus; the forms of continents almost disappear in a sea of reflected light and texture (see pp. 8–9). The rules of mapping cease to exist. Rather than establish "meanings," postmodern artists mess with received wisdom

and poke at assumptions, rousing viewers to reconsider cultural truths. Traditional maps assert, "This is how the world is," and expect the reader to agree. Artists' maps countermand that complicity, saying, "This is my vision, and I encourage you to construct your own."

Around the time that Johns and Bowling were chipping at cartographic bedrock, British artists Terry Atkinson and Michael Baldwin, working together as Art & Language, produced a series of maps revealing

JASPER JOHNS

Map, 1963

Encaustic and collage on canvas
60 x 93 in.
Art © Jasper Johns, licensed by VAGA,
New York

IOWA

KENTUCKY

Map to not indicate : CANADA, JAMES BAY, ONTARIO, QUEBEC, ST. LAWRENCE RIVER, NEW BRUNSWICK, MANITOBA, AKIMISKI ISLAND, LAKE WINNIPEG, LAKE OF THE WOODS, LAKE NIPIGON, LAKE SUPERIOR, LAKE HURON, LAKE MICHIGAN, LAKE ONTARIO, LAKE ERIE, MAINE, NEW HAMPSHIRE, MASSACHUSETTS, VERMONT, CONNECTICUT, RHODE ISLAND, NEW YORK, NEW JERSEY, PENNSYLVANIA, DELAWARE, MARYLAND, WEST VIRGINIA, VIRGINIA, OHIO, MICHIGAN, WISCONSIN, MINNESOTA, EASTERN BORDERS OF NORTH DAKOTA, SOUTH DAKOTA, NEBRASKA, KANSAS, OKLAHOMA, TEXAS, MISSOURI, ILLINOIS, INDIANA, TENNESSEE, ARKANSAS, LOUISIANA, MISSISSIPPI, ALABAMA, GEORGIA, NORTH CAROLINA, SOUTH CAROL-INA, FLORIDA, CUBA, BAHAMAS, ATLANTIC OCEAN, ANDROS ISLANDS, GULF OF MEXICO, STRAITS OF FLORIDA.

only what they wished to show and jettisoning the rest—drawing attention to what cartographers have always done. A & L also made jigsaw puzzles of their maps, demonstrating that a map can be reduced to fragments without connection or context. The artists made no attempt to conceal their motivations. Creative geographer and author Denis Wood writes, "Map artists…claim the power of the map to achieve ends other than the social reproduction of the status quo. Map artists do not reject maps. They reject the authority claimed by normative maps uniquely to portray reality as it is, that is, with dispassion and objectivity."[1]

In the 1960s the emergence of earth art, as pioneered primarily by Robert Smithson, introduced another means of mapping via a direct connection to the territory, with feet on the ground and hands in the dirt. "The lived body is what affords a 'feel' for a given landscape," writes philosophy professor Edward S. Casey, "telling us how it is to be there, how it is to know one's way around in it. Such a body is at once the organ and the vehicle of the painted or constructed map, the source of 'knowing one's way about,' thus of knowing how we can be said to be acquainted with a certain landscape."[2]

For *Buried Poems* (1969–71), a series of private artworks, artist Nancy Holt gave printed maps to five participants—including Smithson (Holt's husband) and other artists—directing them to isolated sites (an unnamed island in the Florida Keys, the Utah desert), where Holt had buried a concrete poem written for

Map of an area of dimensions 12″ × 12″ indicating 2,304 ¼″ squares

ART & LANGUAGE

◀ *Map to not indicate: Canada, James Bay…Straits of Florida,* 1967

Letterpress print
20 x 23.5 in.
Courtesy of the artists and Lisson Gallery, London

▲ *Map of Itself,* 1967

Bookprint
14.5 x 18 in.
Courtesy of the artists and Lisson Gallery, London

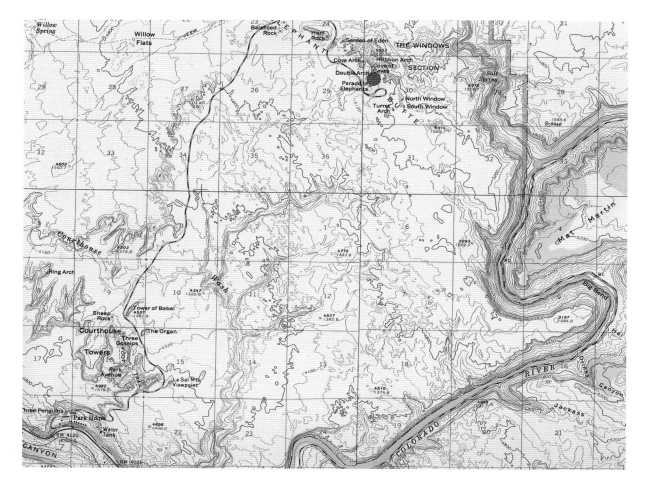

NANCY HOLT

Buried Poems, 1969–71

Documents from private installation
Art © Nancy Holt, licensed by VAGA,
New York

each. "Certain physical, spatial, and atmospheric qualities of a site would evoke a person who I knew," Holt wrote in 1992. "I would then read about the history, geology, flora and fauna of the site and select certain passages from my readings for inclusion in a booklet, which also contained maps, photos, very detailed directions for finding the *Buried Poem.*"[3] The booklets presented a series of maps, beginning with an overall map of the United States, zooming in on the poem's location, indicated with a dot. The gesture of a personalized poem at the project's heart and the "lived body" mapping that occurs via the trek to and from the poem make it obvious that this is meant to be a one-of-a-kind experience. The booklets with maps both enable, and are souvenirs of, the individual journeys Holt "gave" to her friends.

Conventional maps can do no more than point the way to unpredictable, individual experience, while artworks embody those experiences. Conceptual artist Jan Dibbets once chose four spots on a map of Holland, found his way to them, and took a snapshot of each. "What matters is the feeling," he says. "I discovered it's a great feeling to pick out a point on the map and to search for the place for three days, and then to find there are only two trees standing there, and a dog pissing against the tree."[4]

Which comes first, the territory or the map? Artists chart singular perceptions rather than assert meaning for any collective truth. To quote French philosopher Jean Baudrillard on "the precession of simulacra": "The territory no longer precedes the map, nor survives it. Henceforth, it is the map that precedes the territory."[5]

Would you rather navigate a stretch of Utah desert, or find a dog peeing on a tree in Holland—or instead try to fix your position in the wilderness of the internet? Probably not by chance, the escalation of artists' mapping activity in the 1990s coincided with the rise of technological systems of global communication and information dissemination. In mapping modern chaos, some artists may be attempting to defuse its threats. The internet, a network of networks, connects us to a global village. With the world at our fingertips, keeping our bearings can become overwhelming. Do we focus on the forest or the trees, the tiny globe or the immense village? A 2000 song by the folk group Donna the Buffalo puts it this way: "Oh my head / It hurts my eyes / The world's getting bigger as it shrinks in size."[6]

The internet is itself a vast cultural map—if not of a holistic global culture, then at least of a culture that has produced the artists in this book. Like both Lewis Carroll's and Jorge Luis Borges's fictional mapping visions, the map can be seen to overlie the territory in a one-to-one scale.[7] This is a map of overwhelming proportions, a map whose reference points are practically impossible to pin down. Choices of scale, of the whole versus the details, have always been central to cartography, but never to the extent they are today. In contending with such extremes of scale, both web cartographers and artists are recognizing the need for new kinds of cultural maps that acknowledge the impossibility of pinning down what is always shifting. For a Spanish exhibition of new artistic takes on mapping, Lola Dopico wrote, "The organization of information produced by technology, on the one hand, and the constant flux of society, on the other, generate a tension that emerges visually in the form of maps as models…of what is moving and changing rather than of what remains static."[8]

Psychogeography, a relatively new outgrowth of artists' mapping, explores systems and relationships rather than imagery. As the psychogeographer kanarinka writes, the world today needs no representations. "It needs new relations and new uses: in other words, it needs new events, inventions, actions, activities, experiments, interventions, infiltrations, ceremonies, situations, episodes, and catastrophes."[9] For any of these direct interactions with places and their inhabitants, a map can be a starting point, a form of documentation, or the end result.

Psychogeographers probe patterns of behavior, often in collaborative teams, in urban environments, working over a period of time. Projects may involve data collection and personal interviews, experimental actions conducted with scientific rigor, and street theater. Examples of explorations by the Institute for Infinitely Small Things, a Waltham, Massachusetts, performance group include *Unmarked Package* (2007), an event for which team members deployed hundreds of boxes around Chicago and polled residents on terrorism and fear in public spaces; *Funerals for a Moment* (2005), a compilation of eulogies, submitted by people worldwide, for past moments in their lives and funerals for moments held by New Yorkers in the locations where they originally occurred; and *The City Formerly Known as Cambridge* (2008), a project that produced a new map of the city with routes and landmarks renamed by people who live there. Once again, individual actualities come to the fore; the artist/cartographer is the enabler, subverter, and documenter of experience.

Space travel and satellites allow us to see more and more of the Earth, a God's-eye view we have had for less than the blink of human evolution's eye. Now, with Google Earth and other imaging tools, we can both locate ourselves at the center of our worlds and recognize just how colossal that world is. We are thrilled to zoom in on our states, cities, neighborhoods, streets, and homes, even as we feel disquiet at the power of surveillance systems' omniscience. Taking advantage of technology to communicate with the eye in the sky, Nikolas Schiller, an artist whose mapping medium is satellite photography, hauled bricks onto his Washington, D.C., rooftop to spell a message in large block letters: NO WAR.

There is a vast difference between maps that measure geographic features and those that take measure of psychological terrain. Spend time immersed in the world of artists' maps in this book, letting it steer you through familiar landscapes revealed in new ways and over strange topography resonating with hidden meaning. Contemplate each artist's use of cartography and consider maps of your own journey. Discover how mysterious, jarring, thought provoking, and gorgeous artists' maps can be. Wayfinding documents as artworks have never been as diverse, or as stimulating. Mapmaking as a whole is enhanced as each artist makes a mark on a bigger map, calling out, I AM HERE. ◈

THE INSTITUTE FOR INFINITELY SMALL THINGS

The City Formerly Known as Cambridge, 2008

Performance and map

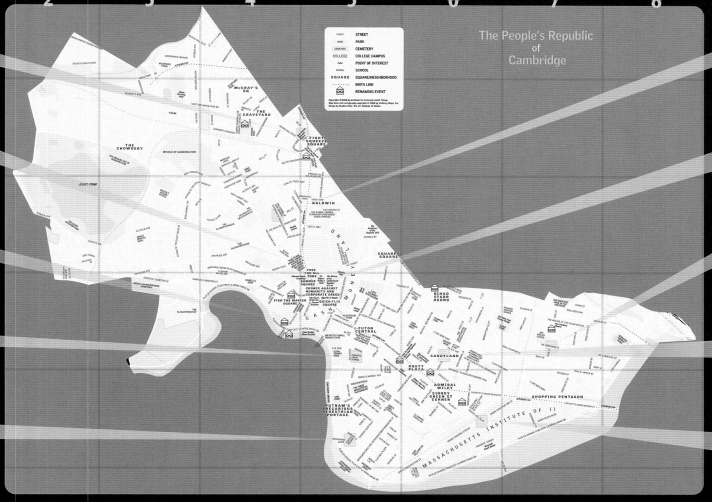

The People's Republic of Cambridge

The City Formerly Known as Cambridge

A hypothetical *(but entirely possible!)* map of Cambridge, Massachusetts.

We collected over 330 new names.

About this map

The City Formerly Known as Cambridge is a hypothetical (but entirely possible!) map of Cambridge, Massachusetts. During 2006–7, the Institute for Infinitely Small Things invited residents and visitors to the city (you) to rename any public place in Cambridge. This was a big experiment to see what the city would look like if the people that live and work here renamed it, right now. We collected over 330 new names along with reasons that ranged from vanity to politics to silliness to forgotten histories to the contested present. This map is a collection of your names and stories about Cambridge, its diverse inhabitants and visitors, its traditions and ever-changing attitudes.

This map also makes the case that names matter. Who gets to name things? Whose stories get remembered? Whose history is consecrated and whose is forgotten? Most Cambridge history books, for example, begin in 1636 with the founding of Newtowne, though there were Native Americans living here long before that time with their own names for its geography. On this map, we have mixed in some real renamed places from the city's history to recall those geographic places that have been contested, disputed, and transformed over time. A city's names, like its communities, are a living, breathing organism.

How it worked

All of these names were collected through face-to-face conversations with people in Cambridge. The Institute for Infinitely Small Things set up its Renaming Booth in commercial centers, at farmers markets, at community festivals and even at a four-square tournament to collect names. Renaming was open to everyone and the Institute did not play any editorial role other than correcting spelling mistakes. Everyone who contributed a new name to the map received a free copy mailed to them.

What about the $$?

You may notice the dollar amounts ($) attached to names on the map. In effect, the most popular parts of Cambridge were auctioned off for small amounts of money. This was designed both to make a political point and to solve a problem: what should happen when 2 people or more wished to rename the same place (say, Harvard Square)? Instead of making a curatorial decision, we decided to mirror real life, which is to say: the person who pays the most money wins. The first time a place was renamed it was free. Each time it was subsequently renamed by a different person, the price went up by $0.25. The money earned from auctioning off names (in total about $20) went towards the production of this map and represents about 0.0025% of the cost of producing the map.

Whose history *is consecrated* and whose is **forgotten?**

About the Institute for Infinitely Small Things

The Institute for Infinitely Small Things conducts creative, participatory research that aims to temporarily transform public spaces dominated by corporate and political agendas. Using performance and conversation, we investigate social and political 'tiny things'. These have included corporate ads, closed-system and post-9/11 security terminology. The Institute advocates for public engagement through its research reports in the form of maps, books and videos. This interdisciplinary group has a varied and open membership which includes artists, filmmakers, computer programmers, historians and hula hoopers. For this project, the Institute was Shannon Coyle, Catherine D'Ignazio, Melissa Eucalitto, Toby Kim Lee, Jaimes Mayhew, James Manning, Dave Raymond, Heather Ring, Katharine Urbati, Matilda Sabal, Alex Sabal, Rob Sabal, Nicole Siggins, and Savic Rasovic.

www.infinitelysmallthings.net
info@infinitelysmallthings.net

The Institute for Infinitely Small Things

This project was made possible with the support of the Cambridge Arts Council, the LEF Foundation and iKatun.

Map design by:
Margaret Rzesa, Ryan Torres and Tarek Awad

Special thanks to:
Aliza Shapiro & Fotini Lazaridou-Hatzigoga (modular table design), James Manning (construction & documentation), Jane Beal & Elizabeth White at the Cambridge Arts Council, Kat Gow & Matthew J. Map (cartography), the Cambridge Historical Commission, Rob Coshow (Map photography), Universal Millennium (printing) and Rick Rawlins and the Senior Design Studio (InRes) at the Art Institute of Boston.

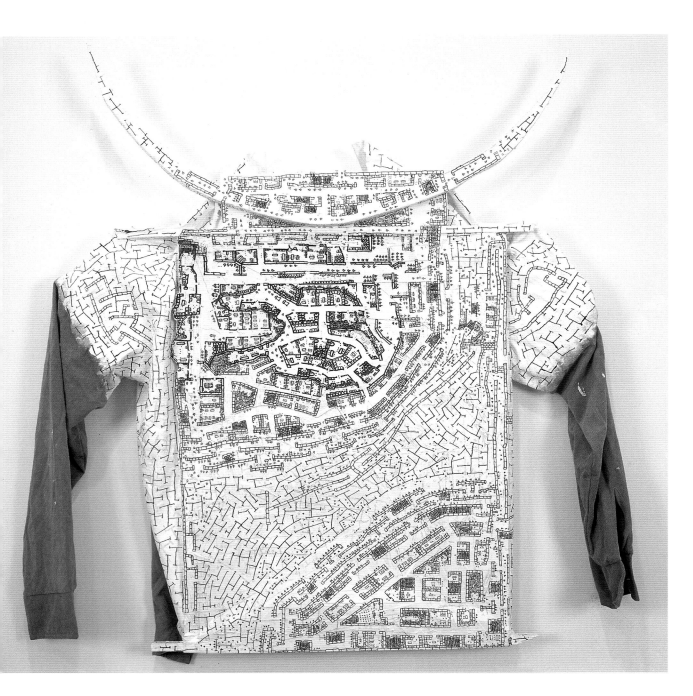

KIM JONES

◀ *Blue Shirt with Horns,* 2004

Acrylic, ink, wood, and fabric
43 x 41 x 5 in.
Courtesy of the artist and Pierogi, Brooklyn
Photo by Joe Amrhein

▶ *Untitled (War Painting),* 1978–1984–2005

Acrylic and ink on paper
22.5 x 28.5 in.
Courtesy of the artist and Pierogi, Brooklyn
Photo by Joe Amrhein

Over the years, Jones has depicted warfare
in imaginary lands—drawn on immense
gallery walls, sketchbook pages, and the
backs of coats and shirts. Some of his
battles take years to end; see the date for
Untitled (War Painting). He describes the
War Drawings as a primitive, hand-drawn
computer game played with pencils and
erasers. Settlements and battlements
may be beautifully articulated, but at any
moment their creator may obliterate them.
Such are the caprices of war.

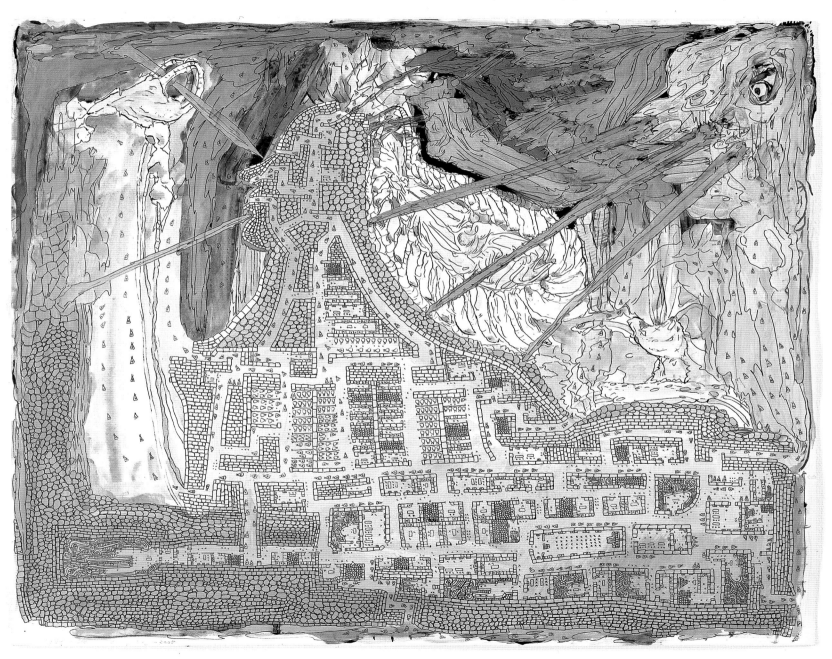

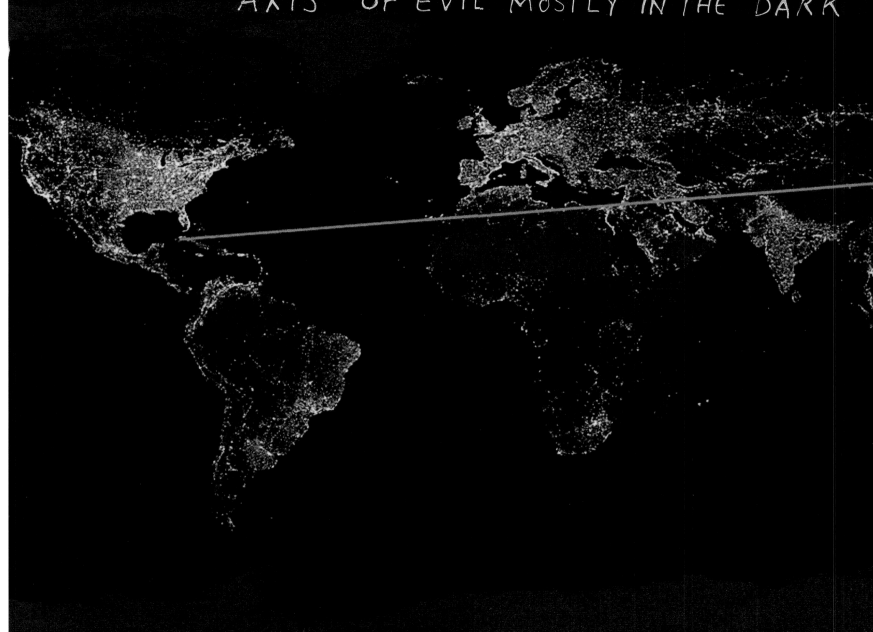

AXIS OF EVIL MOSTLY IN THE DARK

AXIS OF EVIL : CITIES AND LOCATIONS

La Habana — Cuba
Great Exuma
Cape Santa Maria
Crooked Island Passage — Bahamas
Agadir
Taroudant — Morocco
Jebel Sirona
Abadla
Hassi Messaoud — Algeria
Wazia
Tiji
Al Zuwah
Jafran
Al Qasabat
Homs
Zlitan — Libya
Misratah
Ptolemais
Al Bayda
Tulmaytah
Ras Al-Hilal
Apolonia
Tyre — Lebanon
Akko
Har Meron — Israel
Karmel
Teverya

Al Qunaytirah (abandoned) — Golan
Al Mismiyah
Darayya
Damascus — Syria
Akashat
Al Qa'im
Rawah
Anah
Tikrit
Al Hadithah
Jadidah
Khan al Baghdadi
Hit
Ar Ramadi
Al Fallujah
Baghdad — Iraq
Al Khalis
Balad
Biyala
Mandali
Sumar
Al Miqdadiyah
Jalula
Khanaqin
Kifri
Qasr-e-Shirin — Iran
Pol-e-Zahab

Kerend
Gilan-e-Gharb
Eslamabad
Hdabjah
Bakhtaran
Ravansar
Sangor
Sahneh
Harsin
Hamadan
Asdabad
Kangavar
Malayer
Tuysarkan — Iran
Bahar
Tarkhuran
Razan
Nowbaran
Saveh
Farand-e Kahneh
Robat Karim
Sa'dabad
Shahryar
Qom
Kan
Eslamshahr
Tehran

Varamin
Garmsar
Eyvanekey
Firuz Kuh
Semnan
Khaneh Khvodi
Mashad
Sheberghan — Afghanistan
Mazar-e-Sharif
Kholm
Konduz
Taloqan
Badakshan
Qal'eh ye Panjeh
Langar
Mintaka Pass — China
Hotan
Ming feng
Tuokusidawan Ling
Bdrleg
Urt Moran
Da Juh
Delingha
Tianjun
Wuwei
Yingchunay
Tengger Shamo

Sanggin Dalai
Yong Ning
Yinchuan
Wuhu dong miao
Mu us shamo
Meng Djia Wan
Great Wall
Jaoji Babu
Lyoyakou
Dang Cheng
Dinxiang — China
Ouyang
Baoding
Wen An
Duliu
Tientsin
Beitang
Tangga Dagu
Zhoushuzi
Jin xi'an
Changshan Qundao
Talian Dao
Hayan Dao
Hamjong-ni — N. Korea
Taedong
Pi Yongydng

CHARBEL ACKERMANN

◀ *Axis of Evil Mostly in the Dark,* 2003

From the classroom installation *The New Geometry*
Inkjet print and ink on paper
15 x 22 in.
Courtesy of Irvine Contemporary, Washington, D.C.

▲ *Axis of Evil: Cities and Locations,* 2003

From the classroom installation *The New Geometry*
Ink on paper
15 x 22 in.
Courtesy of Irvine Contemporary, Washington, D.C.

In his series *The New Geometry*, Ackermann presents data based on the existence of a geographic "axis of evil," as posited by George W. Bush in his 2002 State of the Union address. Each of the twenty plates in the series portrays an axiom describing a line connecting Havana, Baghdad, Tehran, and Pyongyang and its relationship to other global locations, based on complex analytic contortions involving geometry, physics, music theory, statistical data, and more. The final axiom states: "The Axis of Evil squares the circle (quod erat demonstradum)."

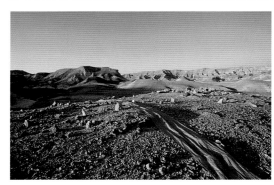
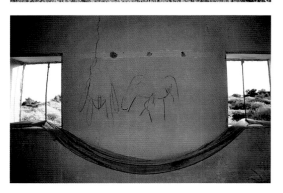

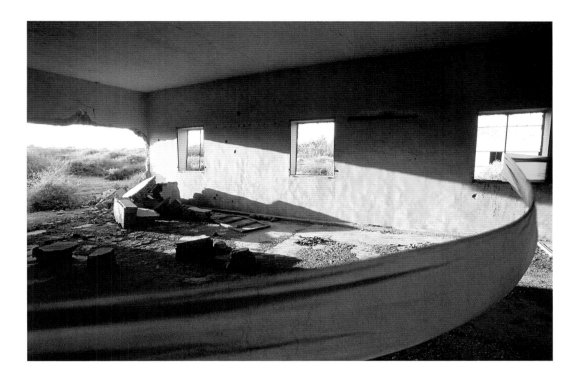

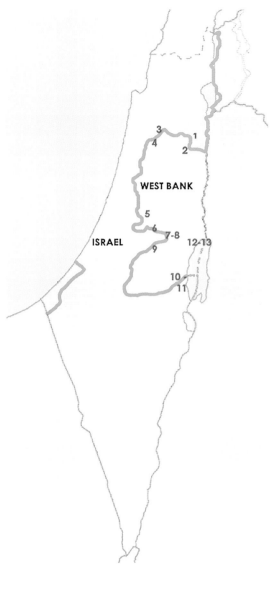

ALBAN BIAUSSAT

Selected images from *The Green(er) Side of the Line,* 2005
Lambda prints, on aluminum and Perspex or transparent fabric
Varied dimensions
Project produced with support from the Al-Ma'mal Foundation
for Contemporary Art, Jerusalem

Facing page, L to R
1. Trees planted along the Green Line, near Moshav Mevav and Jalbun
2. The Fence "touches" the Green Line on Mont Gilboa
3. The Green Line on the Fence, Um El Fahm
4. Butcher in Barta'a East
5. Between Qibya and Budrus
6. Salam, the shepherd from Qatane
7. Har Homa, with Bethlehem in the background
8. Bathing settlers, between Har Gilo and South Jerusalem
9. White donkey in Battir
10, 11. Judean desert
12. Drawing hope inside an abandoned military base north of the Dead Sea

This page
13. Abandoned military base north of the Dead Sea

In 1949 Israeli military commander Moshe Dayan drew a green pencil line on a map, establishing armistice lines between Israel and the West Bank. The Green Line looms large in the region's psyche: when Biaussat made the virtual borderline visible, with thirty-nine-foot lengths of ribbon and painted balls placed in the landscape, people reacted to the shade of green he chose. The color, like the notion of the border, is a subjective construct. Biaussat's green ribbons waving in the wind and portable green balls point to the borderline's artificiality and mutability. He writes, "This project intends to communicate, with a smile, a sense of absurdity when envisaging the likelihood of establishing borders in this landscape, if such a thing is possible at all."

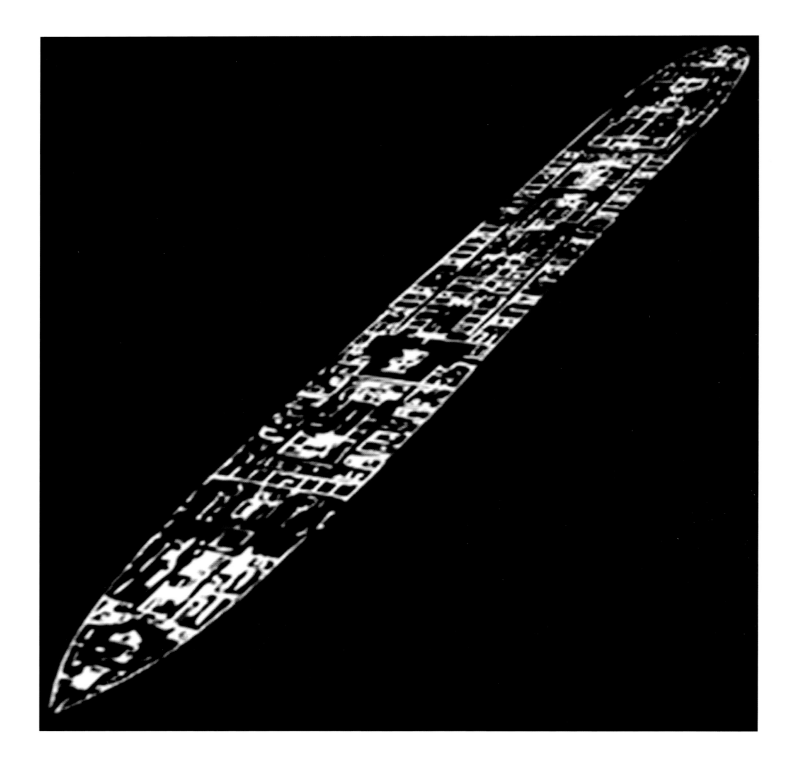

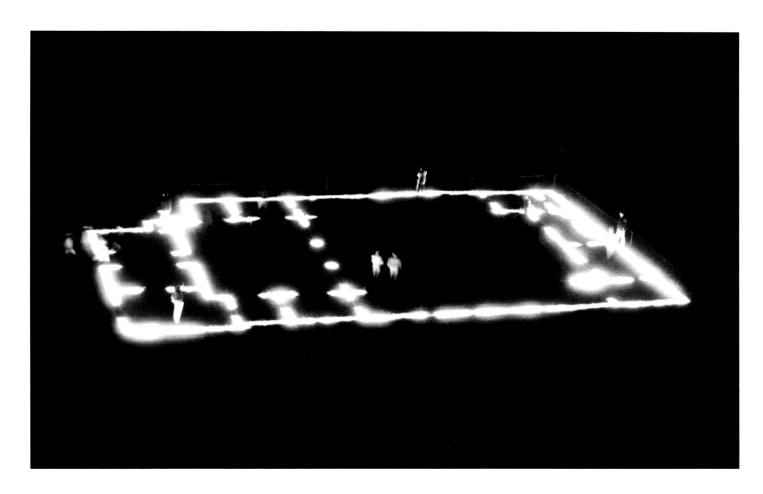

MELISSA GOULD (A.K.A. MEGO)

◄ *Proposal image for Ghostship/ The Titanic Project,* 1991

From the series *Memorial Lightscapes*
92 x 882 ft.
Computer rendering by Marc Rosenberg

▲ *Floor Plan,* 1991

From the series *Memorial Lightscapes*
Temporary installation at the Ars Electronica Festival, Linz, Austria
Site-specific outdoor installation of 110 fluorescent light tubes embedded slightly below ground level with complementary sound installation, "Notes from Underground," by Alvin Curran, from peripherally buried loudspeakers
57 x 80 ft.

Designed for viewing between dusk and dawn, Gould's *Memorial Lightscapes* are dedicated to the memory, both personal and collective, of "lost spaces"—places that no longer exist because of tragic events, reincarnated through the metaphor of light as life.

Floor Plan is a conceptual Holocaust memorial based on the blueprint of a destroyed synagogue, the Reformgemeinde, in the former East Berlin. With its eerie light, Gould alludes to the fires of Kristallnacht, the flames that consumed so many European Jews during World War Two, and the eternal light that burns in all synagogues. Gould has also conceptualized *Ghostship/The Titanic Project,* a full-scale light projection of a Titanic deck plan to be beamed onto the surface of the Hudson River, in the very slip where the ill-fated ship was expected to dock in 1912. She would like the project to be realized on April 15, 2012, to commemorate the centennial of the Titanic's fatal maiden voyage.

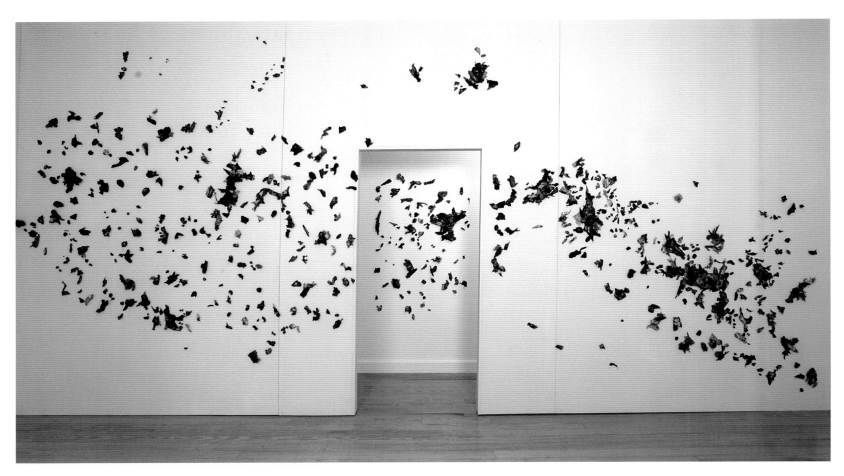

MEL CHIN

Render, 2003 (installation view, with details)

Oil on velvet, steel, kaffiyehs, wax, wood, pigment, traces of Palestinian soil, and white muslin
Installation: 108 x 216 x 216 in.
Photo by John Lucas

Render is the sum of numerous emotionally laden parts, with a map at its center. Shrouds of white muslin, similar to traditional Jewish burial cloths, enclose a space proportionate to the Kaaba, the massive granite cube at Mecca toward which Muslims pray. Inside is a framed portrait suggesting a terrorist; the eyes and mouth are based on a news photo of George W. Bush. Turning to leave, the viewer passes a wall embedded with shredded kaffiyehs, the traditional Arab headdress, painted with pigments mixed with Palestinian soil. These pieces of fabric approximate the mass of a young female suicide bomber and are arrayed as a map of the Palestinian West Bank settlements.

SARAH TRIGG

Frame 1, 2003

From the series *Mutation Sites*
Gouache on paper mounted on panel
5 x 7 in.
Collection of Patrick McMullan

Frame 2, 2003

From the series *Mutation Sites*
Gouache on paper mounted on panel
5 x 7 in.
Collection of Robert A. Southern

Frame 3, 2003

From the series *Mutation Sites*
Gouache on paper mounted on panel
5 x 7 in.
Collection of Maurice Tuchman

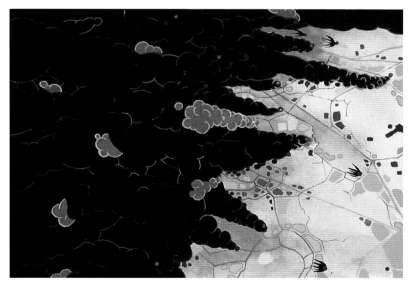

Trigg's *Mutation Sites* series was inspired by reconnaissance images from the Cuban Missile Crisis, which indicated a grave prognosis for the political "body" of the modern age (a nuclear war would be fatal for all concerned). She studied current satellite imagery for signs of malignant sociopolitical activity. "Throughout my work," Trigg says, "I view the surface of the earth as a living system that can be biopsied to undergo analysis much like a scientist or doctor might biopsy a living human tissue." *Frame 1, Frame 2,* and *Frame 3* depict Kuwait's burning oil fields during the Gulf War.

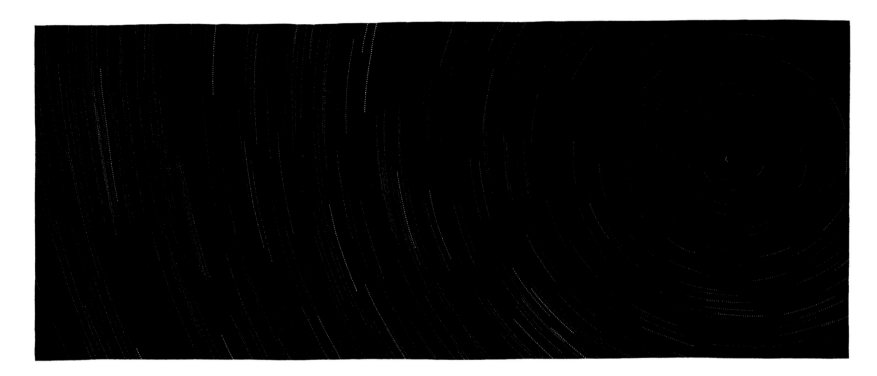

ANNA VON MERTENS

▲ *6:01 pm until 7:05 pm, April 4, 1968, from the balcony of the Lorraine Motel in Memphis, Tennessee (looking in the direction the shots were fired),* 2006

From the series *As the Stars Go By*
Hand-stitched cotton
41 x 97.5 in.
Courtesy of the artist and Jack Hanley Gallery, San Francisco
Photo by Don Tuttle Photography

On cotton canvases, Von Mertens stitches star-rotation patterns linked to violent moments in American history, such as the battles at Antietam, Ardennes, and Baghdad. She calls these events "pivot points, where what came before seems separate from what follows." *As the Stars Go By* includes a map of how the heavens looked when Christopher Columbus first sighted the New World, when stars both enabled global navigation and portended revolutionary changes. The work shown here depicts the stars' alignment at the time of Martin Luther King Jr.'s assassination. The pieces in the series act as memorials, historical viewpoints, and studies of astrological forces, but, Von Mertens says, "ultimately simply document a natural cycle that is impassive and oblivious to the violence below."

KARIN SCHAEFER

▶ *WTC Memorial Model,* 2003 (left-side view)

Paint marker on Plexiglas
12 x 12 in.
Photo by Robert DiScalfani

Schaefer is a Brooklyn-based artist who dealt with the 9/11 catastrophe and its aftermath by imagining a monument to those who died. In reading about the victims, she was struck by their diverse stories and the tragic destiny they shared in coming together at a particular point in time and space. She focused on the geography of the event; on a seventy-five-mile-radius map, she drew a dot that represented each person in the town or neighborhood where they lived and lines tracing the trains, subways, ferries, and highways that brought each to work. Schaefer proposes etching the results onto ten-by-ten-foot sheets of glass, each representing a floor of the World Trade Center, and then layering these to form a thick transparent wall of fatefully converging lines.

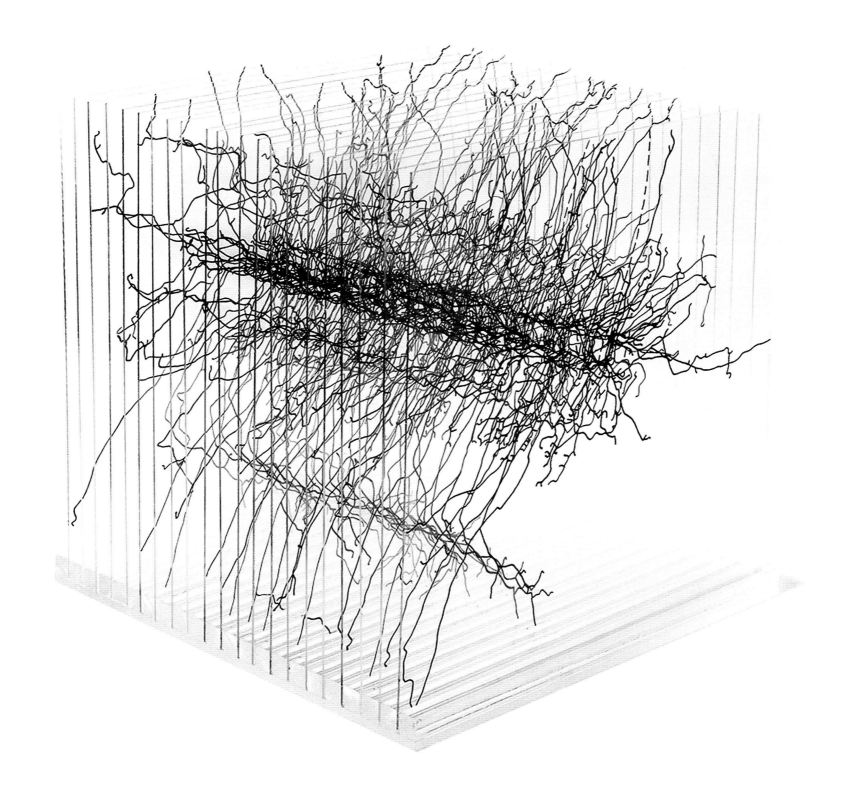

ELIN O'HARA SLAVICK

◀ *We Are Our Own Enemy: First Atomic Explosion, Alamogordo, New Mexico, USA, 1945,* 1999

From the series *Protesting Cartography: Places the United States Has Bombed*
Ink, watercolor, gouache, acrylic, and graphite on Arches paper
30 x 22 in.

◀ ▼ *Philadelphia: The Firebombing of M.O.V.E., USA, 1985 (For Ramona Africa and Mumia Abu-Jamal),* 2000

From the series *Protesting Cartography: Places the United States Has Bombed*
Ink, watercolor, gouache, acrylic, and graphite on Arches paper
30 x 22 in.

This series includes over sixty paintings of U.S. bombing sites, based on military and surveillance maps and satellite photography. Slavick has written that the more sites she finds, the more she thinks the series subtitle should be *The United States Has Bombed Everywhere.* "I suppose I want to instill fear back into us, but not fear of the peripheral world," she says. "We should be afraid of ourselves. Maps are preeminently a language of power, not protest. I offer these maps as protests against each and every bombing."

NURIT GUR-LAVY KARNI

▶ *Aerial Photograph of Gaza 5,* 2002

From the series *Aerial Photographs of Gaza*
Oil on canvas
27.5 x 39.5 in.
Photo by Shay Adam
Original photo by Albatross Aerial Photography

From 2001 to 2006, Gur-Lavy Karni created an extensive series of paintings based on an aerial photograph of the Jabalia refugee camp. She discovered it while searching for a photo of the Karni barrier (connecting Israel and the Gaza Strip), named after her father, Josef Karni, an Israeli who established a citrus packinghouse in the 1960s, hoping to establish business and cultural relations with Palestinian citrus growers in the Gaza Strip. The property was subsequently damaged in attacks and given over to Palestinian authorities. The artist studied the photo of the camp in all its details—alleys, cooking fires, tires securing metal rooftops, wash hanging on lines—attempting to overcome personal barriers to find a connection with its residents. Though each painting in the series is unique, all feature a crossroads—a potent symbol that can also be read as a cross, a gunner's target, or a symbol of elimination.

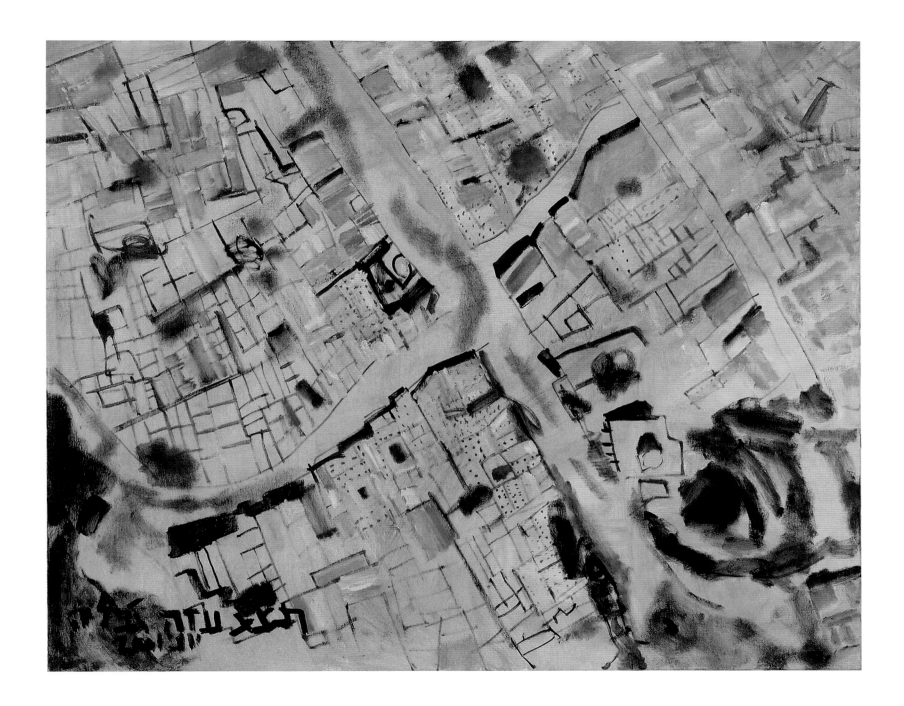

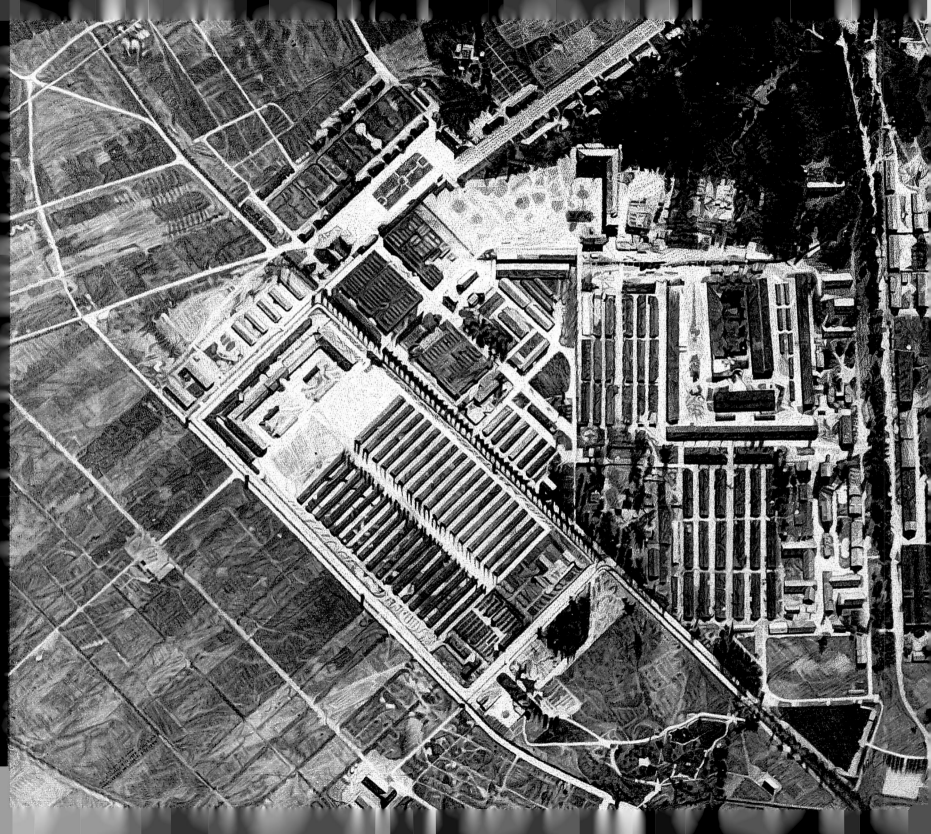

ARIE A. GALLES

◀ *Station Seven: Dachau,* 1999

▲ *Station Seven: Dachau (detail of Kaddish),* 1999

From the series of drawings *Fourteen Stations*
Charcoal and white Conté
47.5 x 75 in.
Photo by Tim Volk

Fourteen Stations is an homage to the millions who perished in Nazi death camps in World War II. The title alludes to the fourteen stations of the cross, as well as to the siting of concentration camps next to rail lines. The drawings, based on Luftwaffe and Allied aerial reconnaissance film, were made over the course of a decade, during which Galles says he felt "strapped to the belly of a bomber, looking down." He was sustained by the act of transforming cold, mechanical photographs into images made by a human hand, bringing attention to each minuscule detail of the camps—including one where relatives died. Of his undertaking, Galles says, "Through my perception of shapes and tonalities I [was able to] map…humanity's darkest undertaking."

Galles describes his suite as a Kaddish, a prayer for the dead. "The most sincere and honest way I know how to pray is through my work," he says. "So many people died in these camps, and there's no one to say Kaddish for them." Galles's art does just this: each of the drawings contains a fragment of the prayer, and when the images are hung in order, the suite "recites" the Kaddish.

Joyce Kozloff A Geography of History and Strife

Since the 1990s, Joyce Kozloff has worked with maps in a variety of ways: painting and collaging cartographic images that track political and geographic phenomena; appropriating and altering historical maps; creating frescoes, murals, and ceramic tiles with mapping imagery; and constructing globes and other three-dimensional objects related to maps. For Kozloff, maps and mapping are evidence of human

> My map and globe works…image both
> physical and mental terrain, and
> employ mutations to raise geopolitical issues….
> With an increasing urgency, I seek
> the physical corollaries between mapping,
> naming, and subjugation, while charting and
> reflecting our earth.[1]
>
> Joyce Kozloff (American, b. 1942)

ideologies and actions, exploitations and imperfections; through them she examines our relationships with history, each other, and our world.

The political messages are often quite clear—Kozloff calls attention to atrocities like the slave trade, wars, and bombings—but she also uncovers the subtle prejudices and misinformed worldviews that have shaped cartography. She invites us to navigate these issues through wry humor, rich references to literature and pop culture, and a great deal of pure visual appeal. Exploration of human drives and desires, along with a deliberate erasure of the division between high and low culture, has been a part of Kozloff's art since her feminist work of the 1970s. One of the founders of the Pattern and Decoration movement, Kozloff created paintings and mosaics that drew on Western, non-Western, and typically feminine traditions of craft and decorative art in order to subvert and expand patriarchal notions of what fine art is.

Her background in feminism, decorative art, and site-specific public installations—such as a series of ceramic friezes for a Los Angeles subway station—led to Kozloff's interest in map work. It's easy to see how she would be attracted to the visual elements of maps, especially the bright colors and vivid contrasts in tone and shape that are used to delineate boundaries and land masses. The all-over quality of maps, with lines and shapes spreading across the surface, would have resonated with Kozloff's interest in pattern and decoration. Methodologically, there are strong connections between her bodies of work. Kozloff says, "Mapping almost seamlessly arose out of public art, working with diagrams and floor plans, layering my own content onto them."[2] But there's more to it than that. Perhaps most important, maps—and their 3-D counterparts, globes—are vehicles for Kozloff's search to reveal patterns in, and thereby some understanding of, our modes of interacting with the world.

Appropriately, Kozloff carries out her artistic journeys according to a structured, but varying, system. She often works in series—bodies of work related to a concept that may take her several years to complete. In

one of her earliest series, *Bodies of Water,* from the late 1990s, Kozloff re-created maps of oceans and rivers as they course through countries and continents. Around and on top of these elements, Kozloff collaged literary passages and body imagery: veins, brains and other internal organs, and circulatory systems are laid over the fluid systems of the external world.

In her *Knowledge* series, from 1998 to 1999, Kozloff looked at maps from the Age of Discovery, the fifteenth through seventeenth centuries, when European powers sent forth ships with cartographers charting the unknown. The maps from this time are filled with errors, reflecting the mapmakers' imperfect and incomplete understanding of the world. Kozloff has stated, "I don't think I could make mistakes that would be as curious as the ones that they made unconsciously, unknowingly, and in full faith," and so she reproduced these maps, mistakes and all, in small-scale frescoes.[3]

In 2000, Kozloff created *Targets,* a nine-foot globe that viewers enter to become surrounded by maps—aerial views of twenty-four countries that have been bombed by U.S. warplanes since 1945. Maps are usually skins on top of topographies, but here they are placed inside the structure of the world. The exterior of the globe is constructed of intersecting wood beams; the overall form of the sculpture takes on associations

JOYCE KOZLOFF

Targets, 2000

Acrylic on canvas with wood frame
Diameter: 108 in.
Courtesy of the artist and DC Moore Gallery, New York

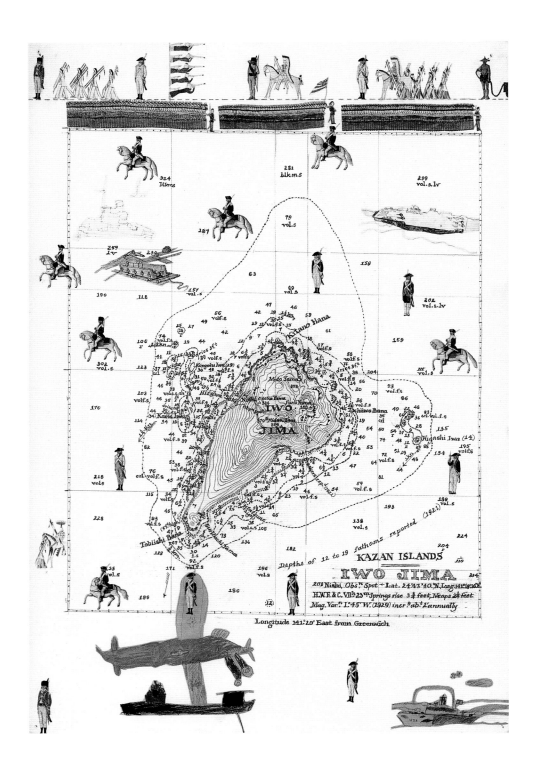

JOYCE KOZLOFF

Boys' Art #9: Iwo Jima, 2001–2

Mixed media on paper
16.75 x 11.5 in.
Courtesy of the artist and DC Moore Gallery, New York

with bombs and hand grenades. Entering this display of history, we examine our relationship with its places and stories. The division between internal and external realities is exploded.

On a tour through Kozloff's body of work, it is worthwhile to take a longer look at *Boys' Art,* a series from 2001 to 2003 that examines masculine and boyish strategies of control, aggression, and play. In these mixed-media maps Kozloff enters territory that is both well charted and unknown. Boys' attraction to war games and imagery has been thoroughly documented, but who can map the imaginative, creative life of boys? Kozloff states:

> There is an underlying sadness and strangeness (for me, as a woman) to the inevitably romantic fascination that young boys seem to have for war, something I have long observed but never understood, and I sometimes make art to try to grasp what is unknown to me.[4]

Kozloff has long been interested in the desire of many boys to draw war and superhero imagery, a phenomenon that she observed in her brother while growing up and in her son when he was young. In *Boys' Art,* Kozloff melded this fascination with her artistic engagement with mapping. In 2001 she brought copies of old military maps from different eras and parts of the world to an artist's residency in Italy. There, she meticulously copied the maps freehand, mainly in black, as her art

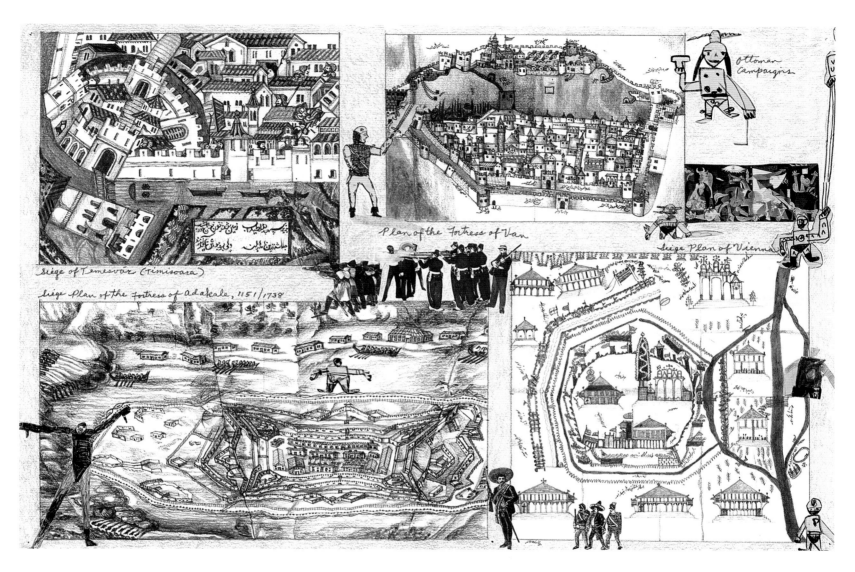

Plan of the Fortress of Van

Siege Plan of Vienna

Ottoman Campaigns

Siege of Temesvar (Timisoara)

Siege Plan of the Fortress of Adakale, 1151/1738

materials were held up in customs. Kozloff's maps, re-created from these historical drawings by men, retained their original connection to specific places and events, but also became the backdrop and setting for her to play. She took her son's childhood drawings of superheroes, soldiers, cowboys, and Indians, resized them, and strategically positioned them, as if they were romping from site to site. "I inserted his strug-

gling, shooting, stabbing, screaming creatures into my artworks," Kozloff says, "and new, sometimes surreal narratives emerged."[5]

Modification of the original context of the maps and of Kozloff's drawings opened up a world of possibilities for her. Soon, military images drawn from popular and high culture joined the childish figures. In *Ottoman Campaigns,* 2003, Picasso's *Guernica* and

JOYCE KOZLOFF

Boys' Art #21: Ottoman Campaigns, 2003

Mixed media on paper
11.5 x 16.75 in.
Courtesy of the artist and DC Moore Gallery, New York

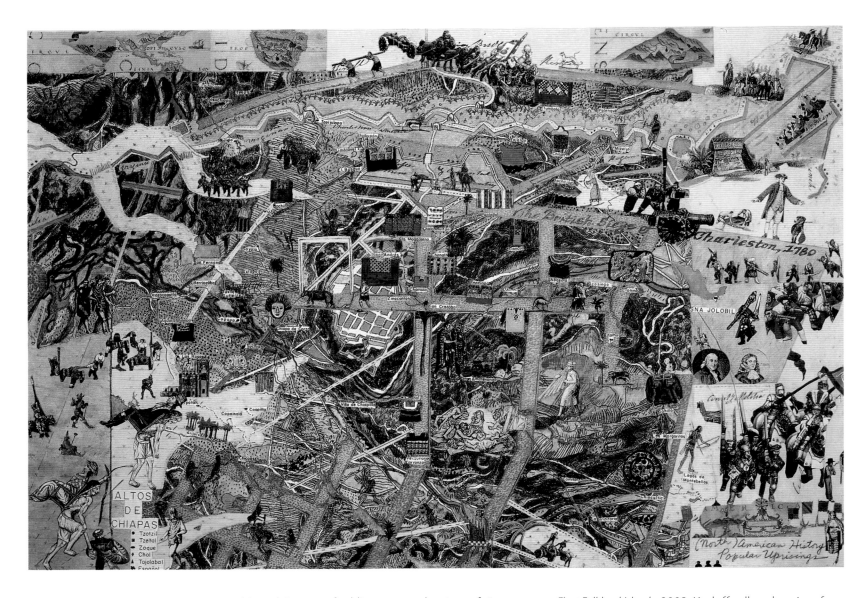

JOYCE KOZLOFF

(North) American History: Popular Uprisings, 2004

Etching, collage, watercolor, pigment print, acrylic, and colored pencil
32.75 x 47.5 in.
Courtesy of the artist and DC Moore Gallery, New York

Manet's images of soldiers occupy drawings of siege plans and fortresses. This is boys' art indeed: the art of war and war-related art, high and low art, and drawings of aliens, knights, and Mexican soldiers live together in a single moment on Kozloff's stage.

Several of the images create links with nineteenth-century drawings of battles by Plains Indians. In *British Fleet Falkland Islands,* 2003, Kozloff collaged copies of figures from Native American drawings depicting Cheyenne, Sioux, Crow, Shoshone, and other warriors on a 1770 British map titled "Plan of the English settlement at Puerto de la Cruzada." More generally, Kozloff's works are reminiscent of the earlier Native American compositions in their turbulent blend of detail and

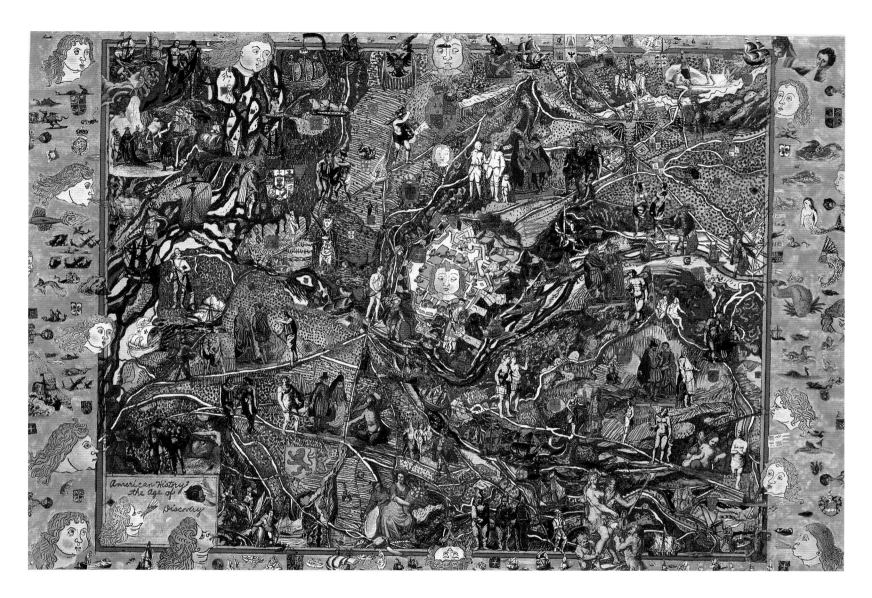

simplified lines, disregard for precise naturalistic scale, and the ability of the characters to generate a sense of galloping freedom despite the known realities of battle.

The dissonance that Kozloff creates through appropriation and mixing sources has a curious effect, heightening the solemnity of the historical events and drawing us in to look at the maps more closely. We wonder what really happened there and who the actual inhabitants and soldiers were. But at the same time there's a sense of whimsy and absurdity. For Kozloff, "the microscopic men are touching and vulnerable, a reminder of my son's childhood and of an earlier period in my own life."[6]

It's too simplistic to draw a straight line from the fantasy life of boys' play to the real history—and present

JOYCE KOZLOFF

American History: Age of Discovery, 2004

Etching, collage, watercolor, pigment print, acrylic, and colored pencil
32.75 x 48 in.
Courtesy of the artist and DC Moore Gallery, New York

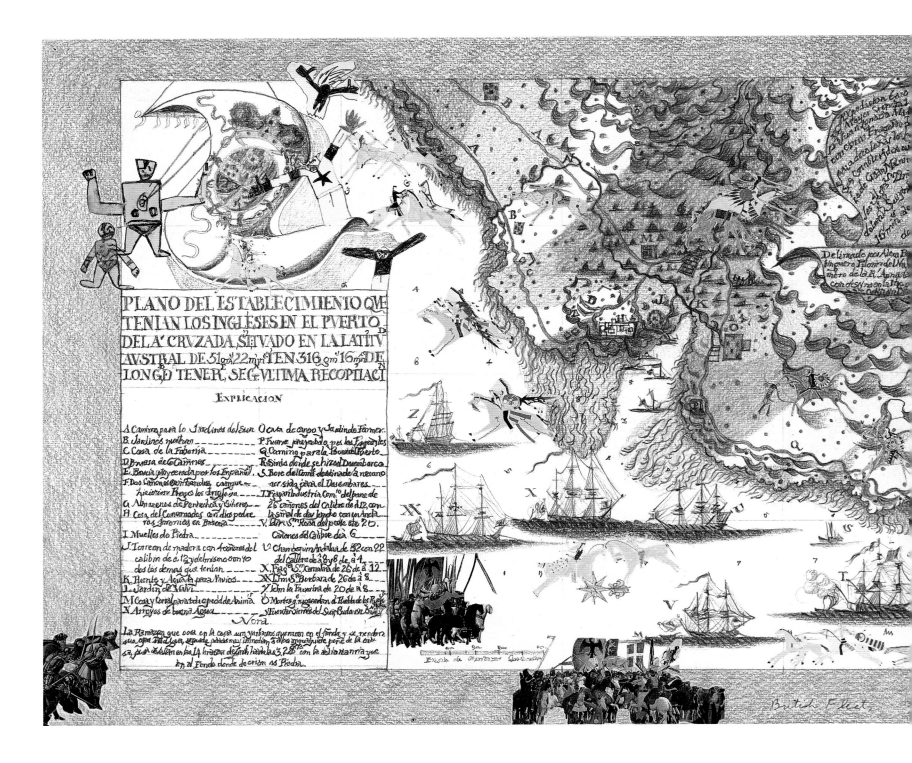

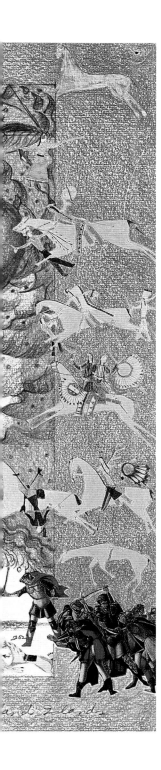

JOYCE KOZLOFF

Boys' Art #7: British Fleet, Falkland Islands, 2003

Mixed media on paper
11.5 x 16.75 in.
Private collection
Courtesy of the artist and DC Moore Gallery, New York

reality—of war. Kozloff's son, Nik, grew up to be a historian, not a warmonger. But the childishly drawn figures of soldiers and villains that occupy her military maps do make us contemplate human nature and our capacity to perpetuate warfare.

Kozloff's quest for understanding does not lead her to make simplistic or generalized statements; specificity is key in her works.

> I would not enjoy a world in which cultures became homogeneous and lost their singularity. All my work is appropriated from outside sources; I create a hybrid, a fusion of diverse materials, but I don't disguise their uniqueness or stylize them beyond recognition. We are flooded with imagery from everywhere: in our museums, our libraries, our media. For years, I've been trying to put it together for myself.[7]

Although for very different purposes, the cartographers who created the original maps that appear in Kozloff's pieces were also mapping to better understand the relationship between people and places. But these maps sought to impose order and clarity on the irregularities and obfuscations of real geography. In military contexts, mapmaking was used to discover areas of strategic advantage or danger. The visual record is an abstraction of the military events that occurred or were being planned at these real places. The human element of real people enacting real acts of warfare on others is invisible. Yet Kozloff adds boyish and artistic human elements, creating cultural and psychological complexities and generating new functions and meanings for the original maps.

In 2004, Kozloff moved on to create the *American History* series, mixed-media pieces that are a visual extension of the ironic and whimsical layering of *Boys' Art.* But these collages zero in on the myths and images of America—from the Native American and white explorer who uncomfortably share the early history of the country, through imagery of the civil and world wars, to current and even futuristic characters.

Kozloff's series are linked together by artistic strategies that are visually engaging, politically engaged, and often quite disarming. Consistently and incisively, Kozloff points to the complex impulse to locate and coordinate ourselves within a mass of images, histories, ideologies, and our own internal compulsions. ◈

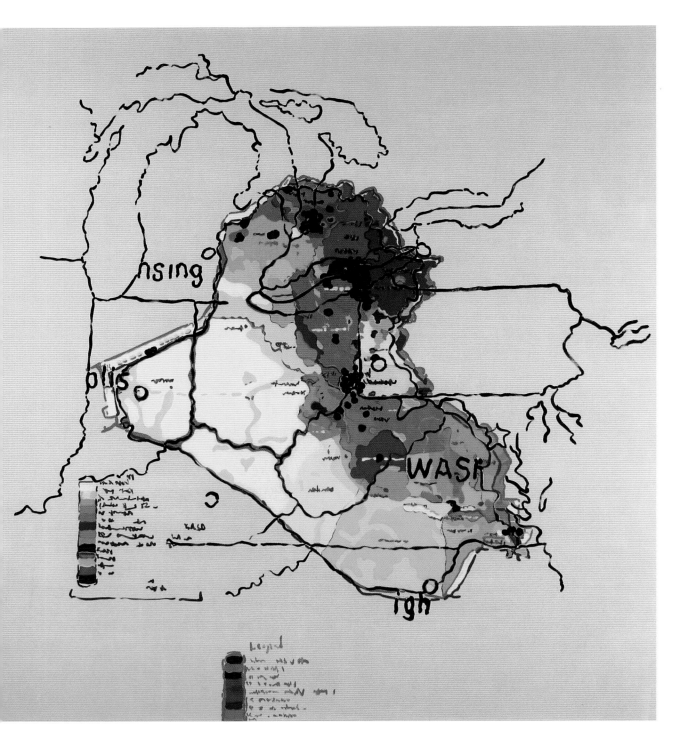

DAN MILLS

◄ *Superimpositions,* 2007

From the series *Future States Paintings*
Acrylic on canvas
56 x 52 in.
Courtesy of the artist and Zolla/Lieberman Gallery, Chicago
Photo by Rachel Porter

► *Future State No. 46, USArctica,* 2005

Watercolor, collage, graphite, and ink on paper
14.25 x 17 in.
Photo by Stafford Smith

In a series of related projects, Mills proposes a bold empire-building scheme: U.S. annexation of various countries as new noncontiguous states with military sites, natural resources, or workforces to exploit. "We are the imperialists of the twenty-first century," Mills writes. "Let's stop pretending. Rather than feign that our actions are benevolent, let us function openly as global imperialists whose actions are clearly defined by direct benefit to the U.S." Mills suggests the takeover of Iraq, Iceland, South Korea, and Qatar as reasonable first steps toward establishing the USE (United States Empire; hence the title of his manifesto, "USE the World"). He has created an atlas of forty-seven proposed future states, as well as *Future States Paintings*—including this image of Iraq, to be renamed USArabia superimposed on the Midwest for size comparison. "I am fond of countries that have boundaries that are either vague or in dispute," Mills says. "Disputed lands are always resolved in favor of the USE."

Global Reckoning Maps That Take a Stand

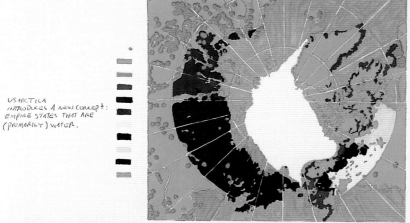

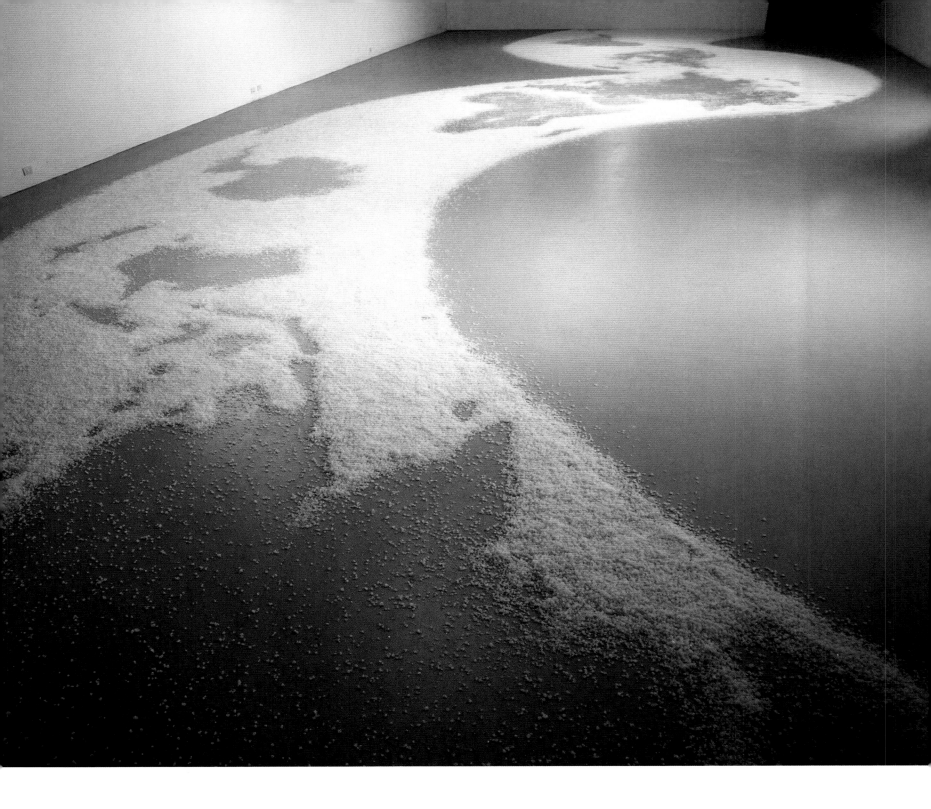

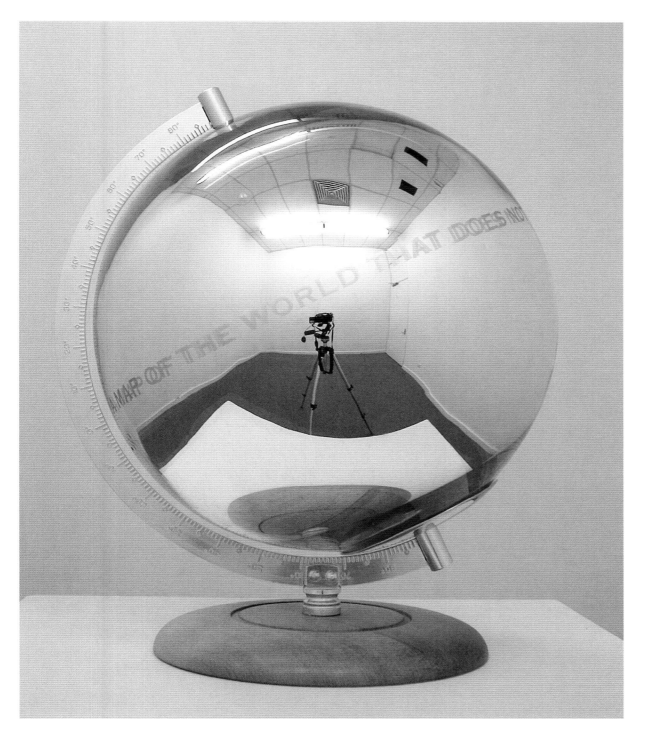

RUTH WATSON

◀◀ *Cry Me A River,* 2002

Rough-grade salt, poured directly onto floor
75 ft. long
Courtesy of the Experimental Art Foundation,
Adelaide, Australia

◀ *A map of the world that does not include
Utopia is not worth even glancing at...,* 2004

Hand-blown, mirrored glass with sandblasted text,
aluminum fittings, and wooden base
Globe diameter 12 in.
Courtesy of the artist and Two Rooms Gallery,
Auckland

Watson's long, winding river of salt evokes several ideas. The artist offered the sparkle of salt crystals—a magical light representing hope—to viewers at a tense time, when Australia (Watson's home country) was supporting the United States in its buildup to war. Salt also suggests tears (referenced in the title) shed for global suffering, as well as serious desalination problems that are threatening one of Australia's most important river systems, the Murray-Darling. The overall intended effect of the river map, says Watson, is quiet contemplation.

The viewer cannot avoid engaging with Watson's reflective globe, onto which she has etched a portion of a quotation from Oscar Wilde's book *The Soul of Man under Socialism* (1891). It reads in full: "A map of the world that does not include Utopia is not worth even glancing at, for it leaves out the one country at which Humanity is always landing." The artist suggests that speaking out against deleterious forces is important, but positive statements—such as ones on the human capacity for hope—are also worth making.

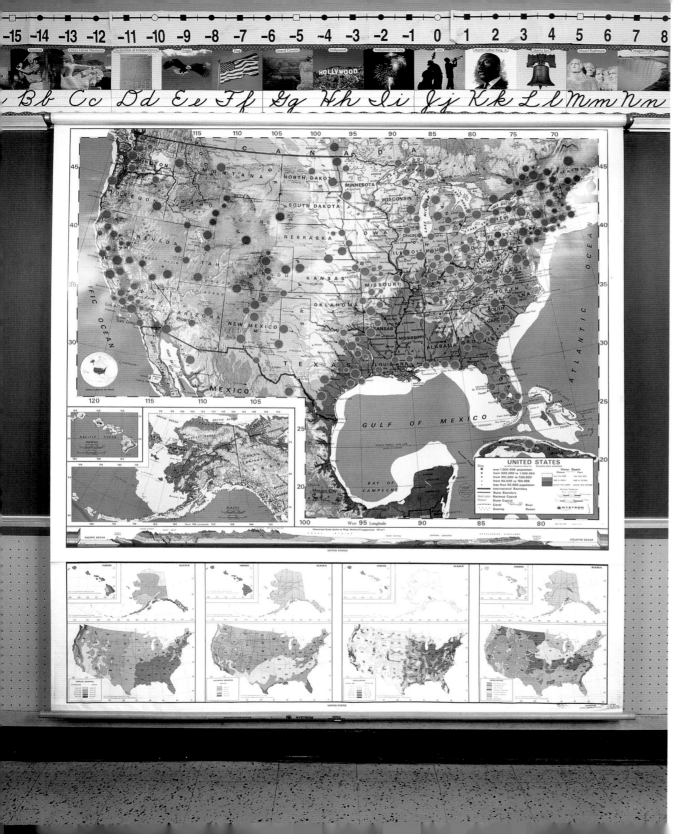

KIM BARANOWSKI

◄ *Nystrom US 1SR1 (Reported sites of alien abduction and unexplained missing time),* 2006

From the series *Mappa Mundi*
Altered pull-down school map
65 x 53 x 3 in.
Photo by Amy Barkow

▶ *Modern Land-Form Series: Asia (Westward spread of H5N1/avian flu),* 2006

From the series *Mappa Mundi*
Altered pull-down school map
48 x 60 x 3 in.
Photo by Amy Barkow

Baranowski's *Mappa Mundi* series presents information that would give schoolchildren nightmares: areas of the world not yet hit by asteroids, potential U.S. nuclear targets, the invisibility of stars because of light pollution. This is geography instruction as reality immersion, or show-and-tell for the paranoid.

Following pages

VIK MUNIZ

WWW, 2008

From the series *Pictures of Junk*
Digital C-print
Triptych, each panel 104 x 71 in.
Courtesy of the artist and Sikkema Jenkins & Co., New York

In making artworks from atypical materials—sugar, diamonds, chocolate syrup, thousands of yards of thread—Brazilian artist Muniz invites people to look beyond what his pictures depict and focus on the acts of making and viewing art. It often takes a moment or more for viewers, moving closer to and away from the images, to realize that pieces in Muniz's series *Pictures of Junk* are, in fact, made of junk. The pictures are composed on a massive scale in a space the size of a basketball court, often assembled over the course of a month or more by youths from the favelas (shantytowns) of Rio de Janeiro. Talking about his work, Muniz says, "I'm a Hugo Chavez of the art world. I want to make populist art that anyone has access to…. If I knew how dogs look at things, I would make art for them, too."

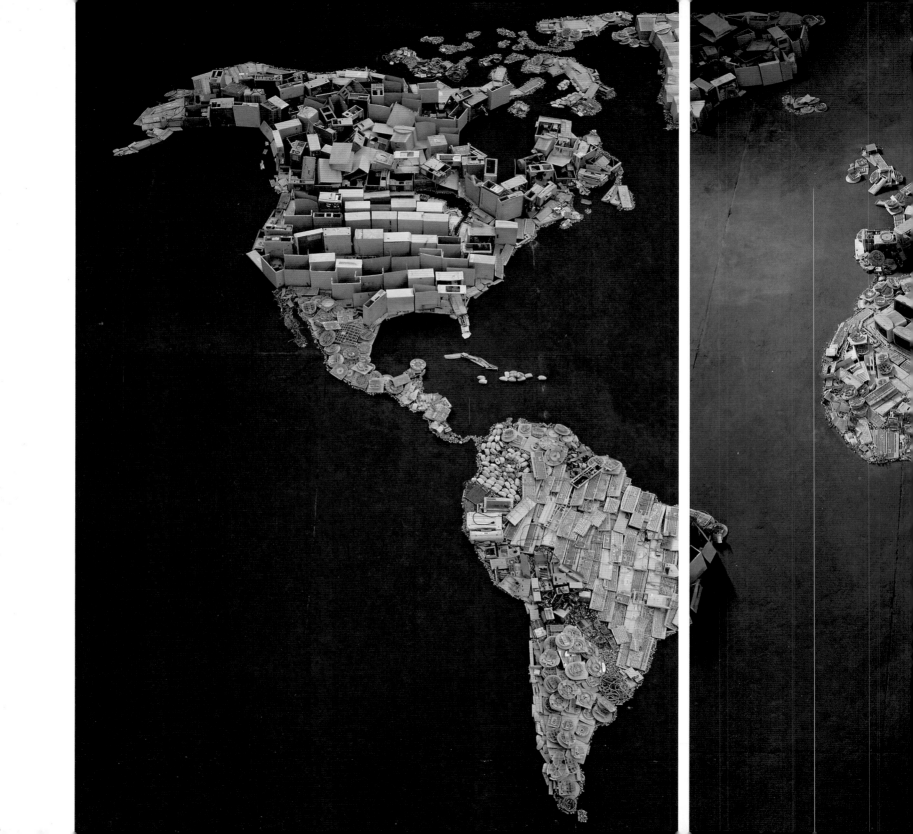

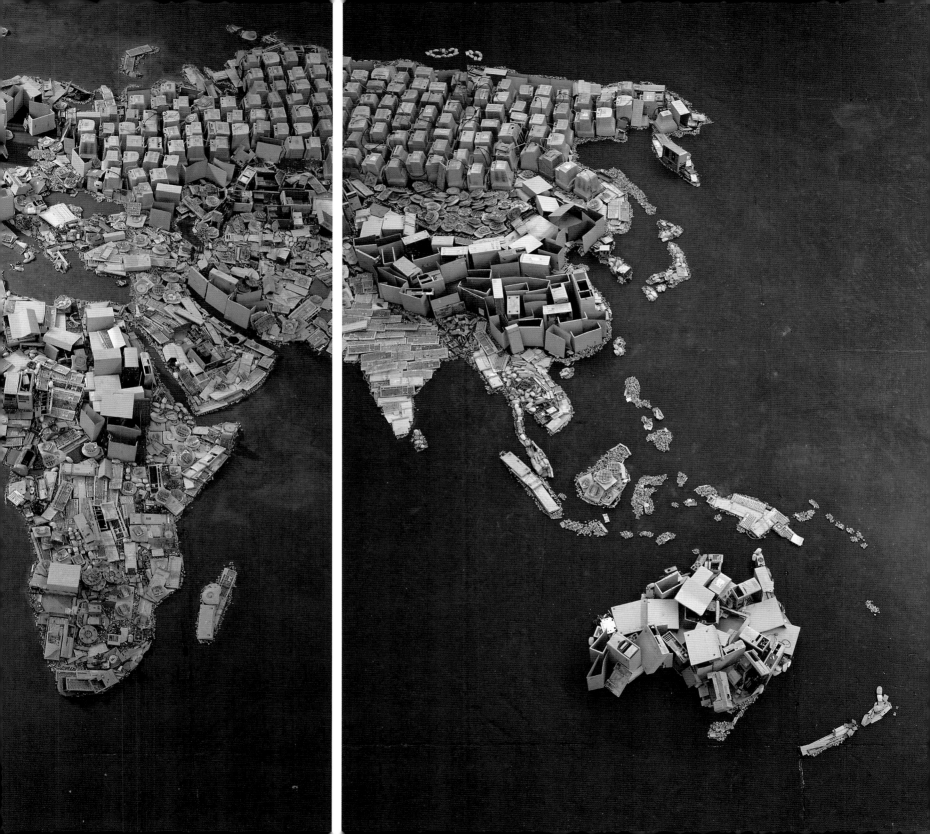

DOUG BEUBE

▶ *First Strike,* 2003–4

Globe, matches
10 x 10 x 12 in.

Beube is a book-altering artist who often reconfigures maps and atlases in ways that enable the viewer to discover new cartographic combinations of text and geography. His work indicates that while it takes very little effort to redraw a border on a map, the on-the-ground reality may be a tinderbox. *First Strike* was burned shortly after its creation; all that remains is a video of the globe going up in flames, and a scoop of black embers in a mason jar.

▲ *Amendment,* 2005

Altered atlas and zipper
19 x 22.5 x .5 in.

▶ *Fault Lines,* 2003

Altered atlas
15 x 23 x 5 in.

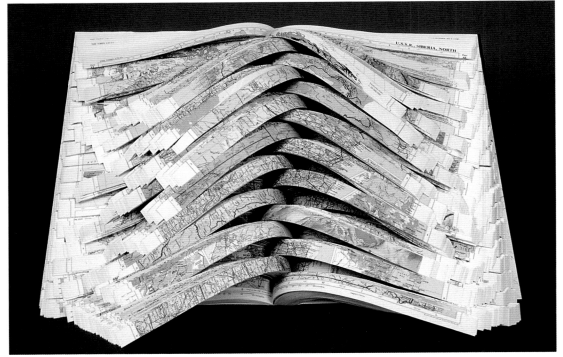

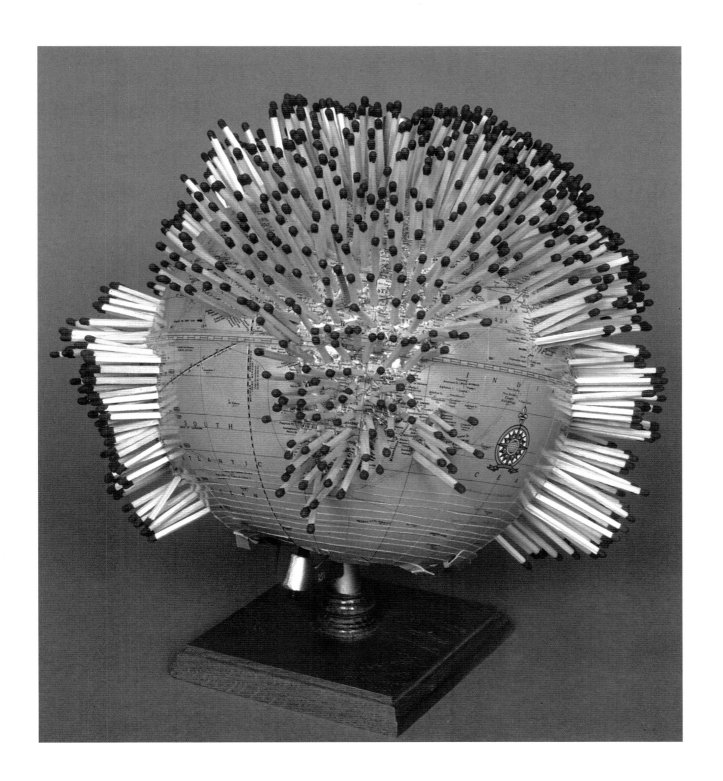

LOUISA BUFARDECI

Ground Plan, 2003

Digital print
130 x 354 in.

Bufardeci uses statistical data compiled by the U.S. government, culled from the CIA's *World Factbook,* to reconfigure maps of the world into compelling illustrations of "hidden" political realities: for example, a comparison of countries' carbon dioxide emissions, lowest recorded temperatures, and numbers of bird species. *Ground Plan* offers an idealized view of the world map. "As an architectural plan it draws on ideas of structure and space," says the artist, "and as an alternative delineation of nations it suggests freedom of movement and cohabitation."

LORDY RODRIGUEZ

▶ *Monopoly,* 2005

From the series *New States*
Ink on paper
34 x 28 in.
Collection of Christopher Hamick, New York
Courtesy of Clementine Gallery, New York

▶ ▶ *Hollywood,* 2006

From the series *New States*
Ink on paper
80 x 64 in.
Collection of Leo Malca, New York
Courtesy of Clementine Gallery, New York

Rodriguez is of Chinese, Filipino, Spanish, and French ancestry; as an adult he has lived in Brooklyn and Los Angeles, but he was born in the Philippines and grew up in Louisiana and Texas. Rodriguez knows about the fluidity of borders. In his *New States* series he cheerfully reconsiders geographic and cultural boundaries, so that, for example, Sun City, Virginia Beach, and Iditarod share a coastline on an island in the archipelago of New Hampshire. He is remapping the entire United States, with five additions: Hollywood, Monopoly, The Internet, Disneyworld, and Territory State, which combines portions of Samoa, the Philippines, and Puerto Rico.

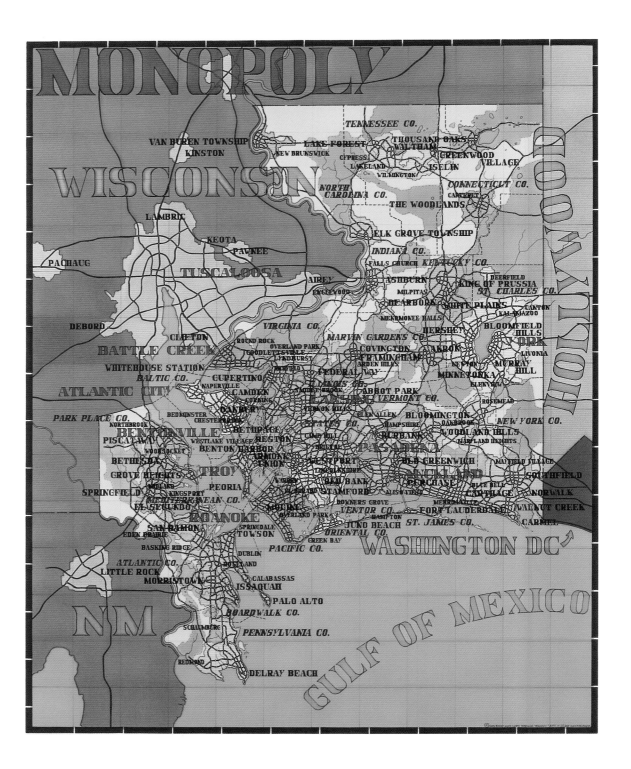

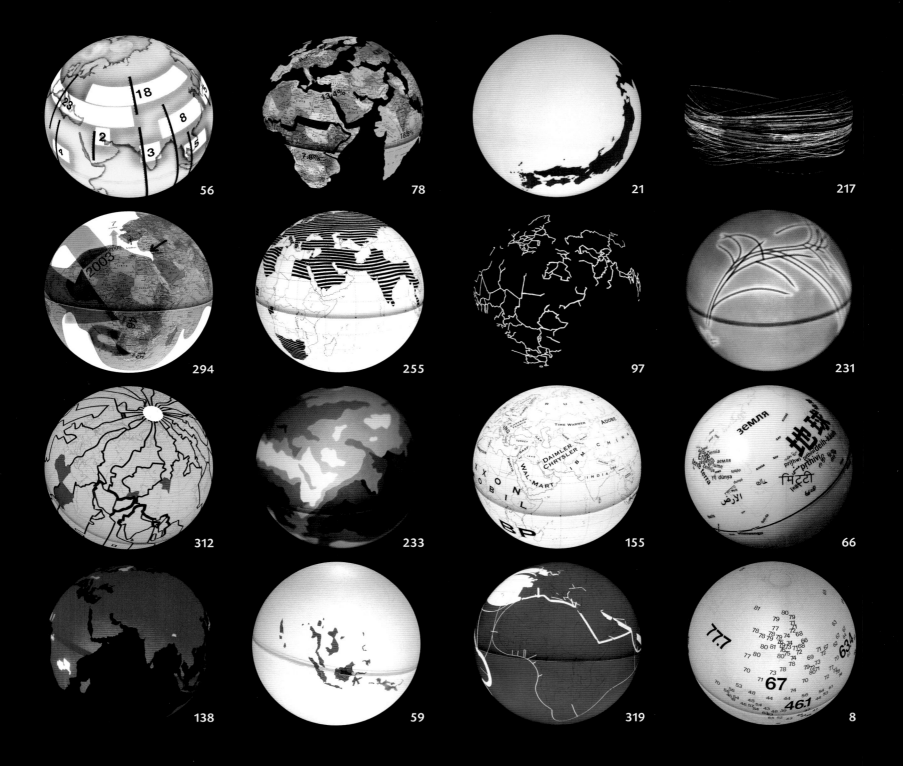

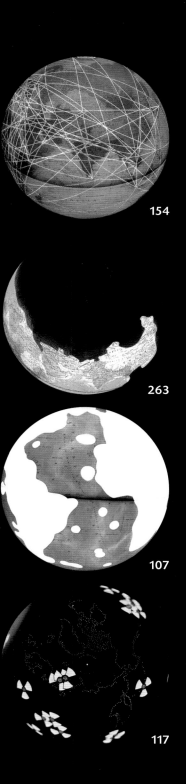

154

263

107

117

INGO GÜNTHER

Selection of twenty from *Worldprocessor* series, 1988–present
Altered globes

Günther's *Worldprocessor* project comprises more than three hundred unique globes, created over two decades (and counting), that provide visual models of geopolitical issues. "[I am] trying to tell the lie of abstraction and visualization that tells the truth," he says.

56 *Percentage of World Energy Consumption*
Percentages of world energy consumption are correlated with bar graphs indicating population figures. Japan, for instance, consumes fifteen times more energy per capita than China, and the United States uses two and a half times more energy per capita than Japan.

78 *People Power*
The scale of regions reflects the sizes of their populations.

21 *Japanese Economic Continent*
If landmass equaled wealth and economic might, Japan would have occupied this much of the globe in 1999.

217 *Jam: 72x Around the World*
If all the cars in the world were placed end to end, they would circle the globe seventy-two times. By the year 2030, the projected 1.2 billion cars in existence would wind around the earth more than 100 times.

154 *Refugee (Republic) Network*
Refugees, who make up 1 percent of the world's population, mostly live in United Nations camps that could be connected to form a self-governing network: a transglobal, experimental, supraterritorial state known as the Refugee Republic.

294 *South–North and South–South Investment Flows*
Cross-border trade is a key element in private-sector development. Trade between emerging-market countries, also called South–South trade, more than tripled between 1995 and 2003, rising from $15 billion to $46 billion. South–North trade also grew substantially, reaching $7 billion in 2003 (according to World Bank estimates).

255 *Access to Drinking Water*
In the nations identified, over 80 percent of the population uses improved drinking water sources.

97 *Political Borders*
Border definitions and their control vary widely. Border zones invite a number of economic anomalies, such as cross-border trade, corruption, and special economic zones (SEZs). As much as borders keep people separated, they may also designate and provide safe havens for persecuted people.

231 *DNA Traces*
Population geneticists have traced the human family tree's origins to an ancestral Homo sapiens community of only two thousand breeding individuals in Africa. Analyses of DNA passed from mother to child have identified only one female, a chromosomal "Eve," at the root of the mitochondrial family tree, represented here by orange lines; other lineages became extinct.

Y chromosome sequences passed from father to son (shown in green) go back to a single "Adam."

263 *Tobacco Cloud*
Over 20 percent of total deaths among men over thirty-five years of age are from tobacco use.

312 *Time Zone Conflicts*
While the idea of time zones is conceptually clear, the reality is far less mathematical than one would expect. Identity politics as well as administrative and cultural issues play a role in the sometimes awkwardly shaped time zone borders.

233 *Rainfall*
As drawn according to rainfall, a picture of our "waterworld" reveals contours subtly influenced by continental masses, but not beholden to geography in any way. The darkest regions receive on average more than two thousand millimeters of rain annually, while white regions receive less than one hundred millimeters.

155 *Company vs. Country*
Some companies' yearly gross income is larger than the entire gross national product of a given country. Fifty-one of the top one hundred economies are corporations, not countries.

66 *Earth in 80 Languages*
On this globe languages are positioned where most commonly spoken. Word size is proportional to the number of speakers.

107 *Extended Exclusive Maritime Economic Zones*
The proposed International Maritime Law would allow nations to extend exclusive economic jurisdictions two hundred miles past their shores into the seas. This law would roughly double the amount of the earth's surface available for exclusive economic development.

138 *Postwar (WWII) Peaceful Countries*
Shown are the few countries that did not engage in military conflicts between 1945 and 2002.

59 *Rain Forest Leftovers*
The green on the globe indicates where rain forests still exist, red where they have perished.

319 *Submarine Fiberoptic Network*
The widths of lines on the globe represent transmission capacity.

8 *Life Expectancy*
Life expectancy is a core factor in the Human Development Index. Japan has the highest life expectancy. More than thirty countries with the lowest life expectancy can be found in sub-Saharan Africa.

117 *Nuclear Explosions*
More than two thousand nuclear bombs have been detonated worldwide since 1945. In 1963 the superpowers of the world agreed to limit themselves to underground testing. By then, atomic radiation in Europe had risen to levels comparable to those caused by the Chernobyl accident.

VERNON FISHER

◀ ◀ *Man Cutting Globe,* 1995

Lithograph
Image: 31.5 x 30 in.; unfolded paper: 38.25 x 36 in.
Courtesy of Charles Cowles Gallery, New York

In his map works, Fisher often uses archetypal imagery—such as the feel-good figures seen here, or those of cartoon characters and clowns—to expose cultural artifice. Seemingly innocent cultural icons contrast with a "rational" backdrop of finely painted, highly realistic maps—or, in this case, with the vaguely menacing act of carving a globe as if it were a Halloween pumpkin.

JULES DE BALINCOURT

◀ *Little Men, Big Map,* 2006

Acrylic and oil on panel
47 x 37.5 in.
Courtesy of Zach Feuer Gallery, New York

French painter de Balincourt was educated in the United States and lives there still, giving him firsthand license to deliver witty commentary on American culture and romantic notions thereof. He freely skewers myriad forms of idealism in an age when intractable challenges lead both individuals and governments to bury their heads in the sand. Colors show the boldness, and flat forms the simplicity, of maps of the United States—such as his painting on the cover of this book.

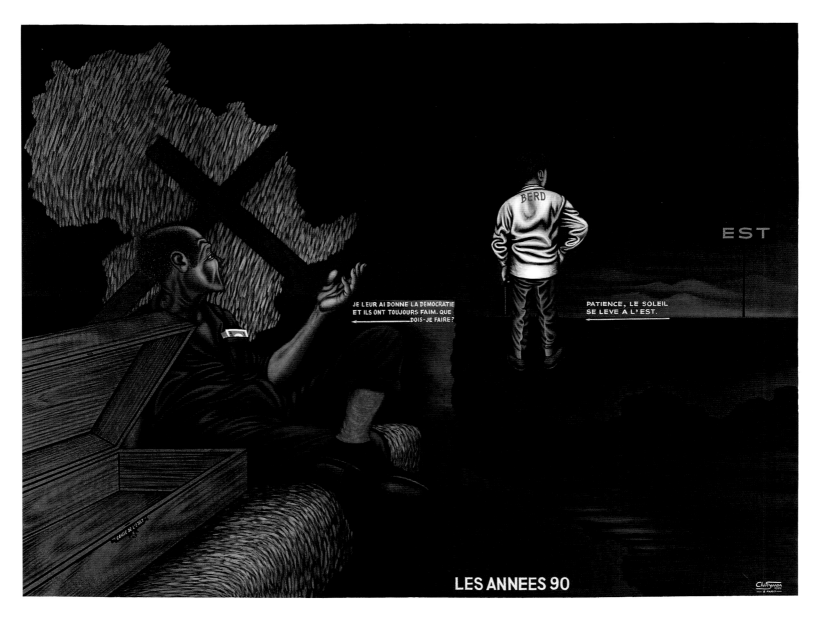

JE LEUR AI DONNE LA DEMOCRATIE ET ILS ONT TOUJOURS FAIM. QUE DOIS-JE FAIRE?

PATIENCE, LE SOLEIL SE LEVE A L'EST.

EST

CAISSE DE L'ETAT

LES ANNEES 90

CHÉRI SAMBA

Les Années 90 (The Nineties), 1991

Acrylic on canvas
59 x 77 x 1.5 in.
Courtesy of the Seattle Art Museum,
Margaret E. Fuller Purchase Fund
Photo by Susan Cole

Samba, a Congolese painter, is among Africa's best-known contemporary artists, and a populist hero for turning a spotlight on political and societal absurdities in his lively paintings. He incorporates text in his artworks as "a strategy to keep people looking at them a little longer." In this painting's commentary on corruption, a cash-laden despot says he has given his people democracy and still they are hungry; what is he to do? A foreign

investor advises patience even as he moves on ("the sun is rising in the east"), leaving a culture of dependency in his wake. Samba says, "When I paint, my main concerns are to represent things as they are, to communicate with humor, to ask relevant questions and to tell the truth. I consider myself a sort of painter-journalist.... As long as the world is the world, and writers have stories to tell, I will have something to say."

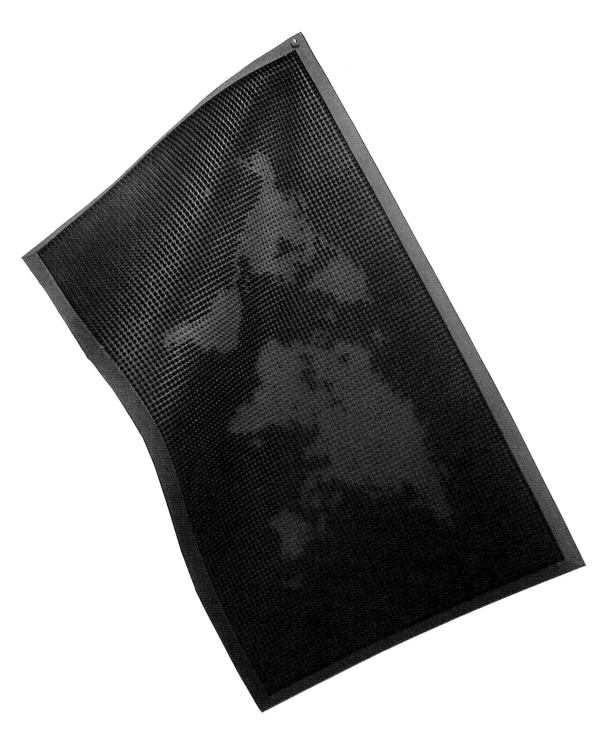

JONATHAN PARSONS

◀ *Wear and Tear,* 2003

Rubber
45.75 x 33 in.
Collection of Roberto Ghio, Milan

Parsons, a British artist, makes a not-so-subtle statement about muddy feet and where they might be wiped. (See also p. 238.)

Following pages

BRIGITTE WILLIAMS

In Peace, 2007

From an edition of ten
Giclée print
43.25 x 43.25 in.

British artist Williams has created a series of circular maps, including one rimmed with countless colorful rings keyed to the flags of world countries, and another that looks like an embryo of free-floating, dislocated black nations. *In Peace* evokes the bygone innocence of an "I'd Like to Teach the World to Sing" hand-holding circle paired with the sophistication of a modern mandala.

NANCY CHUNN

Spring Cleaning (Spring 1999), 2000

Acrylic on canvas
90 x 102 in.
Courtesy of Ronald Feldman Fine Arts, New York
Photo by John Lamka

Since the 1980s, Chunn has used maps to reflect "a topsy-turvy world." Her first series combined maps of continents with farm machinery; this led to *Mapped Countries in Distress,* which depicted individual countries as cuts of meat. "Most people watch the news during dinner," she says. "Perfect: watching all the shit going down." A subsequent series showed countries in chains, and another used a map of China as the basis for a thorough exploration of that country's dynastic history. Chunn has used the Arno Peters map projection, which represents the actual sizes of countries, rather than the better-known Mercator projection, which was designed for navigational purposes. At the close of the 1990s, Chunn obscured geographic forms with explosions of cultural cacophony (as in this painting), portraying societies crying out for a good spring cleaning.

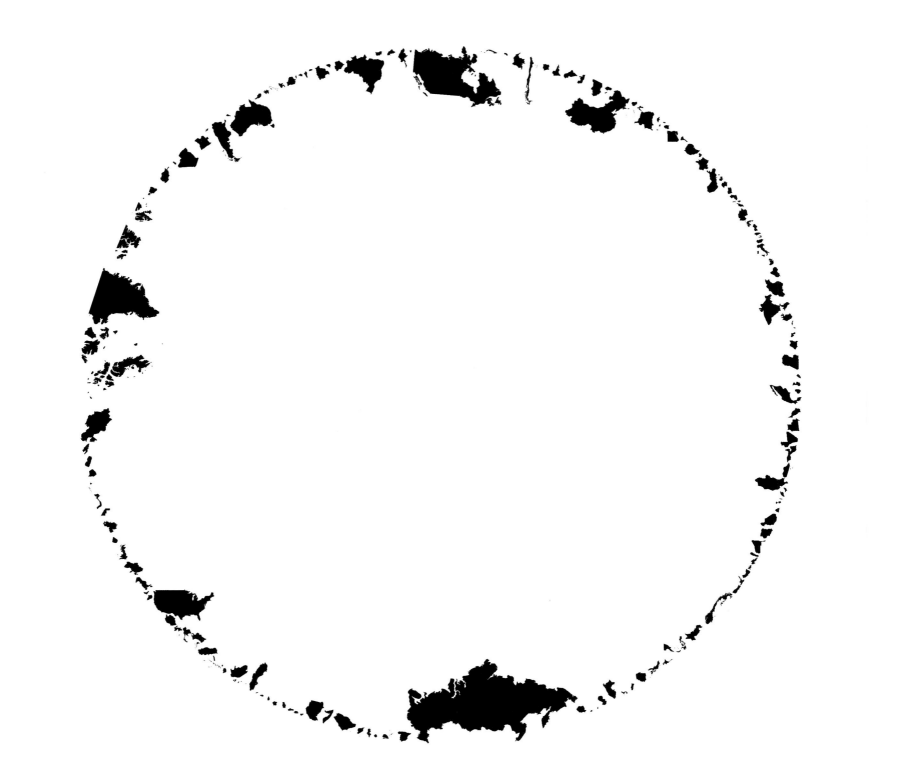

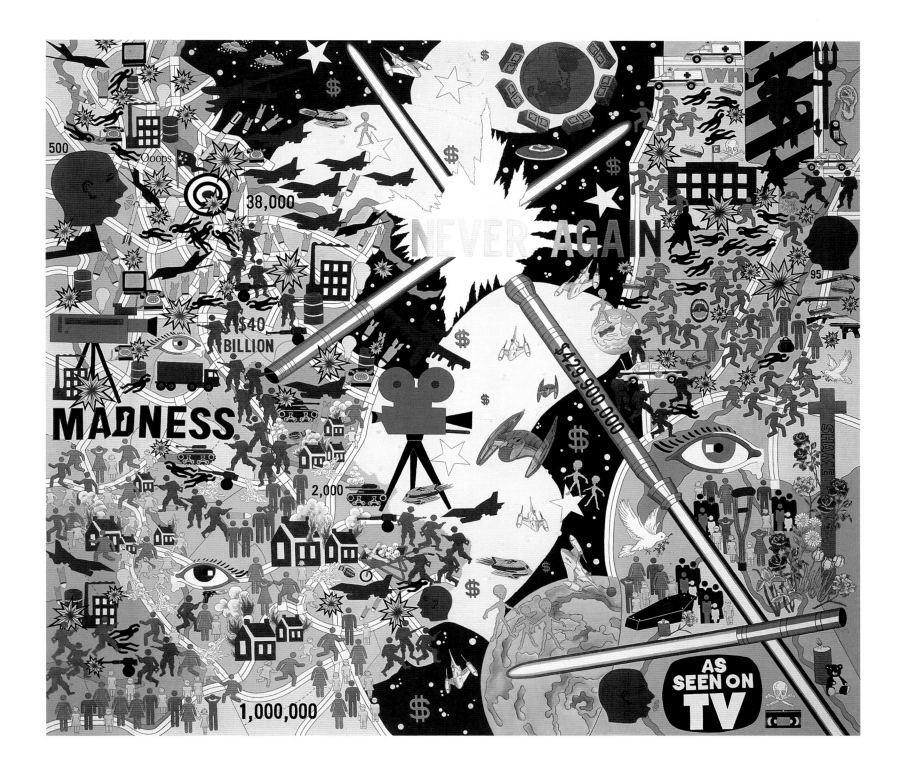

PEDRO LASCH
Route Guide #4 / Vicencio Marquez / New York Arrival Edition, 2006

From the series *LATINO/A AMERICA*
Archival digital print, showing folds and weathering
30 x 43 in.

In his series *LATINO/A AMERICA*, Lasch indicates that the meanings of the words "Latino/a" and "America" depend on their context and reflect the deep impact of cultural shifts. A shared new "Latinidad" is changing what "America" and being an "American" mean. In the fall of 2003, Lasch gave folded maps to individuals planning to cross the U.S.–Mexico border. Each received two folded maps, one to be mailed back to the artist on arrival at the destination. Eight maps showing various degrees of exposure to weather, as well as wear and tear, have been exhibited by Lasch along with selections of conversations he had with each migrant, immigrant, or traveler.

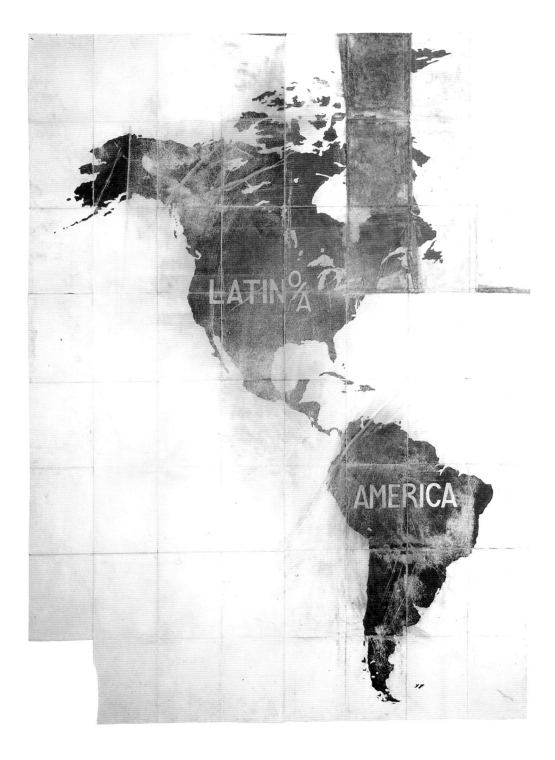

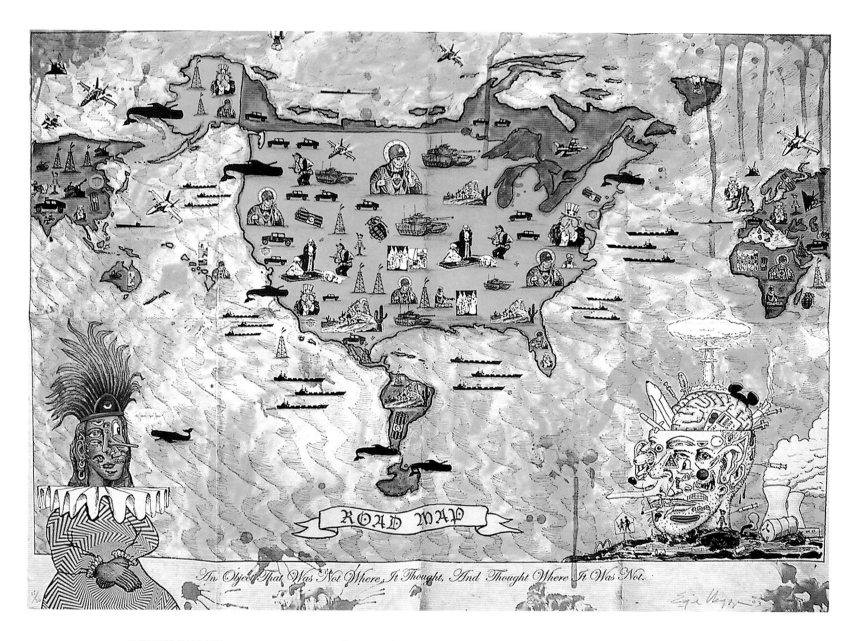

ENRIQUE CHAGOYA

Road Map, 2003

From an edition of thirty
Color lithograph on Amate paper with folds
22 x 30 in.
Courtesy of Gallery Paule Anglim, San Francisco

"The twentieth century has been perhaps the most violent in the world's history. Humankind is in constant war with itself, perfectly capable of total destruction," says Mexican-born artist Chagoya. "This is the raw material for my art." In a map of the world flanked by figures of Hope and Hopelessness and overlaid with military and religious images as well as cultural stereotypes, Chagoya satirizes the United States as superpower and defender of democratic self-determination throughout the world.

Landon Mackenzie The Politics of the Land

You may never have been to the places that Landon Mackenzie so closely maps in her art of the last fifteen years: Canada's Saskatchewan, Athabasca, and Houbart's Hope. But as you become immersed in the paintings' washes of color, immense scale, and layers of information and line, it is easy, almost unavoidable, to become intimately acquainted with the histories and spaces of Mackenzie's artistic world.

Mackenzie, who lives and works in Vancouver and on Prince Edward Island, has explored the places that inspire her art, but to a large extent these places are also fictions constructed of various perceptions and myths, both personal and cultural. Mackenzie gathers these stories and assesses how they were spawned by geographic terrain and sociopolitical ideologies. She then transforms data and fantasy into large, abstract paintings.

She begins with canvases that are seven and a half feet tall by ten and a quarter feet long ("big enough to get lost in"[1]) and layers them with color, line, text, and texture. The colors are soft, modulated, and sensual, and seem dyed rather than built up. Mackenzie's active lines, circular shapes, and handwritten texts suggest geographic and astronomical maps, charts, diaries. The energetic interplay of color, shape, and line evoke topographic features like prairies or rivulets or marvelous events like star showers or cascading fireworks.

Prior to her mapping works, Mackenzie created paintings with abstract figures and suggestions of geography. The *Lost River* paintings of the 1980s are abstract, moody, and mystical landscapes. Mackenzie placed silhouetted animal figures within flat planes of color or alongside geometric lines, reminiscent of fences or graphs.

The art world—after years of focusing on conceptual and completely abstract, formalist art—had begun lauding figurative, representational painting again; Mackenzie's *Lost River* paintings attracted a lot of attention. Mackenzie herself was trained in these conceptual and formalist traditions and was considered a sign-bearer of the reemergence of the image in painting.

I usually work over long periods of time on several canvases simultaneously until stories and constructs begin to manifest a terrain or a pattern that I can follow, like a trail or a puzzle that provokes my imagination and my analytical mind during the process of building a picture.[2]

Landon Mackenzie (Canadian, b. 1954)

This was also a time of heated debate about Native American and First Nations rights, particularly surrounding the contested ownership of territory. Mackenzie thought about the politics of the land, and while she was becoming categorized as a cutting-edge landscape painter she wondered, "How could anyone make a landscape painting again that's just a bucolic romp?"[3]

Setting out to explore the complex relationship between politics and how land is visually represented, Mackenzie used her experience with

LANDON MACKENZIE

Interior Lowlands; Still the Restless Whispers Never Leave Me, 1996

Acrylic on canvas
7.5 x 10 ft.
Collection of the Vancouver Art Gallery, Vancouver Art Gallery Acquisition Fund, and purchased
with support of the Canada Council Acquisition Assistance Program, VAG 96.5
Photo by Teresa Healy, Vancouver Art Gallery

*Tracking Athabasca; Macke It to Thy Other Side
(Land of Little Sticks),* 2000

Synthetic polymer and appliqué on linen
7.5 x 10.25 ft.
Collection of the National Gallery of Canada

conceptual art and formalism to create an intuitive, but structured, method for a new body of work. She began the *Saskatchewan Paintings* in 1993, traveling into that province and sifting through nineteenth-century documents and maps. Mackenzie was drawn to the way the old maps reflect the unique position that Saskatchewan has held in Canadian history and mythology. Saskatchewan is a vast, landlocked province of varied terrain: prairies, sand dunes, boreal forests. The area's huge swaths of unpopulated land have been cloaked in associations with limitlessness and ruggedness. White settlers and explorers didn't map the region until the nineteenth century.

While she may gather material like a historian, Mackenzie does not simply re-present maps or archival material. Instead, she uses these sources as points of departure, generating her own spaces, iconography, and ambiguous stories through the act of painting.

I use painting as a method to sort things out; all the input of stimuli and information I take in need an output channel to remix it and plot it down in a way that works for me—a way to grapple with some pretty large subjects.[4]

Mackenzie began all of her mapping paintings on the floor of her studio and then put them up vertically in order to, as she puts it, "resolve the ending."[5] Mackenzie achieved this resolution by adding text, linear designs, or symbolic shapes—whatever was needed to complete the particular "fairy tale" she was spinning.

The ovoids in the Saskatchewan paintings refer to the gaps she found in the archival material, the "tricks of the pen,"[6] as when maps were deliberately falsified to mislead competing explorers. Mackenzie also noticed gaps in the records as labels and boundaries changed from year to year, map to map; she was "quite alarmed to see a map when the First Peoples owned all the land and a map three years later showing that they owned none of

it."[7] Her frequent use of obscured, painted-over text in these paintings emphasizes how records and maps both reveal and conceal history.

While researching her Saskatchewan project, Mackenzie discovered earlier documents that generated ideas for her next series, *Tracking Athabasca.* For this set of paintings, Mackenzie uncovered and responded to different sets of terrain and archival material. Athabasca, a region in the province of Alberta (as well as the name of a city, county, glacier, and river), becomes, in Mackenzie's hands, something to be tracked, a place and a cultural construct that is marked by ideas of entitlement and potential. Conceptions of this region drove the commercial and political enterprises of fur trading, railroad building, and the opening up of the Canadian West.

Mackenzie tracked these activities and ideologies through maps, trading and mining records, and colonial documents. She also collected more personal histories, including stories from Doris Whitehead, a friend of Cree, Chipewyan, and Scottish ancestry. Mackenzie had begun thinking of her canvases, placed on the ground, as places for activity: for creating art, of course, but also for conducting interviews and having picnics. For the painting *Tracking Athabasca: Macke It to Thy Other Side (Land of Little Sticks),* she and Whitehead sat on the large canvas talking, while Whitehead sketched the layout of her childhood village.

Mackenzie then reworked that map, adding elements from other maps and layering on designs like the white shapes that squiggle across the canvas. Whitehead had mentioned that she was a descendant of Governor Simpson, a Scottish factor at Fort Chipewyan who was rumored to have fathered more than two hundred children during his tenure. Mackenzie referenced this trail of European DNA, part of the history of Canadian settlement, with trails of white sperm shapes. These white lines also evoke meteorological systems—swirls and bursts of wind, rain, or snow on an aerial weather map. Mackenzie then added less maplike cues like the blue

LANDON MACKENZIE

Houbart's Hope (Green); Hope Advanced, Hope Dasht, 2001–4

Synthetic polymer and appliqué on linen
7.5 x 10.25 ft.

beadwork in the upper right corner, which references the relatively worthless goods that white traders exchanged for the furs gathered by First Peoples.

During the Athabasca project, Mackenzie came across still older archival material that she used for her next series, *Houbart's Hope.* In this last series of her mapping trilogy, Mackenzie continued to explore ideas of place, story, and meaning. In 2001, while beginning work on this series, she underwent a series of neurological tests for medical reasons and noticed visual and systemic connections between her artwork and the ways that the brain is visually mapped and coded. Mackenzie observed that "the earth and the brain have hemispheres, arteries, networks, deposits, branch-like forms, electrical, magnetic and chemical properties."[8]

In preparation for this series, she had been working with archival material about the search for the Northwest Passage and the related ideologies of unexplored territory. For seventeenth-century explorers, the Northwest Passage, and other possible trade routes and frontiers, suggested limitless possibilities and a radical shifting of the way the world was perceived. Mackenzie realized that recent scientific discoveries, which have arisen out of digital imaging, bring out similar notions. The brain is now thought of as a new frontier—territory where there is much information to unearth and where old knowledge is being overthrown.

To suggest these ideas of changeable information and worldviews, Mackenzie called the series *Houbart's Hope.* In the seventeenth century, Captain Thomas Button and his pilot Josiah Houbart named an inlet off Hudson Bay Houbart's Hope, mistakenly thinking that this site might be the entrance to the elusive Northwest Passage. Houbart's Hope, a bit of geographic optimism, disappeared from maps in the eighteenth century.

But in Mackenzie's art, Houbart's Hope is a place again, or, rather, many spaces, systems, and ideas in her paintings. In *Houbart's Hope (Green); Hope Advanced, Hope Dasht,* the electrochemical dynamics of the brain and the Earth are suggested through bursts of vivid contrasting colors and energetic, varied lines. The sense of inward and circular movement, the lack of depth, and the central grouping of color and shape are reminiscent of both MRI and CAT-scan images of the brain and thermal maps that register the heat of geographic regions.

While the places in all of Mackenzie's paintings are of our bodies or of the Earth, they also are unearthly and fantastic fabrications. Her paintings, like history and science, examine myths, stories, data, and diagrams, but they are also searching and mystical, revealing old and new worlds as we explore them. ◈

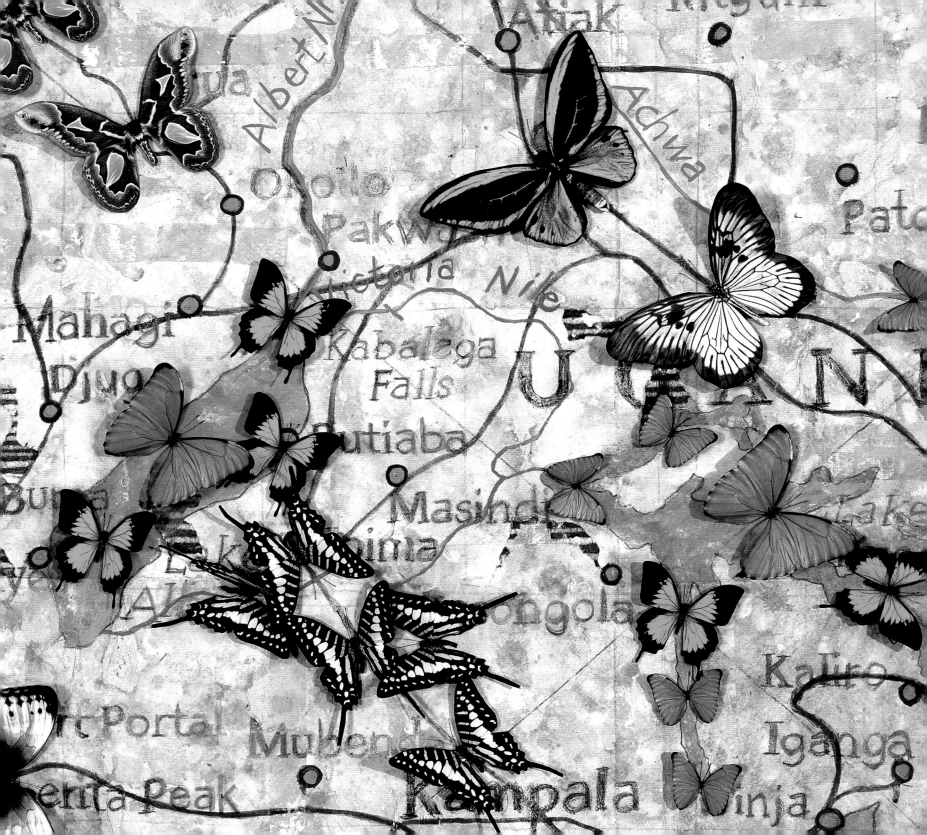

Animal, Vegetable, Mineral Maps of Natural Origins

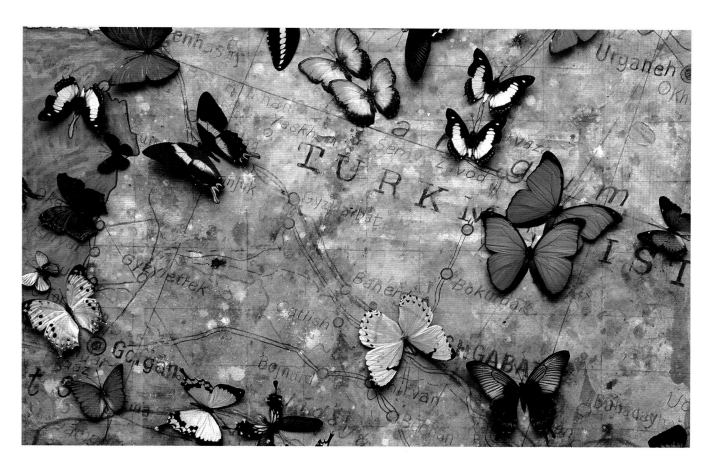

JANE HAMMOND

◄ *All Souls (Masindi),* 2006 (detail)

Gouache, acrylic paint, metal leaf on assorted handmade papers with graphite,
colored pencil, archival digital prints, false eyelashes, and horsehair
Overall dimensions: 54 x 61 x 4 in.

▲ *All Souls (Babel),* 2004 (detail)

Gouache, acrylic paint on assorted handmade papers with graphite,
colored pencil, archival digital prints, and horsehair
Overall dimensions: 51.5 x 62.5 x 3 in.

Television coverage of war often features unemotional cartography
in place of on-the-ground, messy actualities. In the midst of the Iraq
War, Hammond dreamed of a map of the Middle East covered with
butterflies and built a series around it. For her, painting is an entry
point for accessing, and mapping, the unconscious. In the *All Souls*
series, delicate butterflies float on softly rendered maps of South
America, Africa, Asia, and the Middle East as tender evocations of
the world's ephemeral nature.

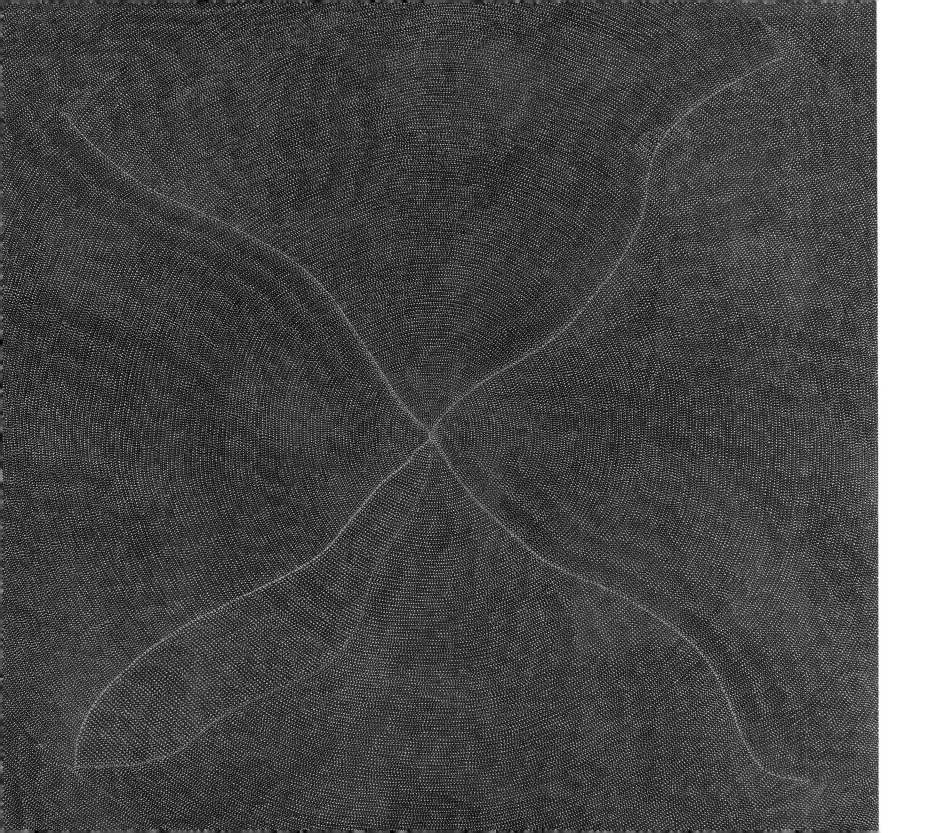

KATHLEEN PETYARRE

◄ *Mt. Devil Lizard Dreaming (Sandstorm),* 1996

Acrylic on linen
59.25 x 59.25 in.
Collection of Margaret Levi and Robert Kaplan

MARGARET NAPANGARDI LEWIS

► *Mina Mina,* 2007

Synthetic polymer on Belgian linen
34 x 25 in.
Courtesy of Gallerie Australis, Adelaide, Australia

Australian Aboriginal people have made maps encoded with sacred designs for forty thousand years and continue to create them today for ceremonial purposes as well as for museums and collectors. These mapworks are spiritual documents of travels through hallowed land, often connecting the maps' creators with their ancestors and confirming custodial responsibilities to their "country." The paintings also have been used in court to prove clan ownership of lands. The maps are not to scale but highlight landmarks such as important rocks, water holes, and sand hills, and often incorporate narrative elements from inherited creation and spiritual myths, called Dreaming stories.

Petyarre paints an inherited family territory of some 125 square miles in central Australia's eastern desert, mapping sources of food and water and significant landscape features. The site is home to the thorny (or mountain) devil, a lizard that moves in jerks and leaves circular tracks in the sand; for Petyarre it represents a dreaming ancestor, an old woman traveling on a big hill that the artist has custodial rights to. Petyarre's sister, Gloria, is another accomplished painter of this territory.

Lewis grew up in, and still lives around, the community of Nyrippi in the Simpson Desert, a remote area northwest of Alice Springs in central Australia. She learned to paint from her father and has also mastered the art of batik; she uses several styles to map her ancestral territory and inherited Dreaming stories.

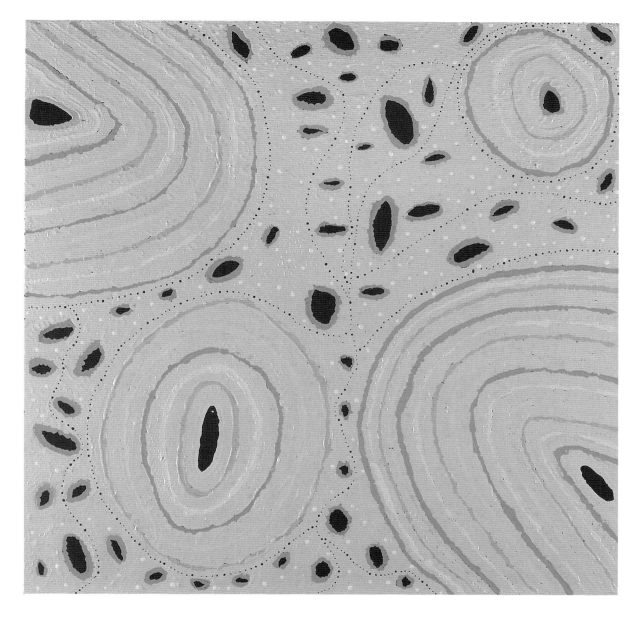

JANE INGRAM ALLEN

▶ ▼ *Kinmen Site Map: Garden Island,* 2004

Artist-made paper from plants on Kinmen island, acrylic paint,
acrylic gel, string, leaves, photos, and found materials
49 x 80.75 in.

Allen's "site maps" are documents of visits to diverse places—mostly in
Asia and the United States—made entirely from materials she collected
there. She gathers plants for making paper and joins the sheets with plant
fiber, so that the constructions can be folded like a map. As an artist-in-
residence in Taiwan, Allen spent a year and a half living and working in
fourteen communities there, and produced site maps from 135 different
plants. Shown are both sides of a map of Kinmen, a small Taiwanese island
a stone's throw from southeast China famous for having received more
bombs per hour than any place in the world. (Over forty-four days in
1958, China bombarded the island with 480,000 shells, and continued
to drop explosives on Kinmen for the next twenty years.) Now Taiwan is
converting this military outpost into a tourist attraction, and it is the site of
the country's newest national park. With this map, Allen says, "I wanted to
emphasize that though Kinmen has many unpleasant military memories, it
is indeed a garden island with much natural beauty and unique plants."

SALLY DARLISON

▶ *Alice Colours,* 2005

Map fragments, papers, fabric, ink, and stitching
11 x 11 in.
Private collection
Photo by Peter Vorlicek

Darlison used soil collected during a trip
to northern Australia to dye fabric, paper,
and thread for a series of pieces about her
travels.

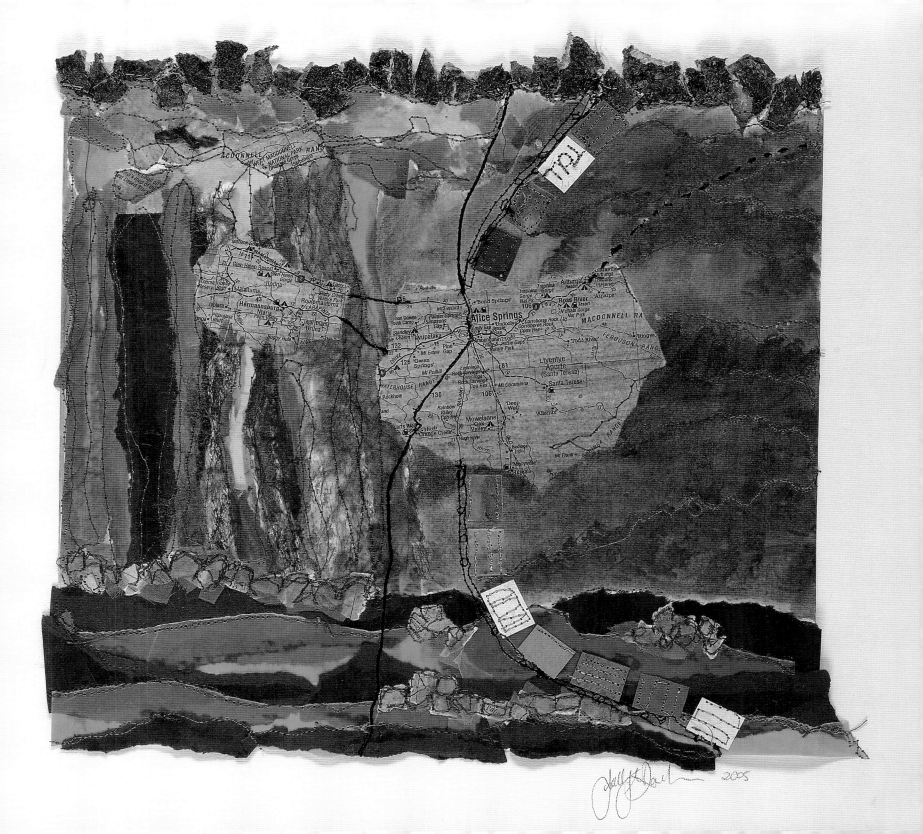

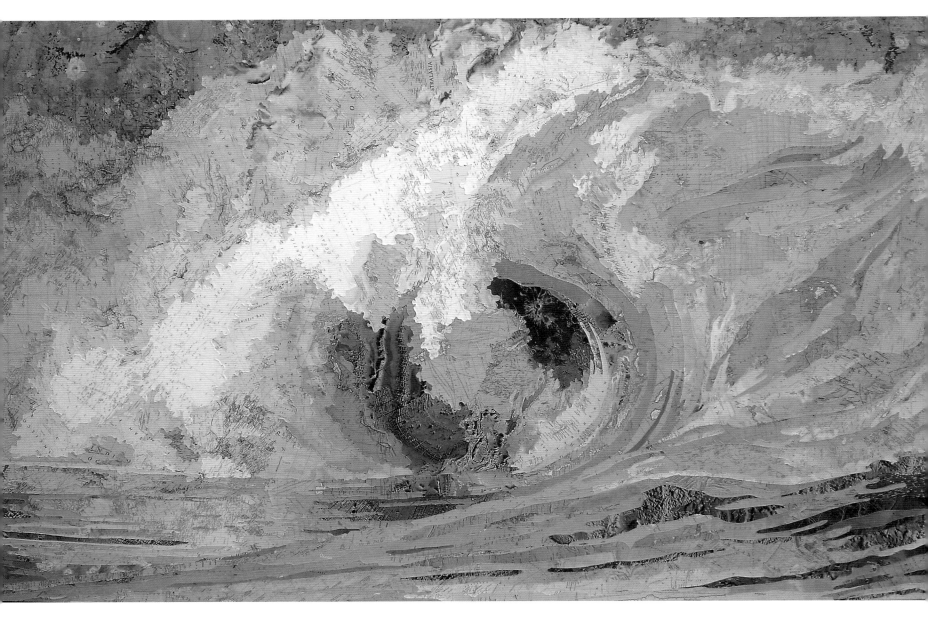

MATTHEW CUSICK

Fiona's Wave, 2005

Inlaid maps on wood panel
48 x 76 in.
Private collection

Cusick creates outsized collaged paintings—of highways converging and snaking into distant mountains, aerial views of developed land, American muscle cars, detailed portraits, and organic forms— from fragments of atlases and school geography books published between 1872 and 1945, a time of much mapping and remapping. For many of his collages, he leaves countries intact, cutting along their borders and fitting them together so that borders are evident. Cusick also paints conventionally, and his painterly approach to collage is evident in *Fiona's Wave*.

JOAO MACHADO

Swimming, 2007

Collage with vintage maps
50 x 30 in.

Machado is a filmmaker, video artist, playwright, sculptor, and
visual artist. His intricate map-based portraits are collages of
human figures in many attitudes, poses, and moods.

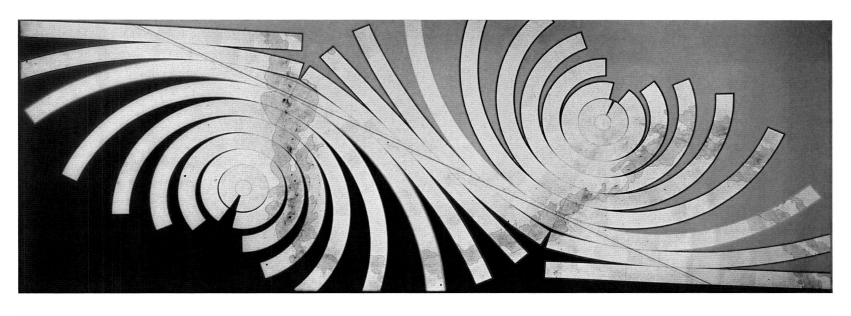

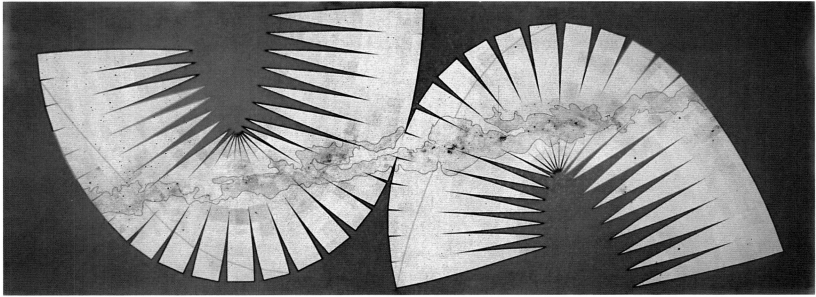

Preceding pages

MATTHEW GERRING

Moon, 2005

Machine embroidery on technical nylon
Diameter: 75 in.

It took nine months for Gerring to create his tactile lunar landscape. He enjoyed the lengthy process, which combined his interest in the textile-based medium with a "conceptual obsession" with our galaxy. He is planning a "reverse map" of the Earth, wall-mounted in the shape of an exploded globe, with twelve canoe-shaped pieces showing all the places Gerring has never been; everywhere he has lived or visited will remain blank.

CHARLES ROSS

SM1975-86.003: Point Source / Star Space / Sun Center by Earth Degree, 1975 and 1986

From the series *Star Maps*
Bakelite powder copies of photographic star atlas,
mounted on painted canvas
106 x 297 in.

SM1975-86.004: Point Source / Star Space / Milky Way Center by Earth Hour, 1975 and 1986

From the series *Star Maps*
Bakelite powder copies of photographic star atlas,
mounted on painted canvas
106 x 282 in.

Ross has investigated experiences of sunlight and starlight through a wide-ranging body of work, including photographs, paintings, drawings, prism/solar spectrum light installations, solar burns on wood planks, and an enormous earth/sky sculpture and naked-eye observatory called Star Axis, currently under construction. Ross believes in "bringing a sense of the cosmos into daily life." His *Star Maps,* a series of seven works, originated in the profound encounters humans presumably have had for as long as they have looked up at the night sky. The images on which Ross based his maps come from 428 photographic negatives in the book *Atlas of Deep-Sky Splendors,* by German amateur astronomer Hans Vehrenberg. Ross has fanned the spherical imagery into "cuts" that reflect degrees of latitude, boundaries of constellations, and the movement of stars during an hour. We may be overwhelmed by the barest hints of the universe's immensity, but Ross's maps enable us to appreciate its beauty from a somewhat reassuring, Earth-centric viewpoint.

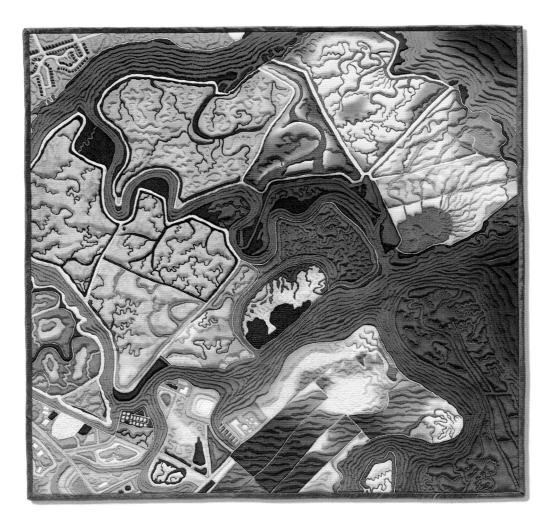

LINDA GASS

▲ *Puzzle of Salt,* 2005

Art quilt
28.5 x 29.5 in.
Photo by Don Tuttle

▶ *Wetlands Dream,* 2006

Art quilt
29 x 29.25 in.
Collection of Lesley Knox
Photo by Don Tuttle

Gass's quilted artworks draw attention to the challenges of water resource management in the American West. The two works shown are part of a series of fabric creations focusing on San Francisco Bay wetlands and the complex task of restoring them to their natural state.

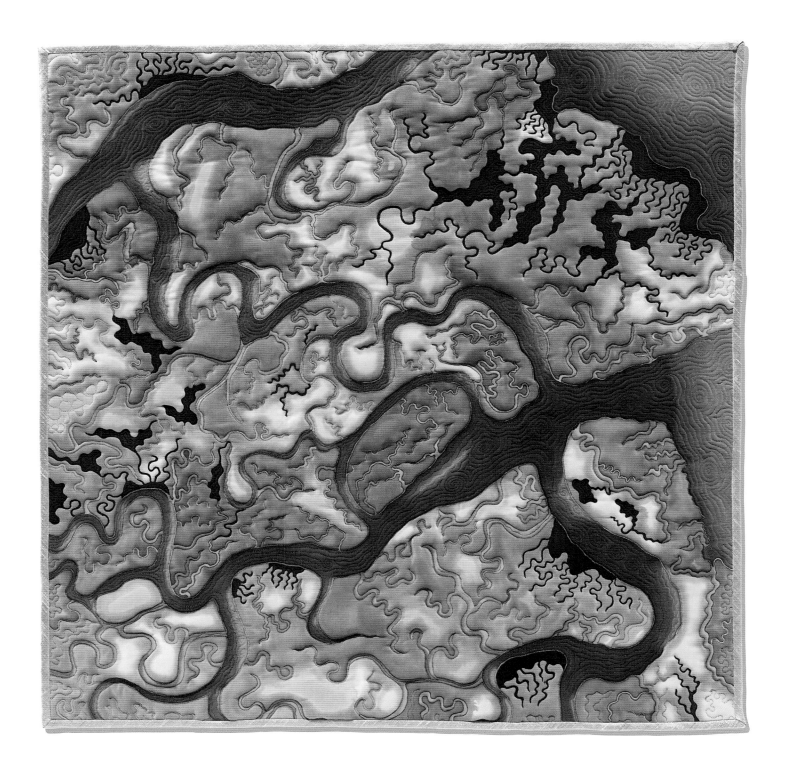

PETER DYKHUIS

◀ *Apr 28 14:55Z (YHZ Series #1),* 1999

From the series *Radar Paintings*
Encaustic and enamel on fifteen panels
Installation: 60 x 48 in.
Photo by Steve Farmer

▼ *May 7 22:55Z (YHZ Series #1),* 1999

From the series *Radar Paintings*
Encaustic and enamel on six panels
Installation: 36 x 36 in.
Private collection
Photo by Steve Farmer

"My interest in cartography as an artist is not about maps as objects," Dykhuis says, "but the mapping process that informs my system-based projects." He based a four-part series, *Radar Paintings,* on Doppler images of storm fronts and precipitation forms issued hourly from a radar site at the Halifax Stanfield International Airport (airport code YHZ) showing weather patterns, overlaid on a grid, for the province of Nova Scotia. Areas of intense storm activity appear in red tones over green landmasses and blue water. In his fourth series of radar paintings, Dykhuis tinkered with the "false color imaging" system, developed with the advent of remote sensing technology, which assigned colors to reflect different data values—colors that we have come to accept as "true." Dykhuis added a political dimension to these artworks, replacing the arbitrary colors with those of logos of oil and gas companies and military contractors.

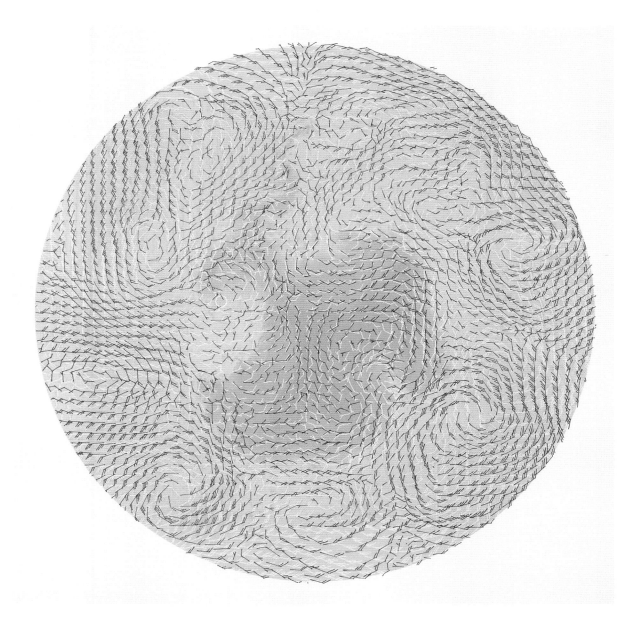

CHRIS DRURY

◀ *Antarctic Winds, 27 & 28 January 2007,*
2007

Inkjet print on paper, overlaid with ink
on transparent film
30 x 29 in.
Photo by Dave Billings

England-based Drury spent two months
in Antarctica with the British Antarctic
Survey, and used daily weather satellite
images of wind and pressure systems to
map the extreme polar environment. For
this piece he superimposed two days'
worth of weather data in a circular form.
A companion circular drawing shows the
circumpolar flight of an albatross—tracked
by satellite over eighteen months—riding
wind currents a few feet above the waves.

Following page

Ladakh I, 1997

Maps, earth, pigment, and charcoal
48 x 48 x 4 in.

Drury went for a two-week walk with a
friend—a guide with three horses—in the
high desert of the Ladakh range in the
Himalayas. When he returned, he created
several map works; the piece shown
features a pattern of nine linked diamonds
that he spotted on village and monastery
walls. To make the piece, Drury wove
together strips from two maps of the area
(some rubbed with ochre earth collected
there), molded these into a dished circle,
and placed the resulting form in a field of
blue pigment rubbed with charcoal.

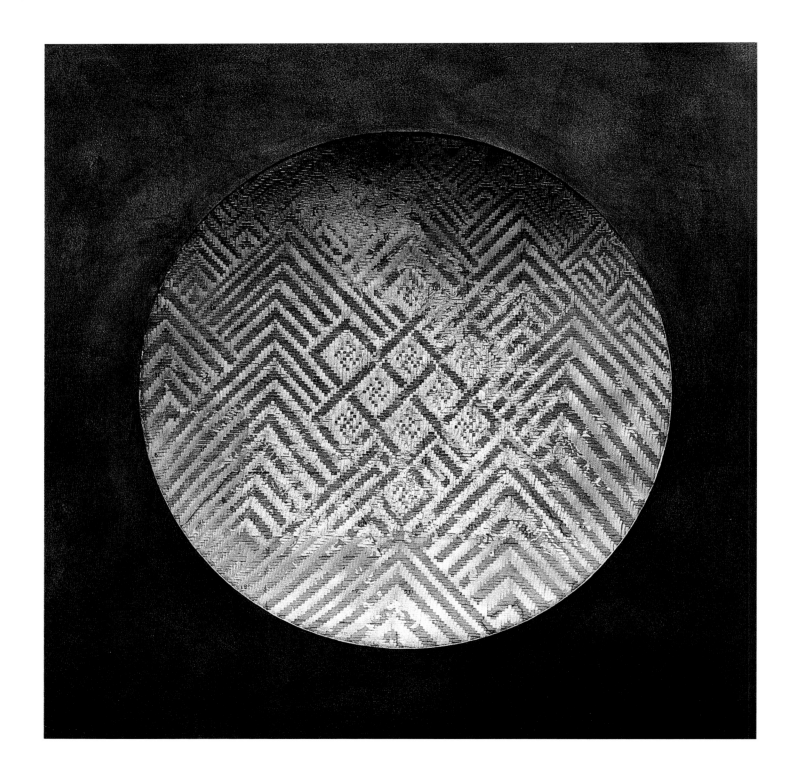

CLODAGH EMOE

The Approach, 2006

Burned book pages, drawing board
13.75 x 19.5 in.
Photo by Clare Pocock

A "crisis of disorientation" is the focus of Irish artist Emoe's work. Just as cartographers are concerned with giving structure to vast geographies, Emoe uses art to grapple with a subliminal tension inside us that comes from trying to place ourselves in an inconceivably vast universe. Her existential approach to art includes using a wide range of media and embracing the impossibility of controlling the creative process. *The Approach* consists of pages from a 1932 edition of J. F. Wolfenden's book *The Approach to Philosophy*, into which Emoe burned a mapped section of the Milky Way, reproduced from a discarded newspaper clipping she picked up on the street.

▲ *Mended Spiderweb #19 (Laundry Line),* 1998

Five patches (29-strand, 19-strand, 12-strand, and 21-strand) short, medium, and long pieces of lightly starched Mölnlycke Tvättäkta #342 red thread segments reinforced with polyvinyl acetate glue, tweezers insertion technique
From the series *Mended Spiderwebs*
Cibachrome print
20 x 30 in.
Courtesy of the artist; Sara Meltzer Gallery, New York; and Catharine Clark Gallery, San Francisco

▶ *Hawaii,* 1992

From the series *Moss Maps*
C-print
Varying dimensions
Courtesy of the artist; Sara Meltzer Gallery, New York; and Catharine Clark Gallery, San Francisco

NINA KATCHADOURIAN

▲ *Mended Spiderweb #14 (Spoon Patch),* 1998

144-strand patch, short, medium, long, and extra-long pieces of triple-starched Mölnlycke Tvättäkta #342 red thread segments reinforced with polyvinyl acetate glue, tweezers insertion technique, anchor lines reinforced by three pinecones and one spoon
Cibachrome print
30 x 20 in.
Courtesy of the artist; Sara Meltzer Gallery, New York; and Catharine Clark Gallery, San Francisco

Katchadourian, a California native, spent her childhood summers on a small island in the Finnish archipelago. Her family's home there sits on a large granite hill, covered with lichen whose appearance reminded Katchadourian of maps. Their shapes suggested entire continents or small islands, depending on the scale in which she chose to view them. For *Moss Maps,* she affixed letters directly onto the lichen in twenty spots, so that "the hill became a kind of scrambled atlas."

Finland is a fecund place for Katchadourian's cartographic imagination. In 2000, for example, she assembled a lineup of hundreds of unnamed Finnish islands, cut from an atlas and sandwiched between microscope slides. For the *Mended Spiderwebs* series, completed during a six-week period at her family's home, she used tweezers to replace missing strands of broken spiderwebs with starched pieces of red thread. Short threads were held in place by the sticky webs, while the tips of longer ones were dipped in glue. "The morning after the first patch job, I discovered a pile of red threads lying on the ground below the web," Katchadourian writes. "At first I assumed the wind had blown them out; on closer inspection it became clear that the spider had repaired the web to perfect condition using its own methods, throwing the threads out in the process. My repairs were always rejected by the spider and discarded, usually during the course of the night, even in webs which looked abandoned." She displays the jettisoned red threads in frames next to photographs of the repaired webs. The thread patches might be taken for a web of thoroughfares on a city map.

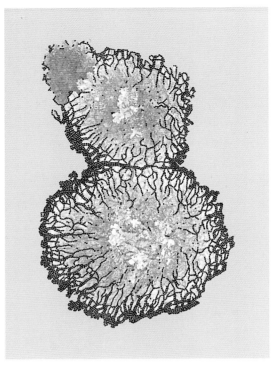
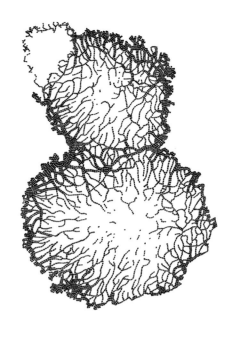

FLORENT MORELLET

L to R

Lichen Empty, 2004

Blue ink on computer-processed photo on paper
9.5 x 7 in., framed 17.5 x 15 in.

Lichen Inhabited, 2004

Black and blue inks on computer-processed photo
on paper
9.5 x 7 in., framed 17.5 x 15 in.

Lichen on Mylar, 2004

Black ink on Mylar over white board
9.5 x 7 in., framed 17.5 x 15 in.

Morellet, a celebrated New York restaurateur, pored over maps as a child and began drawing them as a teenager while growing up in France. For an ambitious, ongoing project based on his own imagination, he uses Rapidograph pens to draw maps of cities he has invented. For each city he compiles an accompanying statement of relevant facts, for example, descriptions of population (with racial and religious makeup), climate, historic events, and political and economic developments.

Morellet says he has always been mesmerized by maps he finds in nature. The first image shown here is a photograph of lichen that he placed against a blue field to suggest a volcanic island. Morellet then "densely developed this tropical island" using black ink on a color print. The final image shows the imagined human impact, with densely populated shorelines, roads up the volcano's flanks, and a marina, perhaps, in the northwest corner. One envisages microscopic creatures taking up residence along the canyons and waterways of this hospitable little island.

JOYCE CAMPBELL

▶ *Images from the series L.A. Bloom,* 2002

Ilfachrome photograms
Each 16 x 20 in.

Campbell is a multidisciplinary artist working in photography, film and video installations, and sculpture. For her *L.A. Bloom* series, she swabbed the surfaces of plants and soil from various Los Angeles County neighborhoods—Zuma Beach, Griffith Park, Azusa, Venice Beach—and cultured these bacterial samples in petri dishes. The resulting growths, twenty-seven in all, are part of a larger series of photograms titled *Bloom.* The images are made as contact prints, the same size as the agar plates from which they are reproduced. Of producing these maps of the city's invisible bacterial world, Campbell says, "I was fascinated by the artificial fecundity of certain regions of Los Angeles as opposed to the relatively barren wastelands beyond the reach of irrigation. There seemed to be a kind of poetic reversal in picturing the most botanically manicured parts of the city as oceans of bacteria and fungi, while revealing the relative sterility of the water-deprived south and east."

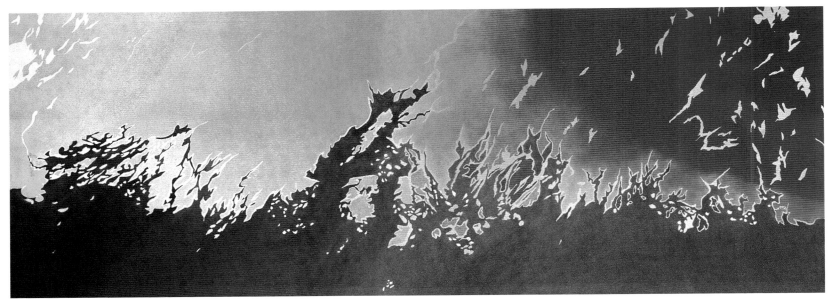

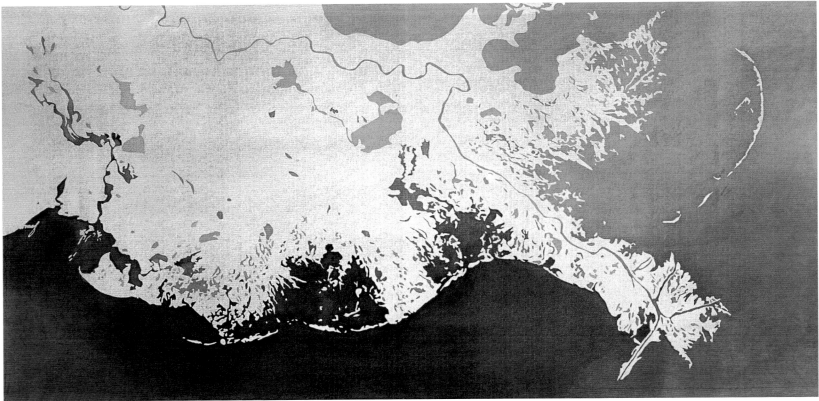

MARY EDNA FRASER

◀ ◀ *Maine Coastline,* 1994

Batik on silk
41 x 112 in.
Collection of Seth Koch

◀ ▼ *Louisiana's Disappearing Chains,* 1997

Batik on silk
33 x 65 in.
Collection of Mary Lou K. Stevenson

◀ *Venice (Italy),* 2000

Batik on silk
61 x 47 in.

Batik artist Fraser took part in an unusual artistic/ scientific collaboration to draw attention to the complexity and fragility of barrier islands around the world. With Orrin H. Pilkey, a geologist at Duke University, she created the 2003 book *A Celebration of the World's Barrier Islands.* Before beginning each of the batiks that illustrate the book, Fraser hiked the terrain of the islands, viewed their waterways by boat and air, made on-site watercolor studies, and consulted satellite and space shuttle imagery. "The batiks convey perspectives that the human eye, conventional maps, and cameras cannot reveal," she writes. "I hope the art will contribute to an appreciation of the dynamic nature of these moving strips of sand, and will act as a catalyst for the preservation of barrier islands for future generations."

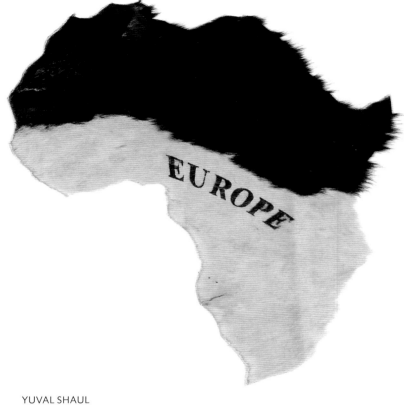

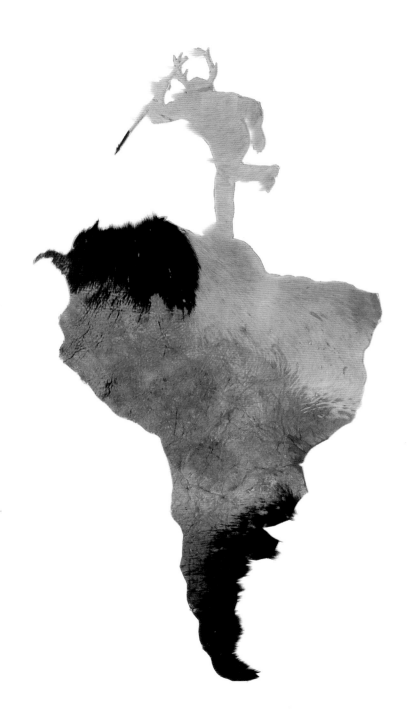

YUVAL SHAUL

◀ *South America*, 2006

Oil on cowhide
14 x 26 in.
Photo by Danny Lerner

▲ *Africa Europe,* 2006

Oil on cowhide
12.5 x 14 in.
Photo by Danny Lerner

"I'm the hairiest artist in the world," says Shaul, a Tel Aviv–based artist. "Hair, fur, skin, shield, sense. Total male, animal, repulsive and attractive at the same time." Since human history began, animals have provided food, clothing, and shelter, enabling humans to spread from continent to continent. Brutal realities collide with cultural development in Shaul's hide maps. "Men are hunters, it's our instinct," he says. "Identification with the victim—that's culture. The repression of the instinct—that's culture. You can't define it—that's art."

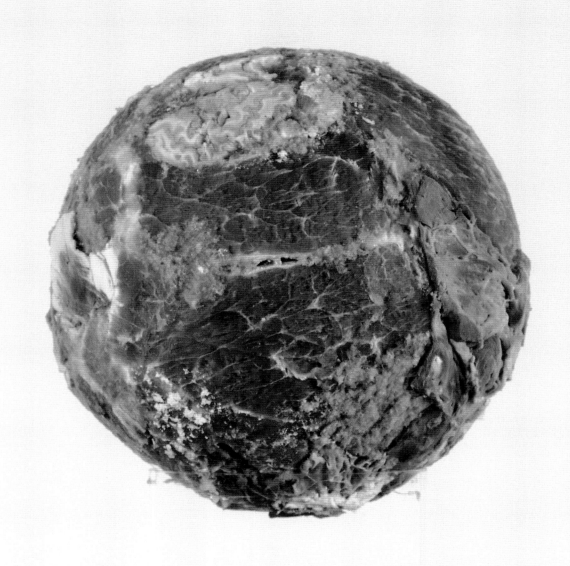

The real world

RUTH WATSON

The Real World, 1998

Animal tissue in formalin-based preservative solution, in Perspex box
15.75 x 15.75 in.
Courtesy of the artist and Two Rooms Gallery, Auckland

"As an artist, you are frequently told about the Real World and that you should join it," Watson says. She calls *The Real World* an exploration of phenomenology. Antarctica appears at the top of the globe, rendered in brain tissue, and her native country, Australia, is at the upper left. Watson is interested in mapping projections that challenge the way we usually see the world, and pushes her map works further by using unusual materials, including photos of the surface of a tongue (for a lingua geographica), chocolate candy wrappers, and pink plastic shopping bags.

DAVID MAISEL

▶ *Terminal Mirage 18,* 2003

From the series *Terminal Mirage*
C-print
48 x 48 in.

▶ ▶ *Terminal Mirage 5,* 2003

From the series *Terminal Mirage*
C-print
48 x 48 in.

Over more than twenty years, Maisel has built an extensive body of work, titled *Black Maps,* made up of aerial photographs of damaged landscapes. From a low-flying Cessna he records sites of human destruction—slopes stripped bare by timber or mining companies, bodies of water barren of life—to wring a harsh beauty from devastation. The *Terminal Mirage* series focuses on Utah's Great Salt Lake; "terminal" refers to the lake's geology, with no exit points, and "mirage" refers to the light it reflects. "Photography is an illusion of mapping the truth, of course—a selective process just like mapping," Maisel says. "These photos stand apart from the thing itself; they are meant to be more open-ended, poetic objects themselves."

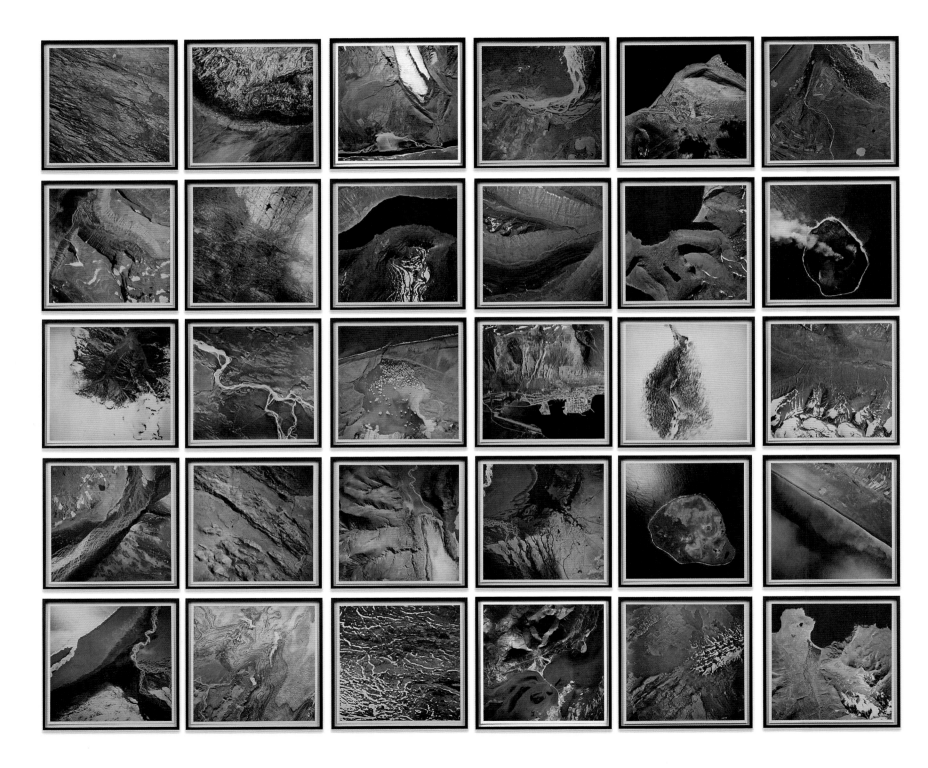

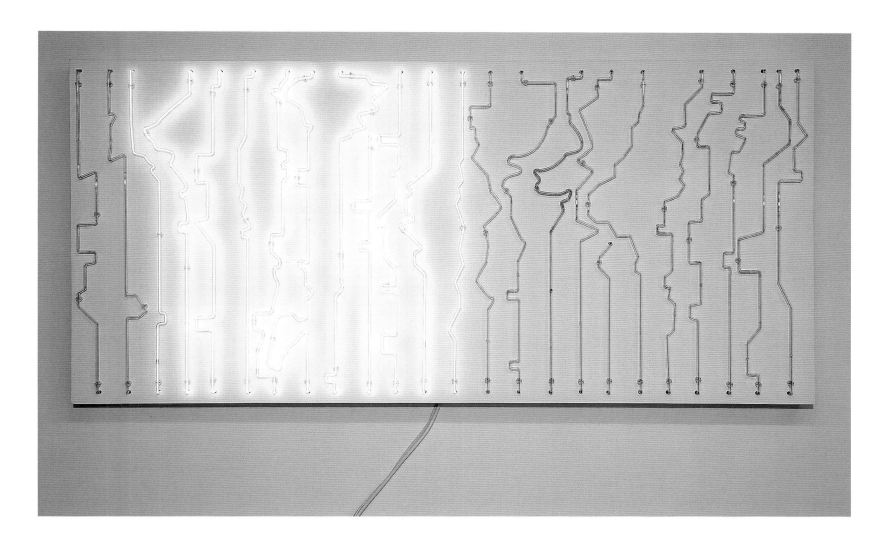

OLAFUR ELIASSON

◀ *Cartographic series III,* 2004

From an edition of sixteen, four artist proofs
Thirty color photogravures on paper (blue, green, and violet)
Edition of sixteen / four artist proofs
Each 19.25 x 19.25 in.
Courtesy of the artist; neugerriemschneider, Berlin; and Tanya Bonakdar Gallery, New York
Photo by Jens Ziehe

▲ *Daylight map,* 2005

Installation view at Western Bridge, Seattle, 2006
From an edition of three
Neon, sintra box, transformers, controllers, sequencer, and timers
48 x 100 x 6 in.
Courtesy of the artist; neugerriemschneider, Berlin; and Tanya Bonakdar Gallery, New York
Photo by Marc Woods

Danish-Icelandic artist Eliasson uses sculpture, light and water installations, immersive architectural environments, photography, and other means to express artistic visions that sometimes touch on mapping concepts. His studio is an experimental laboratory, where a team of approximately thirty-five assistants trained in engineering, architecture, administration, and art techniques work together to realize the artist's projects. The first of two smaller-scale works reproduced here, *Cartographic series III,* shows images of the Icelandic terrain that Eliasson obtained from an institute for geographic mapping in Iceland, then transferred to photogravure, with faint nuances of blue, green, and violet. On the right, *Daylight map,* a map of international time zones made of neon tubes, is a real-time representation of global light conditions. The map illuminates those zones where the sun has risen, and in the zones where the sun has set, the lights turn off. With these pieces, Eliasson shows that there is always light somewhere in the world.

WILLIAM POPE.L

The Great White Way: 22 miles, 5 years, 1 street,
2002

Photographic documentation of performance art piece
Courtesy of the artist and The Project, New York

Pope.L is a multidisciplinary artist who embraces
controversy with conceptual and visual art
projects focusing on issues of race, class, and
societal lunacy. Combining self-flagellation and
self-affirmation, Pope.L has executed dozens of
"crawls" in various locations, the most ambitious
being *The Great White Way.* He performed
segments of this crawl (which also included rolling
on his back on a skateboard for some relief)
over five years, moving north from the Statue
of Liberty through the length of Manhattan and
into the Bronx. He has stated that the piece refers
to immigrant history, the powerlessness of the
homeless, and "the privilege of being a vertical
person." As he commando-crawls through gutters
and grime, Pope.L shows the superhuman strength
and endurance necessary for survival on the street,
especially the streets of New York, and especially
for African Americans.

FRANCIS ALŸS

Fairy Tales, 1995–98

Photographic documentation of an action in Stockholm
Courtesy of the artist and Galerie Peter Kilchmann,
Zürich

The Leak, 1995

Photographic documentation of an action in São Paulo
Courtesy of the artist and Galerie Peter Kilchmann,
Zürich

Among many other artistic projects, Alÿs makes paseos (walks) through urban landscapes, exploring political aspects of poetic actions. Perhaps the most famous of these is his fifteen-mile walk through Jerusalem in 2005, with green paint streaming from a hole in a can as he retraced the Green Line representing the demarcation on a map drawn at the 1949 armistice of the Arab-Israeli war. Ten years earlier, in 1995, Alÿs mapped a route through a working-class neighborhood in São Paulo with blue paint, called *The Leak,* and began a paseo through Stockholm, *Fairy Tales,* with an unraveling sweater drawing sinuous lines on his personal map. He has pushed a block of ice for nine hours through Mexico City streets *(Paradox of Praxis I,* 1997); flown around the world, touching down in seven countries, to travel between Tijuana and San Diego without crossing the U.S.–Mexico border *(The Loop,* 1997); and walked through Copenhagen for a week, each day under the influence of a different drug *(Narcotourism,* 1996). While Richard Long (see next page) navigates the most desolate landscapes, Alÿs follows man-made roadways through densely inhabited surroundings, embracing serendipity along the way. In each case, the lines he leaves as he walks reflect the transient and mutable nature of mapmaking.

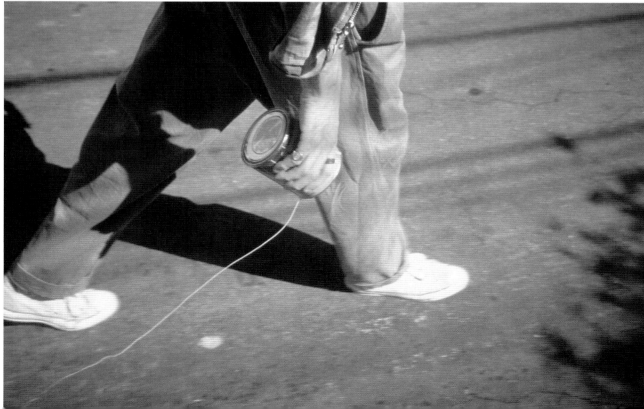

RICHARD LONG

▶ *Walking a Circle on Hoy Along a Four Day Walk / Orkney,* 1992

Framed map and text

▶▶ *Fresh Water Salt Water Line Walk / Southwards / Sutherland, Ross and Cromarty / Scotland 1980,* 1980

Framed map and text
34.5 x 49 in.
Private collection, England

"A map is just one more layer, a mark laid down upon thousands of other layers of human geographic history on the surface of the land," says British artist and sculptor Long. "Maps help show this." Since the late 1960s Long has walked alone through some of the most deserted landscapes on every continent of the Earth. His experiences are private, but he offers those who follow his work a trail of documentary evidence: haiku-like titles of walks, maps with highlighted routes, photographs of land sculptures made in situ, gallery installations created from collected natural materials, and compilations of images and text in book form.

Long's first walk was *A Line Made by Walking,* done in 1967 at the age of twenty-two, and since then he has made countless others. The two walks shown here were both made in Scotland. Though he travels widely, the moorlands of Dartmoor in Devon, England, are Long's most-walked terrain.

FRESH WATER SALT WATER LINE WALK

SOUTHWARDS SUTHERLAND, ROSS AND CROMARTY SCOTLAND 1980

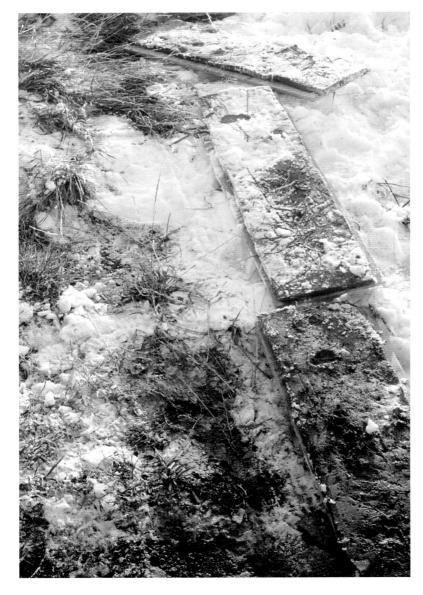

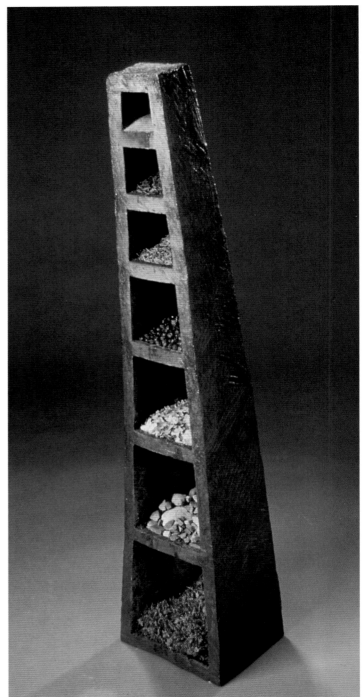

GREGOR TURK

◀◀ *One Inch Equals One Inch,* 1993

From the *49th Parallel Project, 1992–95*
Cast paper of the Montana–Alberta border
7 x 33 in.

◀ *Monumap: 115°/49° (Roosville),* 1993

From the *49th Parallel Project, 1992–95*
Mixed media
46 x 10 x 8 in.

The forty-ninth parallel is the world's longest straight border. Off and on for over six months in 1992, Turk hiked and biked along 1,270 miles of the line dividing Canada and the United States, producing an installation of drawings, sculptures, and artworks made from materials collected en route. *Monumap: 115°/49° (Roosville)* is a "smelling map" with leaves, berries, and moss emitting aromas from a sixty-mile section of the Montana–British Columbia border. Turk also made small paper molds of the ground at points along his route. *One Inch Equals One Inch* is a series of inch-long maps of patterns in snow made along thirty-five feet of the Montana–Alberta border.

THEODORE LAMB

▶▲ *Rock Map 28,* 2008

Color photograph
8 x 10 in.

▶ *Rock Map 54,* 2008

Color photograph
8 x 10 in.

Lamb is a young artist (almost nine) interested in maps and photography. He found this rock map in a rain forest in Costa Rica, in a remote location near the Panama border. "I like finding maps in nature," he says. "Everywhere I look I see maps, out of habit."

Ingrid Calame Constellations of Residue

In the art world, Ingrid Calame has put herself on the map with her engrossing artistic process and her vibrant drawings and paintings. Calame traces the lowly visual remains of human activity—skid marks, spills, graffiti, and stains—and then layers these tracings to create abstractions that seem utterly spontaneous and expressive.

We usually think of maps as reduced-scale versions of actual geography; a map using a 1:1 ratio would be, well, unwieldy. But Calame's to-scale tracings can be placed within other definitions of maps: simplified representations of

> As a child, I always wanted to make a map of the world. My paintings and drawings are not maps, but they come from an impossible, cartographic impulse. I can't know the whole world, but going out into the world is really important to me, to try to know it through a kind of micro-mapping.[1]
>
> *Ingrid Calame (American, b. 1965)*

the Earth's surface or depictions of relationships between the components of a space. Where geographic maps show the relationship between regions or roads, Calame's work documents the relationship between humans and their environments.

Calame calls her works "constellations," a term that can be taken literally—there is something astral about her bursts and configurations of line and color. But a constellation is also simply a gathering or assemblage, often of related things, ideas, or people. In Calame's work, tracings and retracings of the residue of absent individuals offer new meanings and formal relationships. Through her union of found gestures Calame forms a congregation of human presence, mundane events, and different moments in time.

After completing her MFA at the California Institute of the Arts in 1996, Calame began a series of abstract paintings based on the accidental spills on her studio floor and was recognized for her tweaking of formal concerns. The spills themselves had been spontaneous and, when re-presented in Calame's works, they convey a sense of painterly expressiveness. But the works were also postpainterly and postmodern because of the cerebral transference of found stains and the removal of the immediate, direct gesture of the artist. Connecting this work with Jackson Pollock's poured paintings, writers compared the artists' processes and evocations of metaphysical landscapes.

Calame soon found connections between her process and more personal concerns. Her grandmother's death made her "think about how much we can ignore our mortality: that we can disintegrate, that we are very organic beings."[2] She began working on streets and sidewalks, tracing the contours of stains left by human activity.

> *I was hit with the ever-presence of our mortality, and the almost equal human need to hide or not see it. Signs of loss and disintegration are everywhere on the street. I chose the street because I wanted a public parade of loss rather than a private revealing of events. The stains tell more and less about everyday life and incident.[3]*

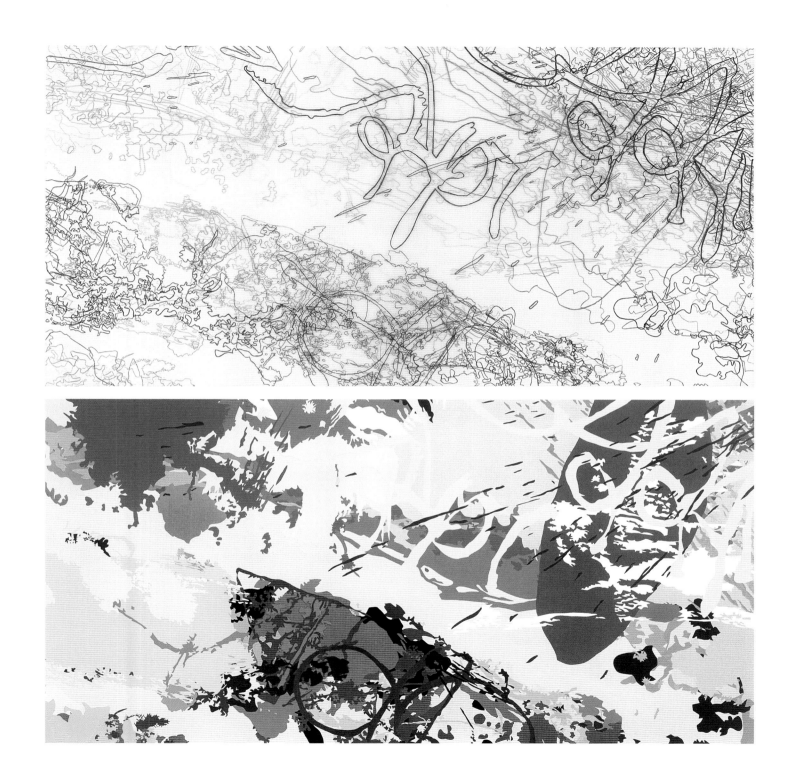

York, tracing portions of the aisles. In 2001, after wrangling permission from the New York Stock Exchange, she spent two weekends tracing structural and accidental markings on the main trading floor. In 2005, she traced the floor of the historic Lowell Observatory in Flagstaff, Arizona. She calls these three projects *Secular Response,* suggesting worldly, material reactions to these emblematic spaces, the systems of understanding they house, and the individual activities that occur within them.

Inside the Methodist church, Calame focused on the aisles—areas that are both pedestrian and ritualistic. For the NYSE project, she traced the areas around the traders' posts, where traders use verbal exchange and high-tech computers in their rapid commercial transactions. At the observatory, she traced the circular floor and steps surrounding two telescopes, as if to call attention to the physical movements of the men and women who survey the skies.

Formally, these tracings of larger sites contain different kinds of markings than those of the incidental spills and stains of the street. The circular floor and steps of the Lowell Observatory are more regular, deliberate, and structured, but, like the street stains, the outlines are still man-made, often overlooked, and record a human presence.

Calame layers these structural tracings with other tracings from different sites. These layers are made on translucent Mylar; the lines and shapes of disparate

Preceding page

INGRID CALAME

#231 Drawing (Tracings up to the L.A. River placed in the Clark Telescope Dome, Lowell Observatory, Flagstaff, AZ), 2006

Colored pencil on trace Mylar
34 x 58 in.
Private collection
Image courtesy of the artist and James Cohan Gallery, New York
Photo by Fredrik Nilsen

From #231 Drawing (Tracings up to the L.A. River placed in the Clark Telescope Dome, Lowell Observatory, Flagstaff, AZ), 2006

24 x 48 in.
Enamel paint on aluminum
Private collection
Image courtesy of the artist and James Cohan Gallery, New York
Photo by Fredrik Nilsen

Calame gave some of these found-gesture works peculiar names. The titles are abstract representations, in language, of actual sounds she heard while tracing, much like her visual traces echo the original marks. These onomatopoeic titles—like *Bb-AAghch!* from 2003 and *vu-eyp? vu-eyp? vu-eyp? vu-eyp?* from 2002—bring in another element of immediacy, making us think about the place and moment of the tracings. Calame stopped using sound titles as her process became more complicated. While her paintings and drawings have become more abstract and layered, her titles have become more representational and direct.

In 2000, Calame began adding tracings of larger structures as backdrops to her gatherings of individual human marks. Selecting sites that are marked by certain kinds of activity and thought, she began with the United Methodist Church in Ardsley, New

Ingrid Calame tracing tire marks at the Indianapolis Motor Speedway,
October 2006
Image courtesy of the artist and the Indianapolis Museum of Art
Photo by Tad Fruits

marks intersect wildly, fusing foreground with background and positive shapes with negative spaces. Calame then traces again to create final drawings and paintings on Mylar, aluminum, or directly on walls.

When it comes to her locations, Calame chooses carefully. She takes the maplike record of a specific place at a specific moment, but combines it with other records of other places and times. The complex product is both an accumulation of particular marks and an obliteration of specificity. While her scale for each tracing is always one-to-one, by layering tracings, the single point of view is collapsed into two, complicating our one-to-one relationship with what we see. How can we interpret this shifting ground?

Perhaps there is a message about the universality of human activity, accident, and mark making. Her work presents an opportunity to contem-

plate how marks are created out of common desires, fears, and behavior: coming to terms with or attempting to overcome mortality, searching for understanding, walking with a full cup of coffee. Or perhaps a bleaker meaning lies in the difficulty, even impossibility, of separating these individual marks, as if our particular presence is inevitably irrelevant. Yet it is tempting to try to distinguish the individual marks and to parse their origins, a desire that reflects Calame's impulse to record marks in the first place.

Calame lives near one of the many portions of the Los Angeles River that are completely covered in cement. The concrete channel can seem dehumanized and deserted, but Calame has found evidence there of human presence and communication. After the 2004 presidential elections, Calame came to the riverbed, feeling detached and isolated; she suddenly saw the evidence of taggers and graffiti artists in a new light. She says, "I was wondering about America and I felt disconnected. I looked down and saw this conversation people were having right in front of me."[4]

Calame has used her tracings of the marks on the riverbanks in combination with other works, including her *Secular Response* project with the Lowell Observatory. Consider the title of one drawing: *Tracings up to the L.A. River placed in the Clark Telescope Dome, Lowell Observatory, Flagstaff, AZ*. It seems straightforward enough, but Calame uses the phrase "placed in" very deliberately, calling attention to the larger, more systemic observatory tracings as a framework or container for the more individualistic markings from the riverbanks. In areas, you can see the circular lines of the observatory floor creating compositional structure for the disparate trickles, tags, and stains of the river tracings. In other areas, it's unclear which marks are from where.

Calame calls portions of her large, single site tracings "viewfinders" and has used viewfinders from the L.A. River in other works, including a 2007 project with the Indianapolis Motor Speedway. In preparation for an exhibition of her work at the Indianapolis Museum of Art, Calame was

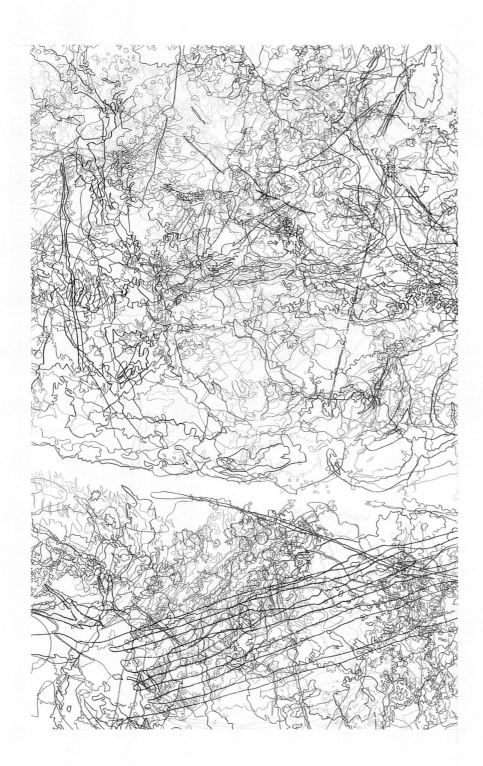

INGRID CALAME

#238 Drawing (Tracings up to the L.A. River placed in the Clark Telescope Dome, Lowell Observatory, Flagstaff, AZ), 2006

Colored pencil on trace Mylar
50 x 34 in.
Image courtesy of the artist and James Cohan Gallery, New York
Photo by Fredrik Nilsen

invited to create a large-scale painting generated by her response to a local site. After a visit to the Speedway, Calame got excited about the speed, sound, and the abundant tire marks.

All day long, for seven days, Calame and a crew of volunteers traced selected skid marks, some as long as two hundred feet. She became intimately familiar with the visual differences between kinds of marks: some tracks at the Pit, where cars zoom in for their thirty-second maintenance stops, had a "digital/crystalline character," while others, elsewhere on the track, were striated.[5] Calame also recorded the famous "victory donut," the circular mark spun out by Dan Wheldon after his Indy 500 win.

Calame layered the Speedway stories with those of the L.A. River, and then worked them into final works of art. She created a series of drawings by transferring the overlapping lines, using colored pencils, onto fresh Mylar; she produced a series of paintings by transferring the lines onto aluminum and creating splotchy shapes by filling in the lines with paint. These works range from a two-by-two-foot painting all the way up to a nineteen-by-seventy-four-foot wall work. The two major forms that she produces—drawing and painting—are quite different despite stemming from the same conceptual, cartographic processes. It's fascinating to see a drawing side by side with its painted counterpart.

In the initial tracings, Calame outlines the contours of stains and marks; she retains these contours in her

INGRID CALAME

From #238 Drawing (Tracings up to the L.A. River placed in the Clark
Telescope Dome, Lowell Observatory, Flagstaff, AZ), 2006

Enamel paint on aluminum
40 x 24 in.
Private collection
Image courtesy of the artist and James Cohan Gallery, New York
Photo by Fredrik Nilsen

drawings, creating lines and shapes that suggest topo-
graphic maps and linear networks. In the paintings,
however, she fills in the outlines with vivid enamel paint.
Calame applies the paint evenly and smoothly, creating
a flat and slick effect that suggests little other than
abstract painting itself.

For Calame, the tracings and retracings are a
deliberate system she has devised for making art. She
doesn't think much about the process anymore, saying
"it frees you up to think about lots of other things. I
spend a lot of time thinking about and mixing color and
watching how color acts."[6] Her use of color is bold and
intuitive. She makes color choices—which have little to
do with the original sources—in the process of retracing
or painting.

All of Calame's works re-present actual lines and
shapes found in the world; they are, therefore, repre-
sentational. But they are also abstract and singularly
expressive. They are not visual copies; the original
marks have been decontextualized and recomposed
through reproductions and additions. For Calame, art
is "a way of processing life." She has said, "I feel, some-
times in the world, a little lost, and that the world is
really big. By tracing this minutia, it's a way of doing the
impossible, trying to represent the world."[7] ◈

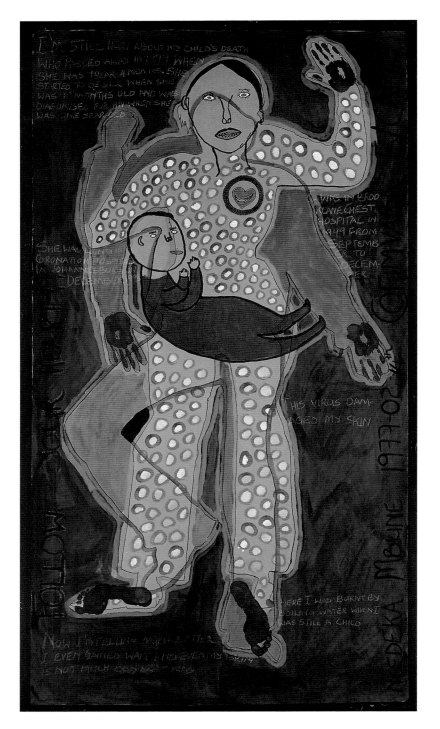

I'M STILL HURT ABOUT MY CHILD'S DEATH
WHO PASSED AWAY IN 1999 WHEN
SHE WAS 1 YEAR 4 MONTHS. SHE
STARTED TO BE SICK WHEN SHE
WAS 10 MONTHS OLD AND WAS
DIAGONISED FOR HIV WHEN SHE
WAS ONE YEAR OLD

SHE WAS ADMITTED
CORONATION HOSPITAL
IN JOHANNESBURG
DECEMBER

WAS IN KROO
KLANE CHEST
HOSPITAL IN
1999 FROM
SEPTEMB
ER TO
DECEM-
BER

THIS VIRUS DAM-
AGED MY SKIN

HERE I WAS BURNT BY
BOILING WATER WHEN I
WAS STILL A CHILD

NOW I'M FEELING MUCH BETTER
I EVEN GAINED WEIGHT AND EVEN MY SKIN
IS NOT MUCH DAMAGED

FOLLOW YOUR HEART

N. DEKA MBANE 1977-02-...

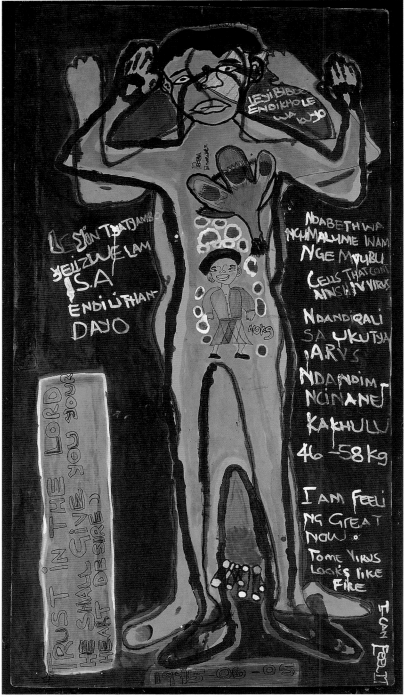

YEYI BIBILE
ENDIKHOLE
WA KUYO

PETER FINGER

NDABETHWA
NGUMALUME WAMI
NGE MVUBU

CELLS THAT CONT
AINS HIV VIRUS

NDANDIQALI
SA UKUTYA
IARVS

NDANDIM J
NCINANE J
KAKHULU

46-58 kg

I AM FEELI
NG GREAT
NOW ..
TO ME VIRUS
LOOK'S LIKE
FIRE

UESIN THATJAMBU
YELIZWE LAM
IS A
ENDILITHAN-
DAYO

46 kg

TRUST IN THE LORD
HE SHALL GIVE YOU YOUR
HEART DESIRE)

1995-06-05

I CAN FEEL IT

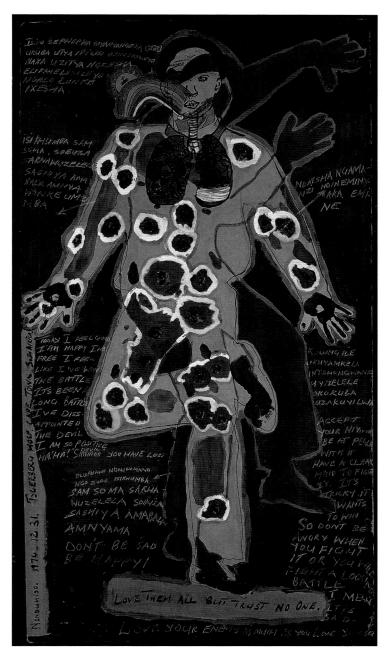

BAMBANANI WOMEN'S GROUP

L to R

Ncedeka

Bongiwe Mba

Nondumiso Hlwele

From the series *Body Maps: A Memory Box Project,* 2003
Digital prints
Each 37 x 23.5 in.
Courtesy of David Krut Projects, New York

In 2003 Jane Soloman, an artist based in Cape Town, South Africa, worked with a group of HIV-positive women undergoing drug therapy through Médecins Sans Frontières. Participants created life-sized body maps that visualize the virus and tell their stories. Each map features areas of emotional significance, the shadowy form of a partner, and a symbol of personal power to embody hope. Accompanying essays are moving accounts of the effects of the women's illness on their children and others, the cultural shame they bear, and the support they have received.

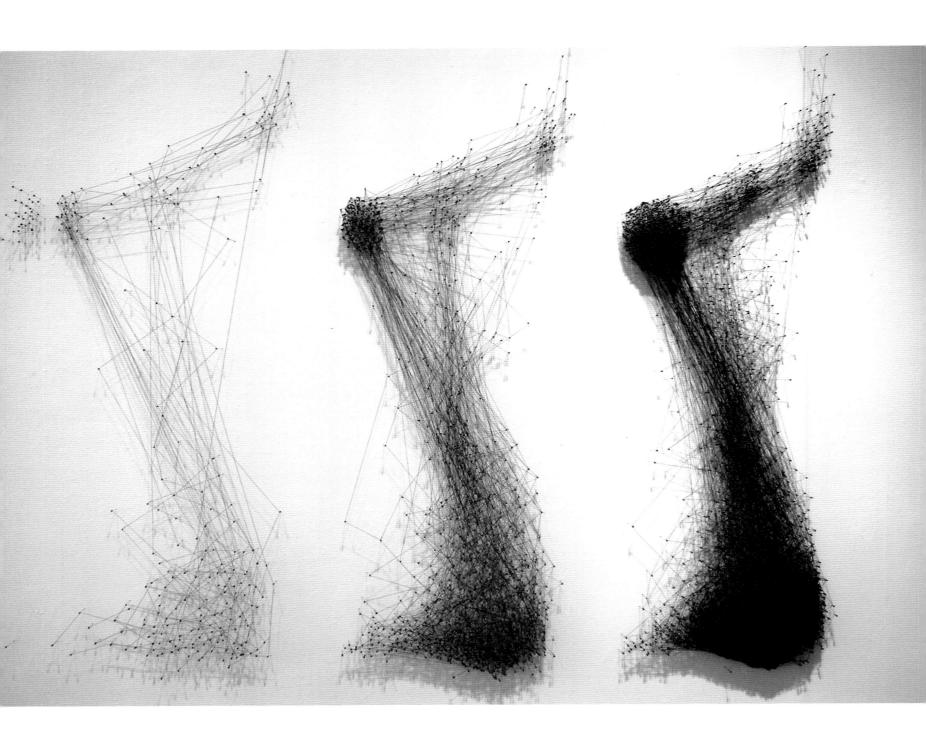

KATIE HOLLAND LEWIS

Tangled Pathways, 2006 (with detail)

Pins, enamel, thread
49 x 106 x 1.5 in.
Private collection

Lewis applies a rigorous system of documentation to map highly subjective body experiences, arising from her interest in "expressing something that does not exist in the tangible material world and does not hold a containable form." She begins by dividing her body into an abstracted grid and, each day, marking with pins on a corresponding wall grid those places where she feels certain physical sensations, such as pain. Threads connect these pins with others representing dates to show the accumulation of data over time. In *Tangled Pathways,* Lewis presents information collected over one month, six months, and a year in a "palimpsest" of accumulated sensations. Her assertive body mapping "is false by nature, as it speaks to the impossibility of harnessing a sensation," she says. "The very logical, systematic, and quasi-scientific approach to the work gives me authority to rationalize something irrational and control something that is beyond my control."

▶ ▶ *Following page, L to R*

PETER CLARK

Global Affair, 2007

Collaged paper / card
43 x 51 in.

Sunny Side of the Street, 2007

Collaged paper / card
32 x 53 in.

Clark creates whimsical cartographic wardrobes. The blue curves of a river outline the decolletage of one fitted dress, and Italy's boots appear on the pleats of another dress's skirt. In the gown shown here, note the state that is humorously placed in an armpit. Clark's map collages include "beasts" such as cattle, a roadrunner, and a variety of dogs (including a French bulldog, a British bulldog, and a Scottie, each made with the appropriate maps).

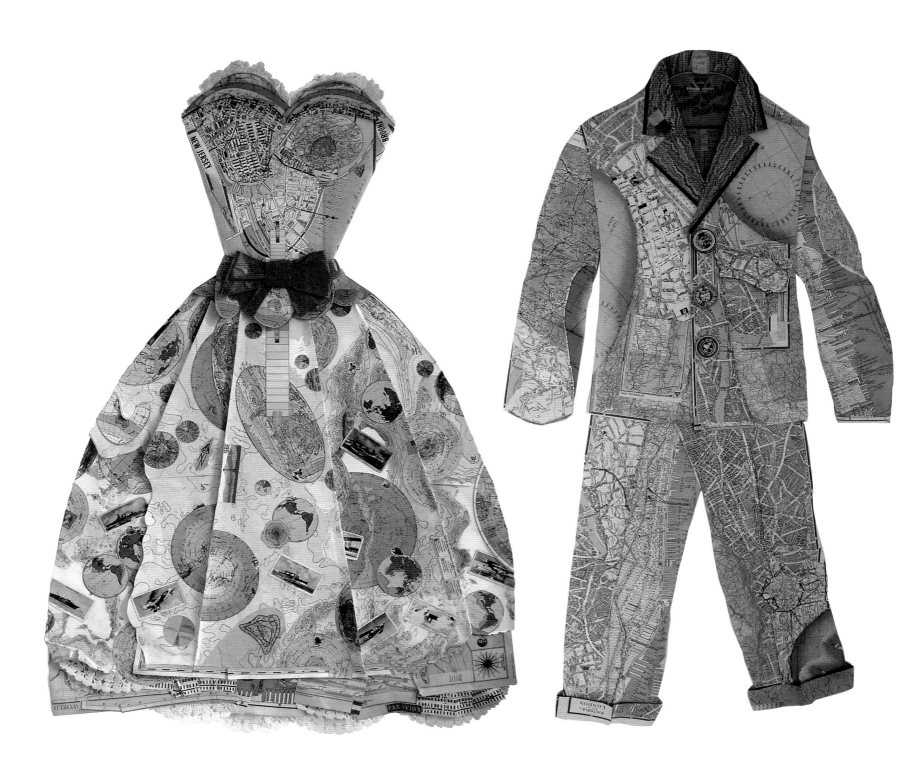

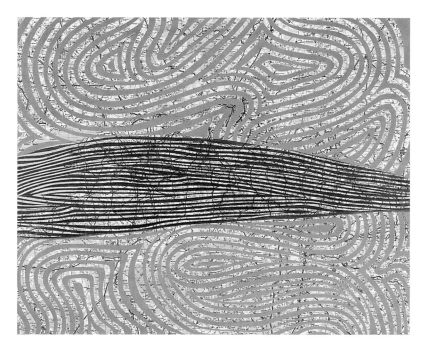

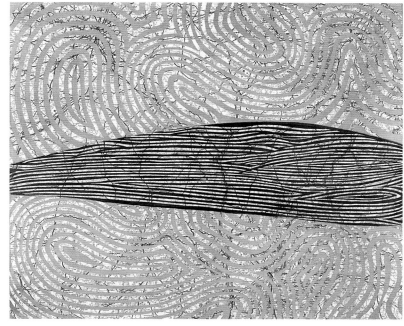

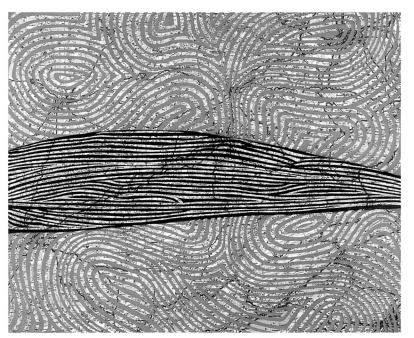

SANDRA SMIRLE

◀ ▲ *no place like it #1,* 2006

Acrylic, maps, and cold wax on panel
20 x 24 in.

◀ *no place like it #3,* 2006

Acrylic, maps, and cold wax on panel
20 x 24 in.
Collection of Steven Angel, Toronto

▲ *no place like it #2,* 2006

Acrylic, maps, and cold wax on panel
20 x 24 in.
Collection of Felicity Parker and Andrew
Gutteridge, Brisbane, Australia

Smirle, a Canadian artist, slices and weaves together different maps to create new
geographies. "Cutting topographical patterns into the maps," she says, "reminds me
of the prints I've left behind." In addition to creating a variety of two-dimensional,
map-based series, Smirle also assembles and rearranges an ever-growing number of
shoes (now over one hundred), cut and sewn from maps.

CORRIETTE SCHOENAERTS

▶ *South America,* 2005

Lambda print
32.25 x 39.5 in.
Photo by the artist with styling by Emmeline de Mooij

▶ ▶ *Europe,* 2005

Lambda print
48 x 31.5 in.
Photo by the artist with styling by Emmeline de Mooij

Schoenaerts, a conceptual photographer living in Amsterdam, was commissioned by the Dutch magazine *Rails* to create images for a thematic issue focusing on countries and borders. "Contrary to the usual fashion photography, which shows off the newest clothes on a human body to sell an ideal," she says, clothing was her medium for creating maps and landscapes—including another map, a mountain of brown clothing with a white T-shirt as its snow-capped peak.

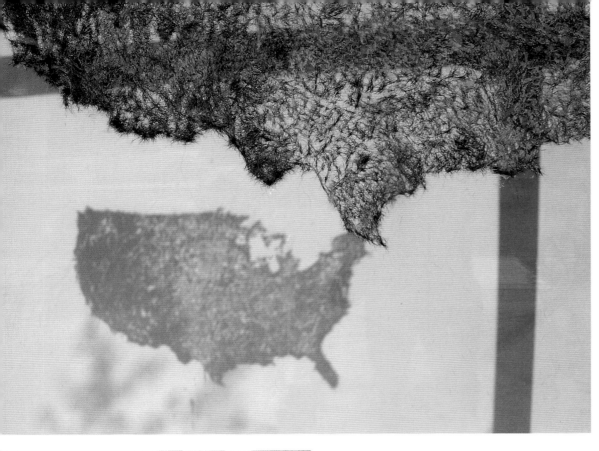

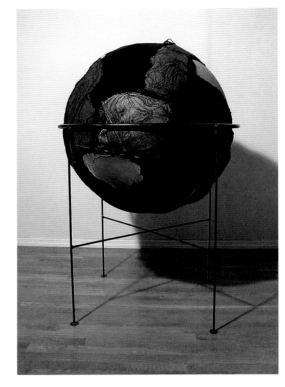

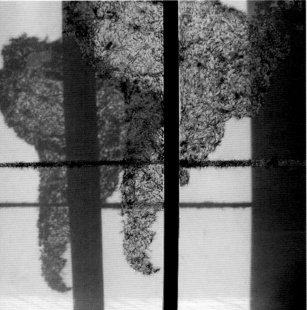

TAMARA KOSTIANOVSKY

▲ *Hair Map,* 2004 (detail)

View of installation at Rosenwald-Wolf Gallery,
University of the Arts, Philadelphia
Artist's hair on windowpane
47 x 33 in.

◄ *Origins,* 2004 (detail)

View of installation at www.gallerythe.org, Brooklyn
Artist's hair on windowpane
64 x 36 in.

▲ *Mapamundi,* 2006

Articles of clothing belonging to the artist, steel, yarn, ink
49 x 32 x 32 in.

Using her own hair as the medium for the maps shown
at left enabled Kostianovsky, an Argentinean artist, to
convey two artistic messages. In the case of the map of
South America, she fully identified herself with her native
continent; with the map of the United States, she expressed
her desire to embody a new, foreign landscape. Kostianovsky
moved to the United States in 2000; a few months later,
Argentina's economy crashed. "Overnight I was forced to
find art supplies in things that I had at hand," she explains.
"I started making three-dimensional maps out of my own
clothes, documenting my journey of immigration."

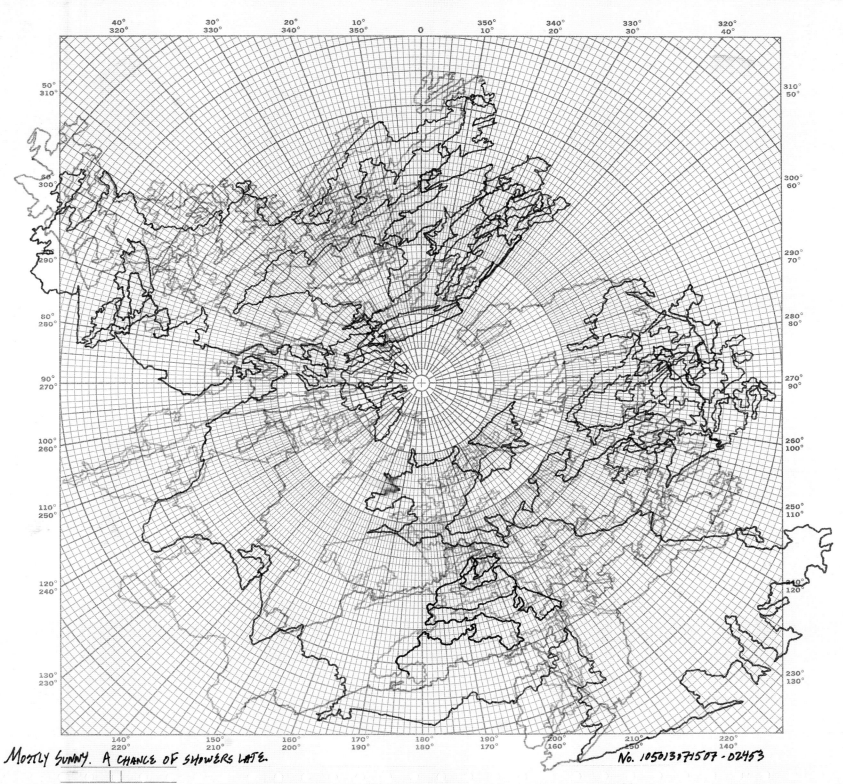

MOSTLY SUNNY. A CHANCE OF SHOWERS LATE.

No. 105013371507-02453

KANARINKA

Mostly Sunny. A chance of showers late., 2007

From the series *12 Inches of Weather*
Felt-tip pen on paper
12 x 12 in.

For *12 Inches of Weather,* kanarinka mapped the atmospheric
data of her body. She collected her sweat on paper as she
ran outdoors in hot weather and then, using an algorithm,
converted the data into contours plotted in colors
representing the date, time, and geographic location of each
run. How better to conduct a scientific investigation of the
question, "Can a body have weather, too?"

JEANNIE THIB

▶ *Tabula 3,* 1993

From the series *Tabula*
Linocut on kozo paper
48 x 36 in.
Collections of Art Gallery of Mississauga, Ontario
and W.K.P. Kennedy Gallery, North Bay, Ontario

▶ ▶ *Geographia*, 1995 (detail)

Screen print on kid gloves in showcase of linen, wood, glass
Collection of Oakville Galleries, gift of the artist

Thib's art uses images of the body—typically, individual parts
imbued with various associations—as canvases for social
commentary. She combines body segments with cultural
objects and documents as allusions to "the human desire
to leave a mark, to alter the terrain, to create, organize,
and understand." *Tabula* is a series of images of five hands
(one of which is shown here) overlaid with interpretive
systems—historical and contemporary maps, wilderness
survival tips, body camouflage patterns, and garden
designs—that explore human relationships to the wilderness.
For *Geographia,* Thib printed fragments of early maps of
Canada onto a pair of white kid gloves, similar to gloves
genteel British ladies might have worn to tea at the time the
maps were made. The artist suggests that mapping swaths
of uncharted wilderness for Queen and empire is dirty work,
not for dainty hands.

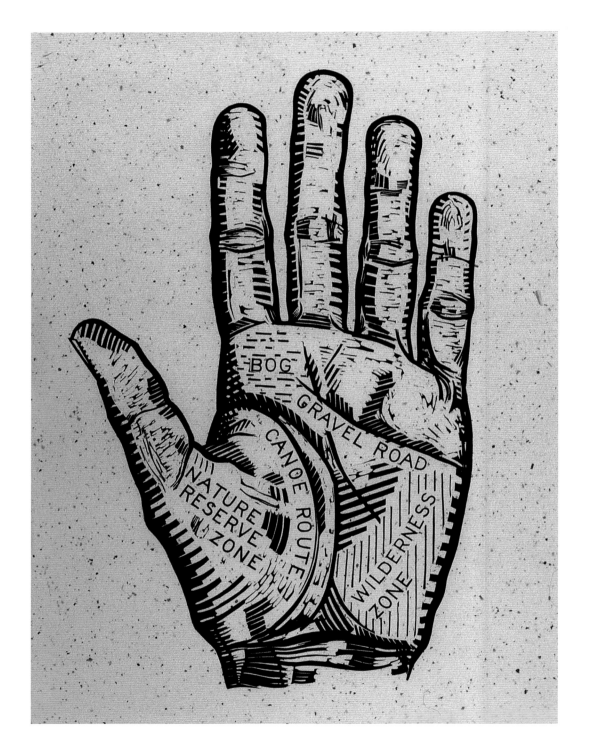

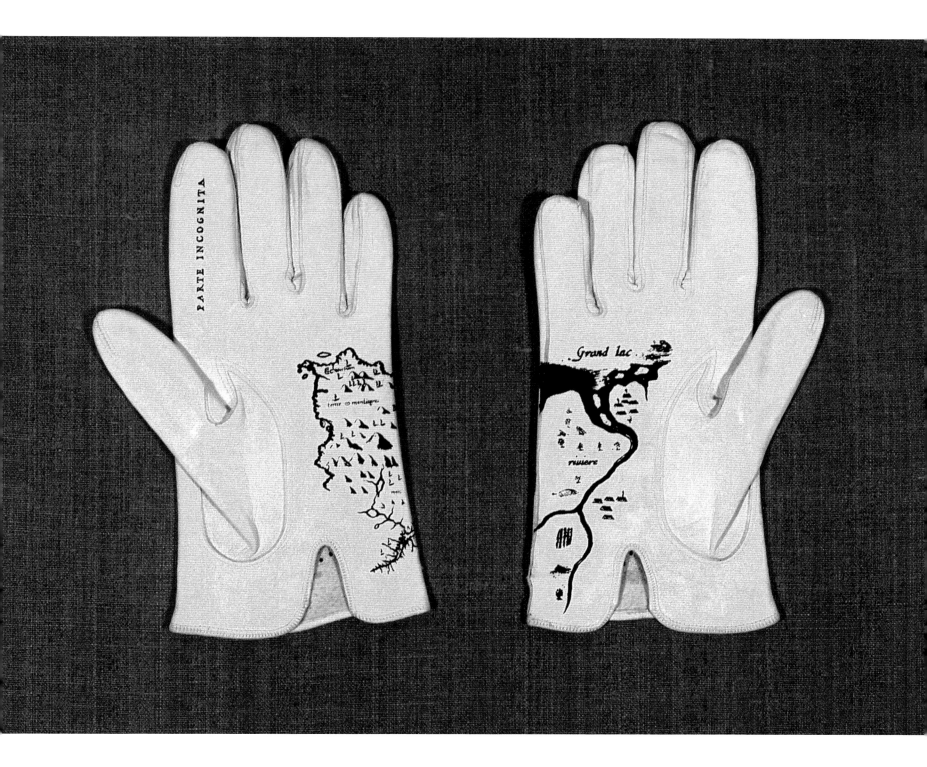

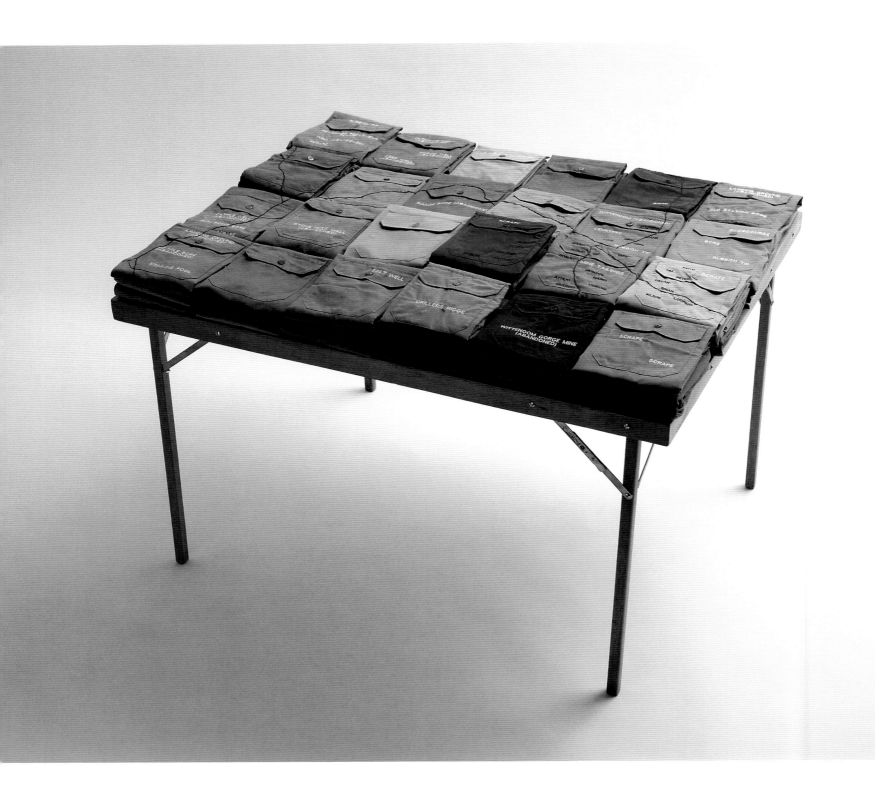

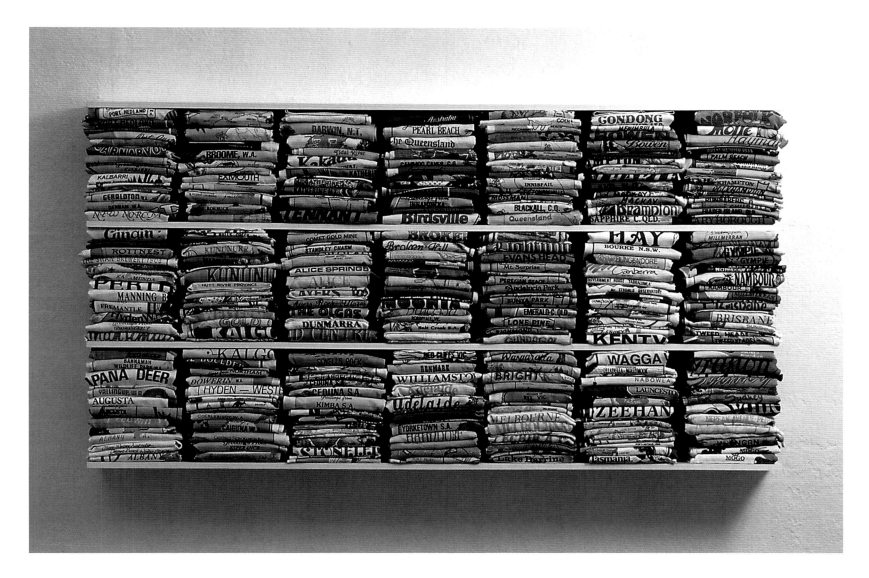

SUSANNA CASTLEDEN

◄ *Abandoned,* 2005

Embroidered work shirts on a table

▲ *Souvenir,* 2004

Folded souvenir tea towels on shelves

Castleden has an abiding interest in the naming of places in Australia—designations of towns, mountains, cattle stations, cyclones, and mine sites. "My art practice sits somewhere between mapping and naming the land," she says. "I like to examine the dichotomies between the visual language of map making and the actual presence of place in the landscape, borrowing elements from both disciplines."

MONICA DE MIRANDA

▼ *In the back of our hands*

From the series *Road Lines,* 2006
Seven lightboxes
Each 8 x 12 in.

▶ *Adriano adewale*

From the series *Where r u from?* 2006
Five photographs on canvas, five prints on acetate, sound installation
with interviews
Each 35.5 x 75 in., accompanied by one hour of sound

In a culture with everyone on the move, de Miranda calls for a new "cartography of affections." Her work uses maps to find networks of connective tissue uniting collective and personal places, and the individual with the whole.

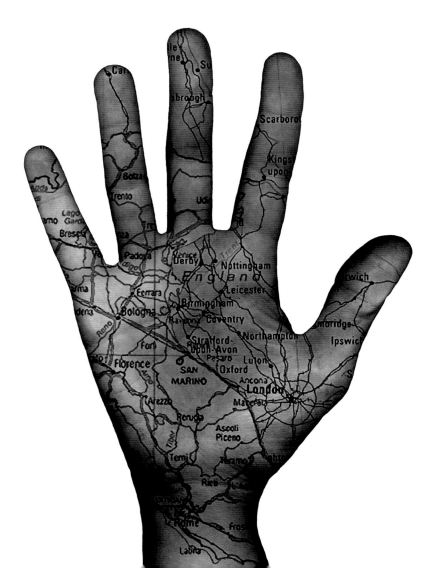

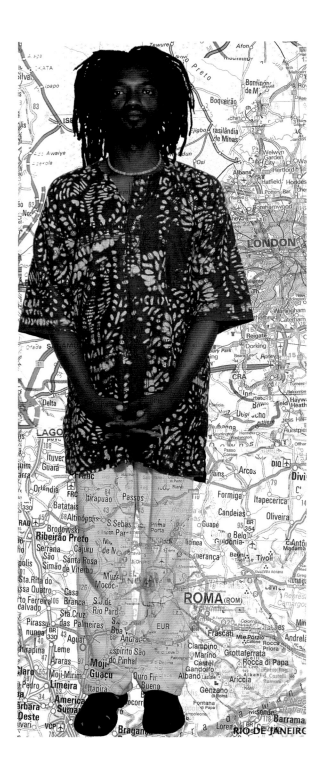

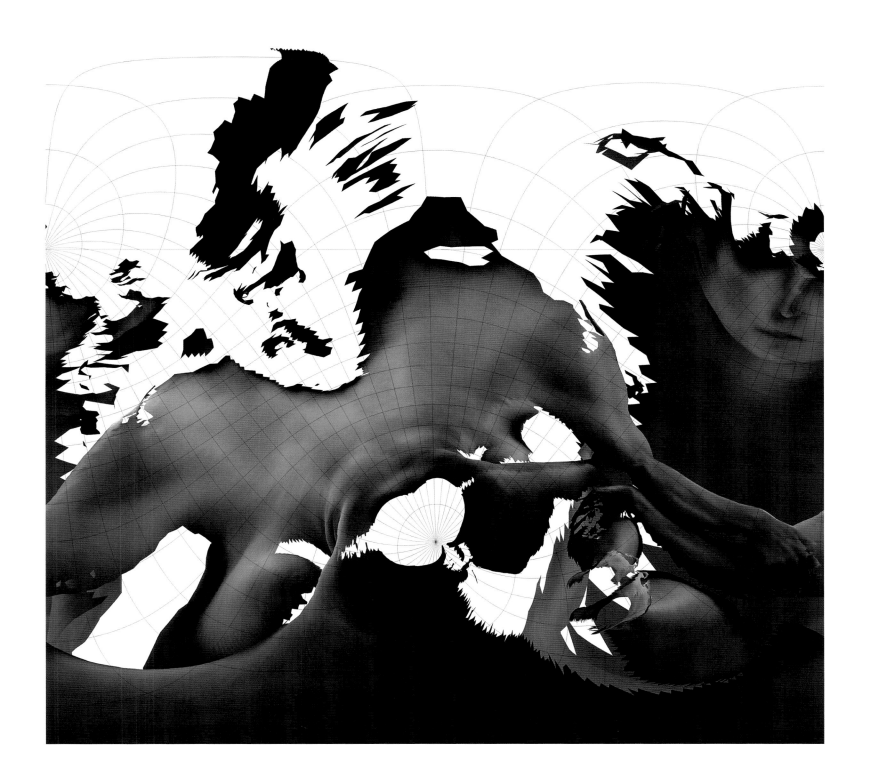

LILLA LOCURTO AND WILLIAM OUTCAULT

Preceding page

Urmayev III L3sph(8/6)7_98, 2000

From the series *selfportrait.map*
Chromogenic print
48 x 52 in.

In their self-portraiture project, LoCurto and Outcault use sophisticated digital imaging tools to explore the knotty problem of how to represent 3-D objects on 2-D surfaces. The two sculptors were inspired by Buckminster Fuller's 1946 *Dymaxion World Map,* a projection of the earth on an unfolded polyhedron that maintains the proportional integrity of global landmasses while enabling the viewer to see them simultaneously. As the digital maps of the artists' bodies are unfolded, the images tear apart along jagged, coastline-like fissures; these, for the artists, both underscore the mapping theme and the vulnerability of human life.

JANICE CASWELL

▶ *Alternate Realities—from Ft. Collins,* 2006 (detail)

Ink, paper, pins, beads, and enamel on paper, mounted on aluminum-backed archival foam board
39 x 31 in.
Photo by John Berens

Like mapping, memory is a flawed system, notes Caswell, whose drawings and installations investigate "the mind's peculiar ways of organizing memories." She says, "This work arises out of a desire to capture experience, an impulse to locate, arrange, and secure the past. I use a pared-down, coded language through which points, lines, and fields of color define spaces and retell narratives, making memories concrete." She openly concedes that the process is faulty, like any attempt at re-creating past experience, yet the inherent energy is apparent.

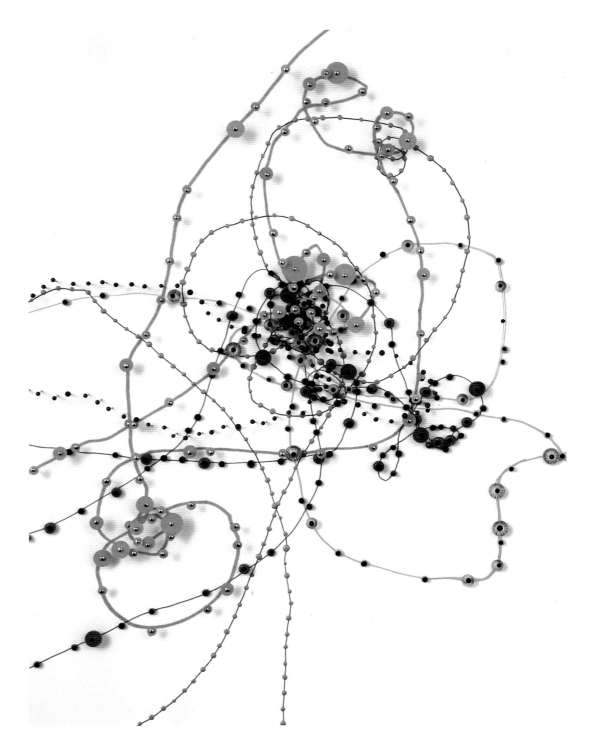

ELLIS NADLER

◀ *Map of Australia drawn from memory,* 2007

Pen and ink on paper, digitally colored
5.5 x 3.5 in.

Nadler, a visual artist and illustrator comfortable working in many styles, is amused by the cartoonish images that result when he asks friends to draw maps of places near and far—so amused, in fact, that he is planning an exhibition and book of these maps, compiled from submissions to the "Drawn from Memory" project explained on his website. The sole rule: no cheating by peeking at a map before or while drawing. Nadler created his U.S. map from a pile of cut wire that accumulated during a soldering project. Australia was drawn by a friend who is, Nadler says with wonder, "a highly educated man who has even visited Australia."

▶ *Map of USA from memory,* 2007

Cardboard, wire, glue, ballpoint pen, and felt-tip pen
23.5 x 19 in.

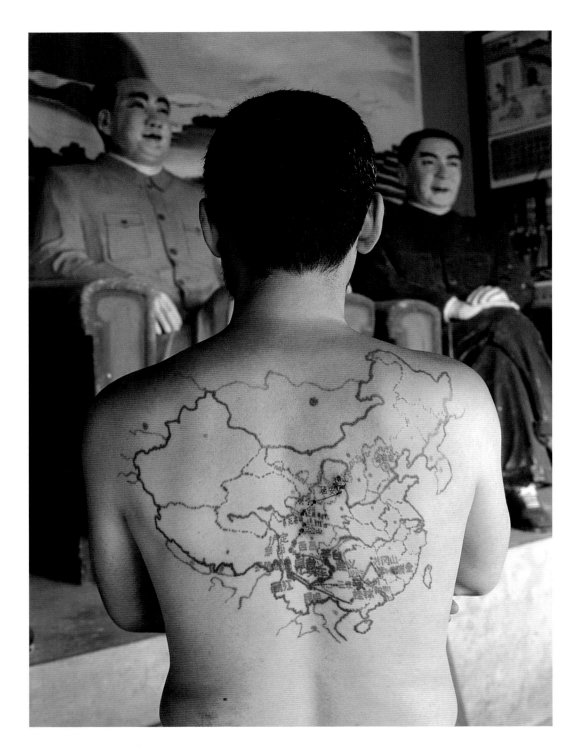

QIN GA

◀ *Site 22: Mao Zedong Temple*

▼ *Site 18: Hongyuan Grasslands*

From the series *The Miniature Long March,* 2005
C-prints
Courtesy of the artist and Long March Project, Beijing

In 2002, participants in the *Long March Project* began a "Walking Visual Display" along the route of China's historic, six-thousand-mile Long March (1934–36). As the team undertook the arduous journey, Beijing-based artist Qin kept in close contact with them and tracked the group's route, with needle and ink, on a tattooed map on his back. Three years later, Qin continued the trek where the original marchers had left off. He was accompanied by three cameramen, who recorded their movements over unremittingly demanding terrain—from snow-covered Himalayan peaks to swampy grasslands—and a tattoo artist, who continually updated the group's progress on Qin's back. The tattooed map is the physical embodiment of this personal journey, and the individual and collective experiences of thousands who previously endured the march or died in the process. In cartography, extreme human hardship can be reduced to a simple line. Qin's map is more complicated; it was laboriously and painfully made, and challenges any reductive legacy of the original Long March.

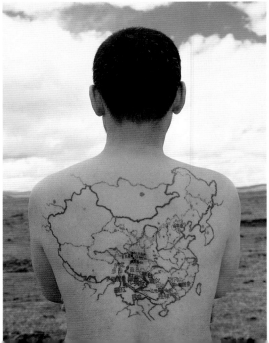

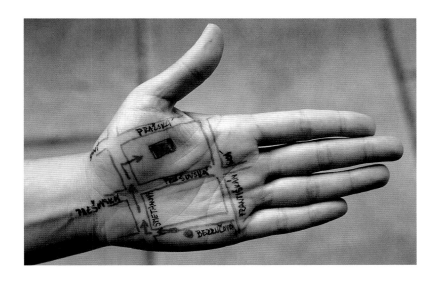

YUMI JANAIRO ROTH

Images from Meta Mapa, 2007

Project conducted in Pilsen, Czech Republic, in collaboration
with Andrew Blackstock and Casey McGuire

On request, Pilsen residents drew maps on the hands of Roth
and her collaborators leading to various sites in the city (for example,
from a coffeehouse to a cathedral, or from a university to a shopping
mall). Roth and friends then showed photographs of the hand maps,
printed and folded like tourist maps, to people on the street, asking
for help in following the directions.

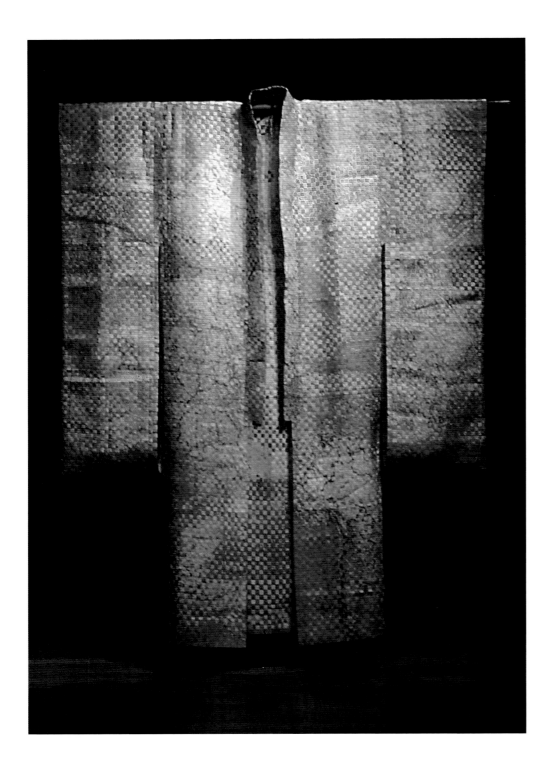

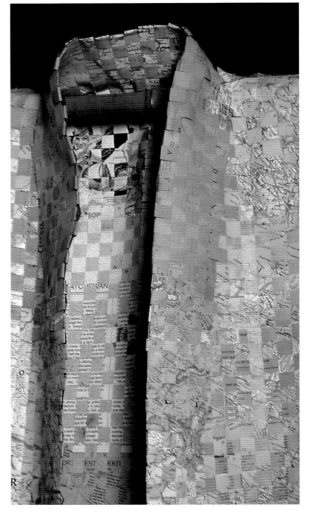

GALE JAMIESON

Pangaea, 2003 (with detail)

National Geographic maps, bamboo
60 x 72 in.

Pangaea is the theoretical landmass believed to have broken into
the continents we know today. In this work Jamieson used political
maps of the Eastern and Western hemispheres to symbolically weave
the world together, eliminating political alienation, Western cultural
dominance, and concomitant threats to diversity. She sees the
kimono shape as a protective shroud.

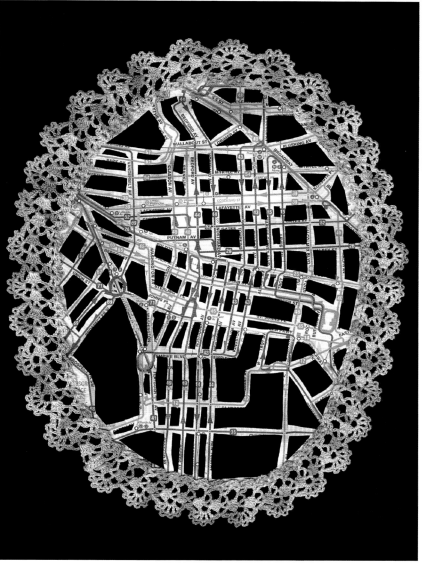

MERIDITH MCNEAL

Palm Portraits (LM, HH, EL), 2001–present (ongoing)

Vintage crystal beads and thread on vintage gloves
Varying dimensions

Doily Portrait (MM), 2004

Cut Brooklyn bus map, thread, velvet
11.5 x 8 in.

Since 1996, McNeal has used maps as inspiration and material for a veritable trousseau of creations: dresses, corsets, sandals, and luggage. She has also made series of map-based paintings, art books, and drawings. In exploring maps' artistic possibilities, McNeal is drawn to their feminine aspects. Her series of doily portraits resulted from working with a 1903 map of Brooklyn—painting, drawing, and embroidering until a lacework of transportation routes emerged. For many years McNeal has sewn friends' palmistry lines onto vintage gloves, enabling people to try on the maps of others' destinies.

To Alter a Landscape

Volcanic Mountain To prevent a Fire

Desert To find a Well

Cavern To move a Passage to the Harbour

KATHY PRENDERGAST

◀ *To Alter a Landscape,* 1983

Mixed media on paper
30 x 22.5 in.
Collection of Irish Museum of Modern Art, Dublin
Donated by Vincent and Noeleen Ferguson in 1996
Courtesy of Kerlin Gallery, Dublin
Photo by Denis Mortell

Prendergast has used maps in many contexts to magnify the underpinnings of power, identity, and gender. She has created bronze sculptures of flowers and teacups painted as topographic maps, inked colorful patchwork quilt–like patterns onto pages of a U.S. atlas, and is producing a set of 113 drawings of every capital city in the world. In an early series of eleven delicate ink and watercolor drawings, titled *Body Map,* Prendergast draws parallels between the exploration, conquest, and exploitation of virgin lands and that of the female body.

ABBY LEIGH

▶ *My Personal Atlas,* 2004 (two of a series)

Cotton paper with inclusions and colored pencil, overlaid with watermarked abaca and ink
Each 60 x 30 in.
Courtesy of Betty Cuningham Gallery, New York

Leigh's series of drawings, layered over lines of latitude and longitude, chart her interest in the natural world and its mysteries, the dichotomy of scientific inquiry and lived experience.

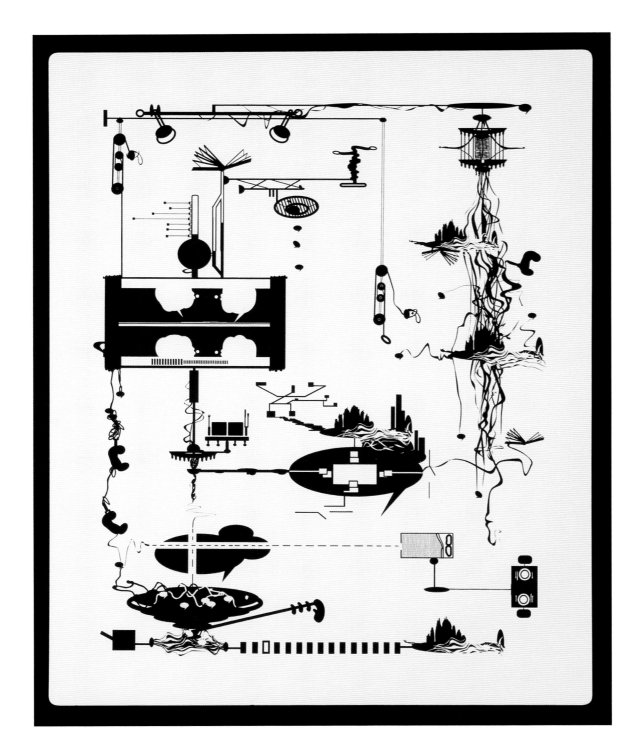

EMILY GINSBURG

◀ *Social Studies #16*, 2005

From the series *Social Studies*
Screen prints on archival board
Each 32 x 40 in.
Photos by Bill Bachuber

Ginsburg's ongoing *Social Studies* series maps the cerebral interactions within and between people going about their everyday lives. These "idiosyncratic portraits of human dynamics" are narrative-based, using imagery from the body, electronics, plumbing, architecture, and other dynamic systems. Ginsburg is parsing a visual language that is part comic book, part blueprint, and part screenplay—humor, instruction, and drama combined. Ginsburg describes her artistic viewpoint as "the idea of everyday life as an integrated circuit."

JANE LACKEY

▶ ▲ *survey (matrix)*, 2005

▶ *survey #1, dgm*, 2005

From the series *survey*
Paint, tape, and stickers on paper
Each 9 x 18.5 in.

In these pieces, two of a series of fourteen, Lackey mapped discussions about creativity during an artist residency at the Camargo Foundation in Cassis, France. As participants in this work/live community came together to discuss their projects in various disciplines, Lackey visualized the ephemeral connections between ideas and means of communicating them. In her series, identified pathways underscore the choices artists make in pursuing particular ideas over others, and "you are here" dots mark interactions of particular significance.

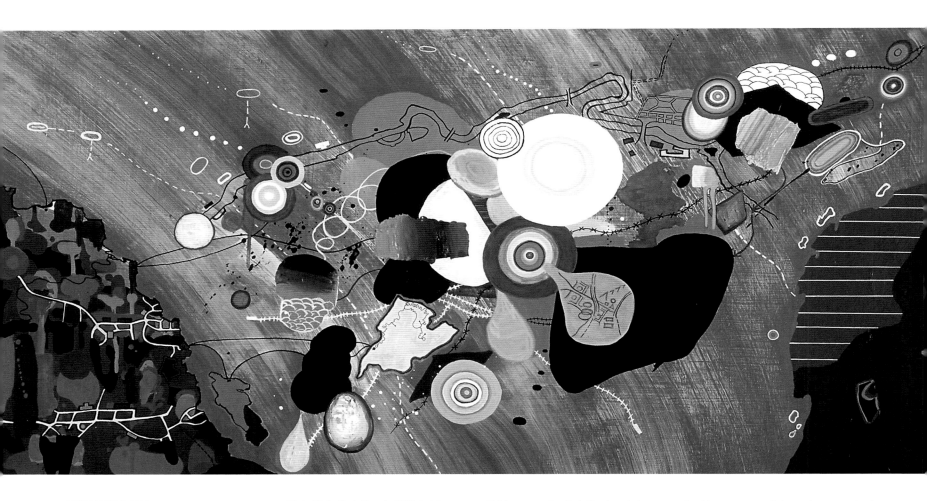

HEIDI WHITMAN

▲ *Out of Bounds/Brain Terrain (186),* 2006

From the series *Brain Terrain*
Acrylic, Flashe paint, and ink on panel
22 x 45 in.
Photo by David Caras

▶ *Night Flight/Brain Terrain (158),* 2006

From the series *Brain Terrain*
Acrylic, Flashe paint, and ink on panel
33.5 x 45 in.
Photo by David Caras

Whitman says her *Brain Terrain* paintings are an intuitive response to information processing in contemporary life—how we take in the disturbing events unfolding in a turbulent world. The mental maps chart states of mind in the language of cartography: symbols for railroad tracks, streets, rivers, and aqueducts act as neural networks, always churning, whether we are awake or asleep. "I'm interested in how experience is translated into thought, how memories are layered, and how dreams jumble reality," she says.

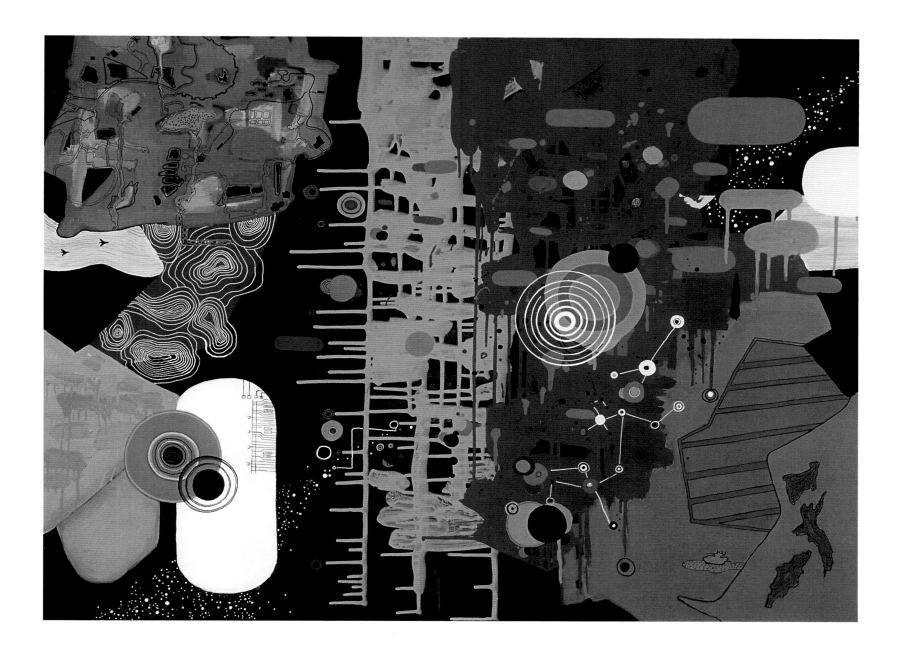

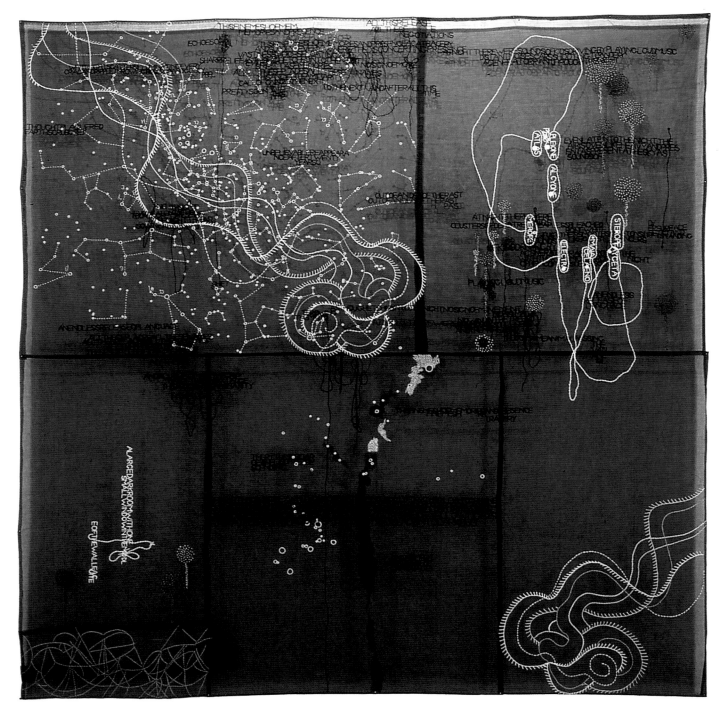

JESSICA RANKIN

Nocturne, 2004

Embroidery on organdy
84 x 84 in.
Collection of Andrew Ong
Courtesy of The Project,
New York, and White Cube,
London

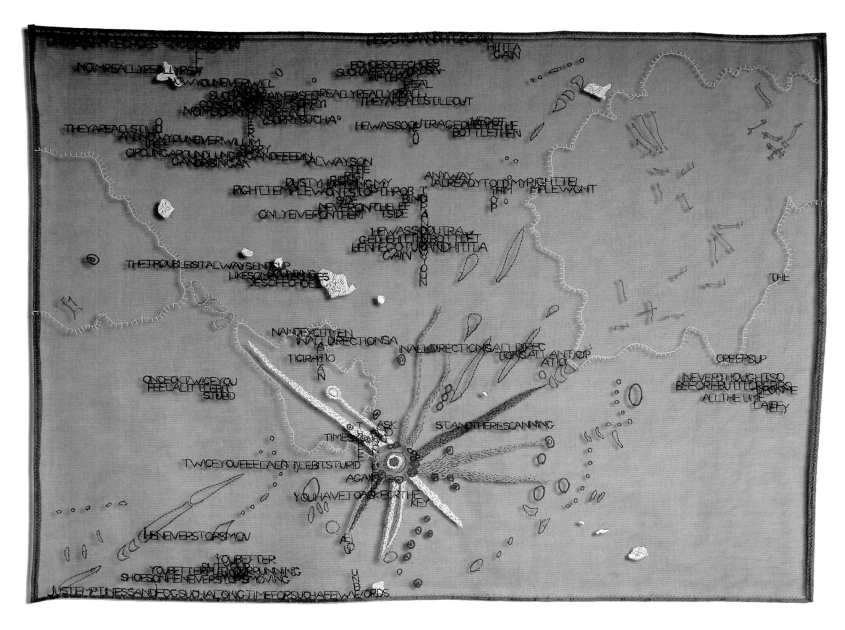

Lunar Effigy, 2006

Embroidery on organdy
44 x 60 in.
Collection of A & J Gordts-Vanthournout, Belgium
Courtesy of The Project, New York, and White Cube, London

An Australian now living in New York, Rankin explores the landscapes of her mind in a series of mental maps, embroidered with text and fragments from an array of mapping documents: for example, topographic outlines, thermodynamic charts, astronomical plans, and genetic diagrams. Her organdy "canvases" hang a few inches from the wall, giving the threadwork's shadows depth and adding a dimension of dreaminess to her work, designed as "an embodiment of thought." Text fragments in her works show what is on her mind: WHENYOUHIDEINTHESHADOWSYOUBECOMEME, for example, or IWANTEDTOSCREAMBUTINSTEAD-DIDSOMEWEIRDSORTOFJIG.

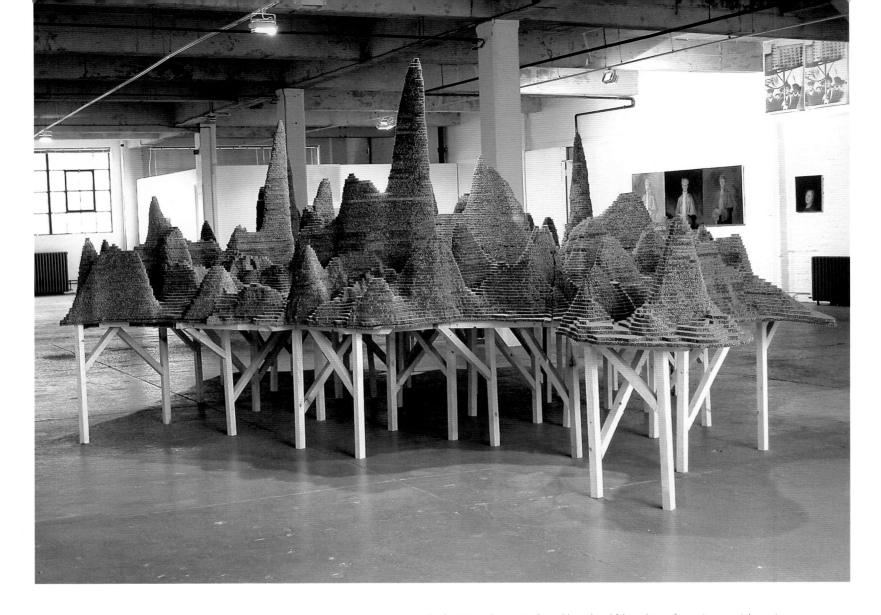

ABIGAIL REYNOLDS

Mount Fear, East London: Police Statistics for Violent Crimes 2002–3, 2003

From the series *Mount Fear*
Installation view at New Contemporaries, London
Cardboard and wood
57 x 21.25 x 167 in.

For her *Mount Fear* series, Reynolds analyzed felony data—of sex crimes or violent crimes (shown here)—compiled by London police, and from this created sculptural representations from stacked layers of Styrofoam, corrugated cardboard, and roofing felt. She uses a computer program to produce digital topographic maps of crime locations, committed over a given period of time, and then renders these into 3-D depictions. Summits show the areas of highest crime levels, and valleys the relatively safer areas. The terrain of danger associated with urban living is translated into a metaphor of a mountaineering expedition, requiring feats of endurance; safer neighborhoods enjoy a more pastoral existence. Despite the unemotional nature of the data, with this mapping project Reynolds makes clear that living on a mountaintop is not a matter of choice, and living within view of the mountains does not impart tranquillity.

Someone from a car was staring at me while I am jaywalking

I danced for Jaren in front of a claw/prize game on Mission

Talking

Hotdog stand reminded me of Jem Cohen film

Traffic and lots of stuff

My backpack fell onto my clutch so I had to move it

Got my picture taken with the sad clown. He promised that tomorrow he would be happier

Group of guys drinking and hanging in street - Tree Crew?

More relaxed on Valencia, away from Mission Street

Picked up the car

Phoned my friend

There is a little semi-public garden here

Lots of stuff going on

Starts to get gritty

Busy corner

Nice looking magazine shop but seems to be closing down

Wooden church, so different to the rest of the Mission

Lingering suspiciously

Thought about having to tell my wife that I took part in this project on my own

Really relaxed

Pretty unremarkable stretch

Noisy environment, cars, vendors, music from shops

Gutted restaurant, bike shops this is a more active area

Beer truck was unloading and a keg dropped onto the ground like an explosion

Went to a corner store

Foxy Lady Boutique

Cultural explosion for me, exotic place

Bought ice cream from lady with trolley

We were talking about how upset I was about the Jones-town massacre I saw on TV

Got hot and took my jacket off

Went into the bank. The teller did not ask about the equipment

Walked past my old pre-school

Latin-American restaurants! I love the smells. I wanna have pupusas

I pulled some posters off the wall

In the car trying to hold all the stuff

People in the street

Saw the revolution pickup truck with loudspeaker

Talked with Jesus Christ of latter day saints missionaries

Buddhist temple

Little boy playing soccer on si

I walked into our backyard and started to water the garden. Some of my relatives started to prepare an art kit and I tried to explain the project to them

Lovely wooden buildings

Lots of activity here with lots of people

Not very comfortable on Mission Street, I have all my enemies here

Lot of people and great smells

A bit boring here

Little girl in jewelry store

Reading store names

Took photo of my old hous

Smelled really strong pee but only a second later smelled beef, mmm good

Saw seniors from my school

Coffee spike at Philz

Crossing the street- Woah!

Jaywalking

Had garlic fries - exciting!

Running a little and Bart stop

Walking by Philz - best coffee

Do I know you? You seem familiar...

Stopped and looked at church

Evangelist

Smiled at two guys playing guitar

I saw Josh on the corner

Had to put money in the parking meter

Walking by Philz - best coffee

Saw an old highschool friend who droppe

Crossing against a red light

Saw a girl

Many people

Got excited watching skateboarders

Went into shop to get a drink

Mentioned to friend that I use

Jaywalking

Ran into Hector

Put money into meter

Have to watch the intersections when you are on a Xooter

Saw Olivia with fries and started chasing her

Looking at attractive people noticing smells

Got harassed by teenagers

Saw MacDonald's

Saw cyclist almost get hit

Got a chocolate covered, cream filled donut

Looking at the public library

Got coffee at Muddy's

I was dodging bunch of cyclists by the library

Skateboarders

I was waiting for friend outside of McDonald's Demonstration posters and people giving out leaflets

Guy bending down combing hair in alley

Had to move cars

Guy selling palms

El Pollo, exciting new chicken take out with a band playing outside

Went into Muddy Waters and had a coffee cake

We split up now I am on my own

Alley with fragrant people popping out

Reminising, this used to be my neighbourhood. Feels good to get out with my baby

Horrible place

Saw Catholic bookstore

Police car stopped right by me

Looked at the possible future SoEx space and then turned round

Hid the GPS. Didn't want to draw attention to myself

Dirty people were walking by and I was trying to dodge them

I was eating and saw 4 guys trying to break into a car

Feeling sad about return to SoEx

Los abuelitos borrachos

Really nice, cool garage sale

Felt worried that I was going to be monitored and give things away

Stopped to get a drink

I want food and something to drink

A dog scared me

Got scared by motorbike

Felt hungry while waiting for my friend

Paying the meter

Pregnant Ledia goes to Taqueria

I was thinking about how carrying the equipment would make me feel different. Has anyone been mugged doing this?

I got startled by pigeons

Drum 'n' bass music coming from a store stereo

Ran across the street

Bumped into a woman

Car was parked here

Lots of traffic

Watching a hawk fly

Saw and heard two police cars

Tried to stomp on pigeons

Josh tried to kick pigeons

Great photo of poor guy trying to load fridge

Sat down at Mission Pie and ate pear and raspberry pie

Met another participant

Put a sticker on a light bulb

Start point

Southern Exposure

Street crossing

Walking by my house

Big truck coming I didn't notice it

Met Diana

I was talking about my current boyfriend

Heard loud police sirens

Had a shot of whiskey at the bar here

Corner

Car

Felt hampered by tech couldn't be social and interact with people

Starting place

Looked in the window of Mission Pie

Oddly manicured block for this neighbourhood

Found box of cloths?

Who has the right of way?

Plants and trees

Really cool porch with bike rims, ceramic pipes and bike parts. I got really excited

Girlfriend was messing with me

I almost got hit by car when I crossed over a red light!

Nice neighbourhood

Creepy backalley

Someone who had earlier seen me at the gallery jumped out and yelled at me

Overheard a gaggle of girls talking about Receiver Gallery moving to this location

Got a phone call but my phone is not loud enough to hear properly

Parked here

Taking photos of place where kids wrote: Fremont kicks A$$

Felt really nervous at the beginning because of the weird thing stuck on my finger

We used to live here

Panhandling

I saw somebody I knew and felt bad for not waving or talking to them

Noticed Michael's State of Mind sticker on the wall

Didn't want to see people with the gear

First strapped the device on

Went through small alley

Early on – I thought I wanted to go up hill

Met a girl but can't remember her name

Friend was talking to me

Used to play poker in a house round here

Took pictures of murals through gates

Somebody yelled and startled me but it didn't seem to show up

Not many people. There wasn't a lot going on here apart from traffic

Maybe people thought I was a patient from St Luke's

Went and talked to this little girl with black dog that had escaped

Little alley

Ice cream lady

area

Very quiet road. The murals change all the time so I was curious to see what was there

The Wig Factory - crazy fancy wigs. Wonder what I would look like?

Ran into my friend here

Friend was kicking me

If my laptop goes down I will go down with it!

Saw Alex and almost got hit by car

Watched a prostitute getting out of a Chinese man's car

Someone called me a honky

Cafe a friend used to own

Person delivering mail over the weekend, they didn't look happy

I had a cigarette here

Fairly industrial and not very intriguing

Beautiful mural by Andrew Schoultz

Talked on the phone about where we are going to meet for dinner

Made a decision to take a shortcut

Watching shops and traffic

Good looking young lady

Saw Jen and took two photos of her

19TH ST

Strange sounds coming from basement

Received a phonecall

in' in street

I steered clear of the pitbull

Done with this street

20TH ST

onto

We were talking about figuring out fertility stuff. It is crazy to have 2 kids!

of the it

Anticipating seeing prostitutes on Capp

Looking at classic cars

Lots of traffic and crowded sidewalk

the bottle

Scary looking transvestite

Sat in the park eating and looking at flowers. What an oasis!

House that looked like Florida. No artifacts of human existence

Crossing

closed used to go ething

Checking out all the shops and the food - cute dresses

We were laughing about how this used to be a KFC and is now a swanky restaurant

Friend used to live round here

Found an odd teal coloured Volkswagen - the house was painted the same colour!

21TH ST

Really nice neighborhoods around here

I love Shotwell with all those trees

Trying to take off my jacket - it took me a while

People asking for change

Place where my ex-boyfriend used to live

VALENCIA

MISSION ST

CHRISTIAN NOLD

San Francisco Emotion Map, 2007 (detail)

Internet-based mapping project

In creating "emotion maps" for cities in the United States and England, British artist Nold recruits volunteers to stroll through familiar places wearing a biomapping mechanism he devised that measures galvanic skin response—levels of emotional arousal—related to location. Participants add personal annotations, marked on the map with red dots, for places that elicited particularly strong responses. Nold's map is an emotional portrait of a neighborhood, demonstrating how new tools can allow people to share and interpret their own biodata.

BRYAN MAYCOCK

▶ *Suther Street and Montague Road*

From *Genealogy Series No. 2: Eight Footstools,* 1997
Acrylic on padded canvas, wood frame
Each 26.5 x 18.5 x 7 in.

For twenty years, Maycock pored over census data and vital records going back to 1828 to piece together the stories of his ancestors living in and around London. Placing relatives' homes on maps helped Maycock imagine the courses of their daily lives, and maps then became the common element for a culminating series of drawings, paintings, and objects. A grouping of three corsets is painted with the streets where Anne Cale Maycock, a female head of household, supported her family by working as a staymaker. Likewise, a map carved into a wooden box honors a boxmaker, and a lightbulb is etched with the location of an electrician's home. *Genealogy Series No. 2* consists of eight footstools showing household locations for other members of Maycock's family tree. Buttons mark the location of each residence.

MARY DANIEL HOBSON

▶ ▶ *Territory,* 1997

From the series *Mapping the Body,* 1996–2002
Kodalith and mixed media
Framed 7 x 5 in.

"I am interested in what lies beneath the surface of the skin," Hobson says. "It is not the physical structures that concern me—ligaments, organs, bones. Rather it is the emotions and experiences that are imprinted on our bodies—the places we travel, the music we listen to, the letters we read and write. Our past informs our cells." Cartographic images recur in her collage work, valuable to Hobson "for their beauty and their inaccuracy." We navigate personal journeys with established cultural maps that can mislead; the maps we create, as we explore our lives, are beautiful for their poignancy.

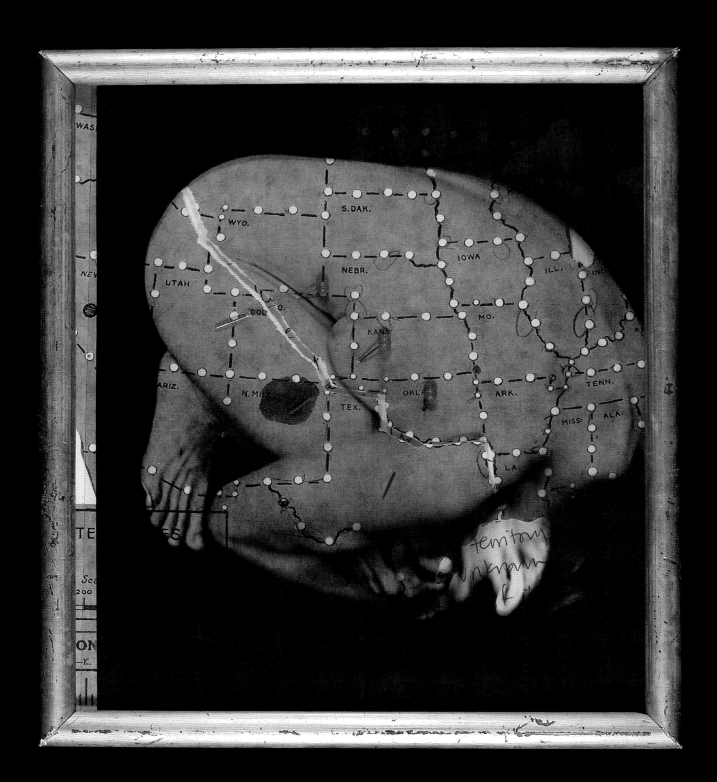

ED RUSCHA

▶ *L.A.S.F. #1,* 2003

From an edition of thirty-five
Color soft-ground etching
Image 30 x 24 in.; sheet 37.5 x 30.5 in.

▶ ▶ *Los Francisco San Angeles,* 2001

Portfolio of seven etchings, from an edition of forty-five
Color soft-ground etching
Each image 4 x 5.5 in.; each sheet 8.25 x 9.5 in.
Courtesy of the artist and Crown Point Press,
San Francisco

In the late 1990s, Ruscha began borrowing
elements from maps to depict the repetition
and flatness of the urban landscape. These
etchings meld two cityscapes into maps that
won't get you far in either place.

You Are Here, Somewhere Maps of Global Positioning

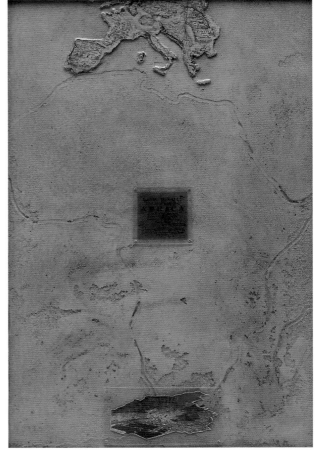

RODNEY PLACE

Three Cities Triptych (Cape Town, Durban, Johannesburg), 2002
(*Durban* not shown)

Mixed media and casting resin
48.5 x 113 in.
Sindika Dokolo African Collection of Contemporary Art

Cape Town and Johannesburg, the most common entry and departure points for southern Africa, appear as twin foundations for the continent and possible personal grounding points for the artist. Place is a multimedia artist who was born in South Africa, studied architecture in London, taught multimedia studies for fifteen years in the United States, and lives part-time in Warsaw. Many white South Africans who left the country during the Apartheid regime have returned in the years after the 1994 elections, and since then the country has been re-created in ways that make maps an apt metaphor for wayfinding in a new political climate.

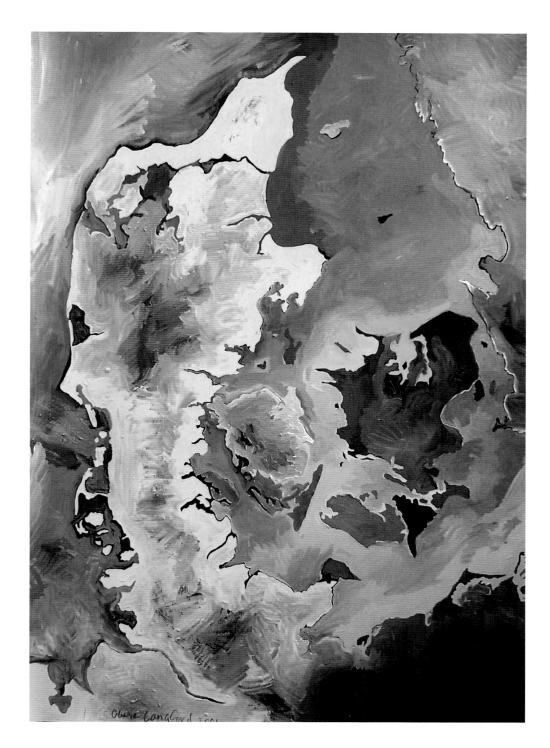

CHASE LANGFORD

◄ *Denmark on Fire,* 2001

Oil on paper, mounted on panel
45 x 32 in.
Collection of Catherine Ormerod Bander

▼ *Red China, Yellow Sea,* 2001

Oil on paper, mounted on panel
38 x 28 in.
Collection of Bettina Weiss

Langford has been enamored of maps for nearly as long as he can remember. By the time he reached his teens, he had amassed a collection of over a thousand maps and atlases, and occupied countless hours drawing them. He studied cartography and subsequently spent twenty-one years creating maps at UCLA. "Imagine the effect of spending much of a lifetime intimately tracing coasts, rivers, highways," Langford says. "Inevitably the visual rhythms of geography largely created my visual sensibility—that is, my sense of what works or does not work visually. I would dare say it has even seeped into my DNA."

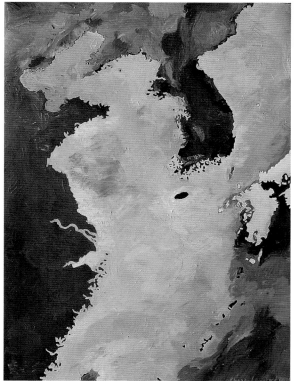

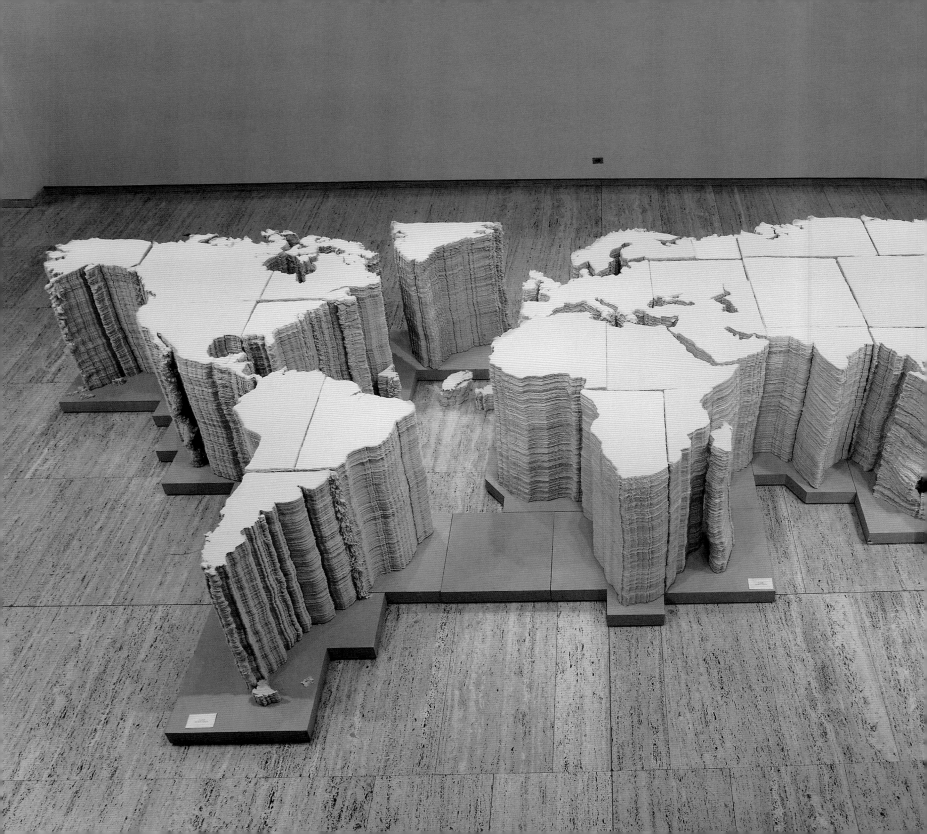

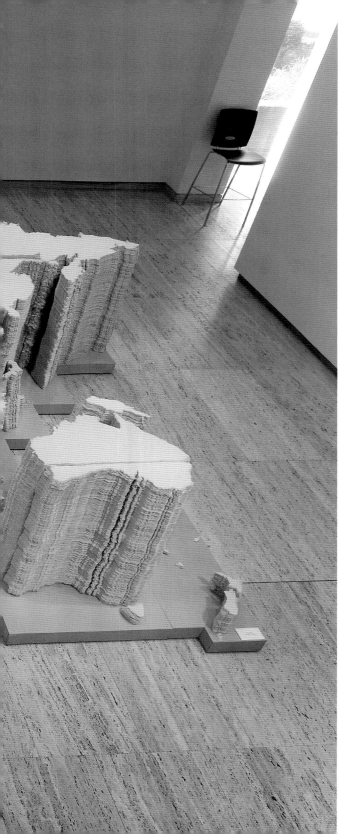

AI WEIWEI

◀ *World Map,* 2006

Cotton and wooden base
39.5 x 315 x 236 in.
Photo by Greg Weight, courtesy
of the Sydney Biennale

▼ *Map of China,* 2004

Tieli wood from dismantled temples
of the Qing Dynasty
20 x 78.75 in.

Ai is a Chinese artist, curator, publisher, and designer who has, during twelve years in New York and in the years since he returned to China in 1993, played a major role in the development of contemporary Chinese art. He uses Chinese materials and traditional crafts to create large installation pieces in which history and modern culture collide. *World Map* (constructed of two thousand layers of cotton cloth, meticulously cut and assembled) reminds viewers that Chinese clothing manufacturers keep much of modern humanity clad.

Map of China is made from centuries-old tieli (or iron) wood—a dense, heavy material—salvaged from Qing Dynasty (1644–1911) temples that were destroyed to make way for new construction. Ai worked with carpenters over many months to craft several of these weighty sculptural masses. Swirls in the grain of the joined wood blocks hint at turbulence, yet the placid solidity of *Map of China* suggests that the country's long history has absorbed much tumult with impunity, and will continue to do so.

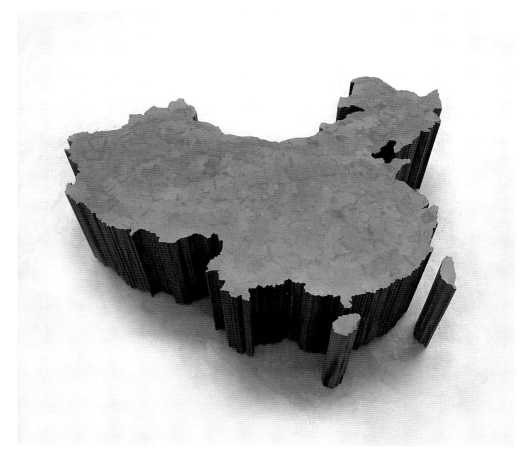

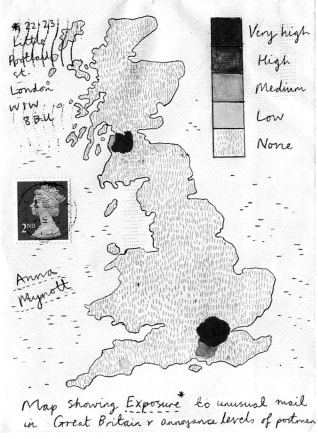

HARRIET RUSSELL

◀ ▲ *Envelope sent to 17 Montague Street, Glasgow,* 1999

Pencil and red pen
5.75 x 4 in.

◀ *Envelope sent to 175 Sussex Gardens, London,* 2002

Pen and collage
6.25 x 4.5 in.

▲ *Envelope sent to Exposure Gallery, London,* 2006

Pen and paint
4.5 x 6.25 in.

Russell is a British illustrator who has sent herself more than a hundred envelopes, artistically addressed, for the fun of seeing if they would make their way back to her mailbox. In the preface to a published collection of her mail art, she wrote, "I am sure that the patience of many postmen has been severely tested."

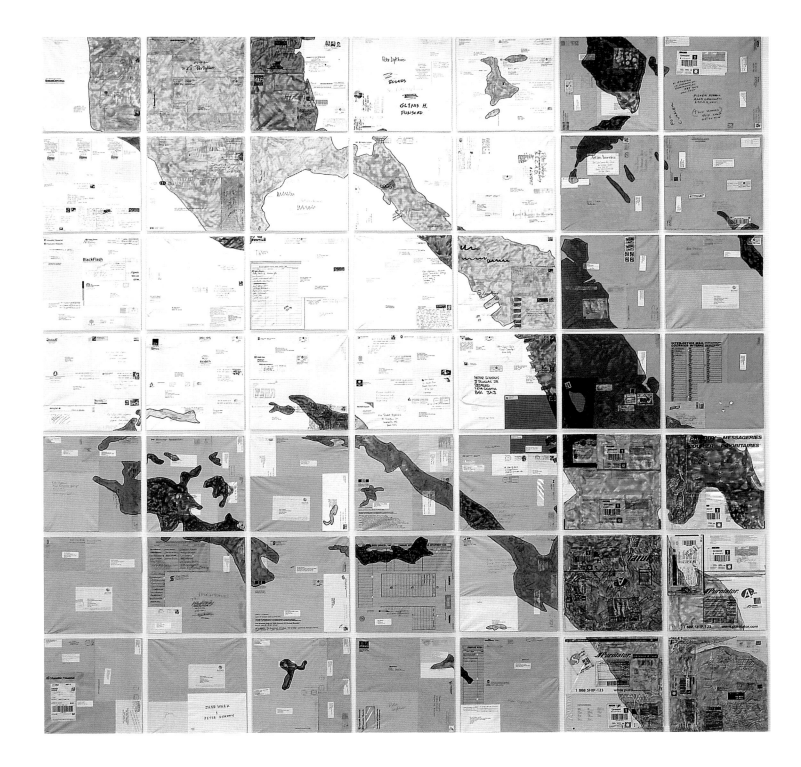

Preceding page

PETER DYKHUIS

You Are Here, 2005

Encaustic on collaged used envelopes, on forty-nine panels
Each panel 16 x 16 in.

You Are Here, a map of Halifax Harbor, was installed at a pier in Halifax where cruise ship passengers disembark each summer. Dykhuis painted the map on a collaged field of envelopes from mail he received at home and work, resulting in a cityscape that, in his words, "passively maps my life."

JOHN BALDESSARI

▲ *Calif. Map Project Part I: California,* 1969

Color photographs and text
Each 8 x 10 in.

◄ *Calif. Map Project Part II: State Capitol,* 1969

Color photograph
8 x 10 in.

Baldessari, a native Californian, has infused a rich artistic career with often humorous and ironic send-ups of widely held assumptions about what art is, how it is made, and how it should be interpreted. Here he turns his gaze to the map: its supposedly "real" representations of geographic features, and what is or is not included. Baldessari pinpointed, as closely as possible, the physical locations of printed letters spread across a map of California and—in their tangible absence—created the letters in situ with materials at hand. In a separate piece, Sacramento, the state capital, received its star.

SIMON ELVINS

Silent London, 2005 (with detail)

From an edition of ten
Blind-embossed etching on paper
29 x 19.5 in.

To adhere to European Union environmental noise regulations, a British government agency maps noise levels throughout urban and industrial areas in England and studies their effect on the public. The maps also support efforts to preserve low noise levels where they exist. Elvins took the data on noise intensities in London, identified the most silent areas, and rendered them as raised dots on a braille-like map of the city.

In 2006, the artist made an innovative *FM Radio Map*, showing the locations of commercial and pirate radio transmissions in London. When a viewer touches the station symbols with a metal pin or just a finger, an electrical current connects to an off-the-shelf radio kit, enabling participants to listen to real-time broadcasts from each station. With both of these sound-related maps, Elvins reveals auditory features of London that are generally overlooked.

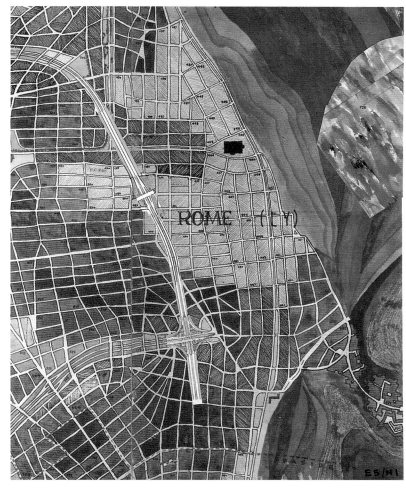

JERRY GRETZINGER

Sample panels from *The Gretzinger Map,* 1963–present (ongoing)

Ink, pencil, acrylic, marker, collage, gouache, and watercolor on paper and board
9.75 x 8 in.

The Gretzinger Map is an ongoing project describing an imaginary landscape. In its entirety
(as of June 2008), the work includes nineteen hundred contiguous panels covering an area
measuring thirty-five by thirty-six feet. The map's current population is about fifteen million
and, in "MapTime," the year is 780. "It started as an idle doodle," Gretzinger says. "I had a
boring job in a ball bearing factory in Ann Arbor and started drawing a map on a sheet of
typing paper. When I got to the edge of the page, I added another and let the map continue."
The map incorporates towns and cities with museums, government buildings, churches, parks,
railroad stations, and airports. Gretzinger is a clothing designer and manufacturer in Cold
Spring, New York. On occasion he sells color copies of *Map* panels online.

DANNIELLE TEGEDER

BaskraPataci (India-Iran): Tri-Level Schematic with Long Escape Routes; Safety Chrysalis into Yellow Lower Level Station, and Upper Level Tower with Tri-station Containing Hollow Safety Igloo and Winter Line Trees, Upper Mandala and Triangle Forest with Oval Garden, Electric and Water Tower with Nuclear Route Ellipse; Schematic and Yellow Excavation Safety Areas; and Miniature Oz City and Grio Planet with Secret Square Gardens and Circle Floating Shelters, 2004

Ink, dye, pencil, design marker, and acrylic gouache on Fabriano Murillo paper
56 x 80 in.
Courtesy of Priska C. Juschka Fine Art, New York

Bamoshan (China-Mali): Cream Desert Drawing with Center Production and Suspended Circle Habitats with Metallic Transportation Center and Yellow Human Tunnels with Central Food Storage and Triangle Convent, and Left Safety Dome, and Three Stations with Color Coding Station. Ellipse Information Routes, and 12 Connectors to City Electricity, 2004

Ink, dye, pencil, design marker, and acrylic gouache on Fabriano Murillo paper
56 x 80 in.
Courtesy of Priska C. Juschka Fine Art, New York

Tegeder's titles are as artful as her artworks. Both their words and her blueprints detail interconnected components of multilevel, sometimes subterranean, cities. Her pieces include habitats, tunnels, and parks for human inhabitants, but because people are absent from them, one imagines that these are planned refuges for emergency situations, perhaps with mechanical beings keeping systems at the ready. An air of superefficiency makes these technological shelters both highly appealing and somewhat scary. Tegeder draws inspiration from historical monuments and architects of diverse styles, including Zaha Hadid, Paolo Soleri, and the later works of Frank Lloyd Wright.

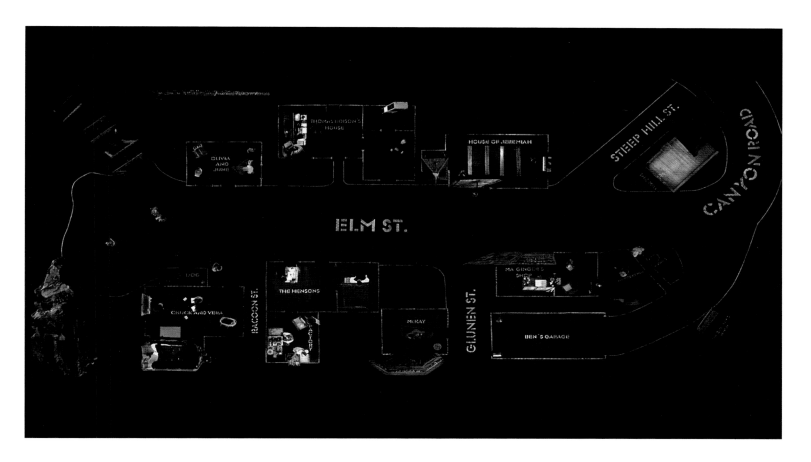

LARS VON TRIER

Dogville, 2003

Photograph of film set

Danish director and independent filmmaker von Trier is a cofounder of Dogme 95, a movement emphasizing commitment to purity, honesty, and simplicity in filmmaking, resulting in films that focus on narrative and acting over the bells and whistles of special effects and props. *Dogville,* starring Nicole Kidman, features a minimalist, theatrical set laid out as a map of "a quiet little town not far from here." Though it doesn't adhere to Dogme 95 principles, the bare-bones setting draws attention to the story and the actors' performances.

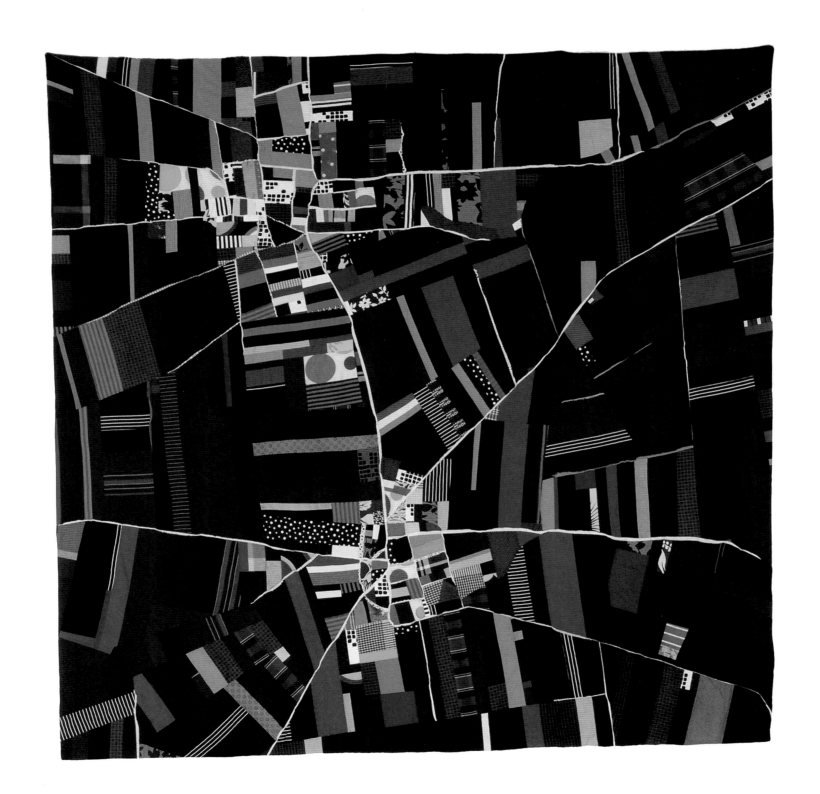

IAN HUNDLEY

◄ *Bierbergen Oedelum Black,* 2006

Cotton, wool, silk, and linen
80 x 80 in.

Hundley is a native Canadian whose British father taught him to sew at a young age. This is not unusual in England, where tailors are more commonly men. Hundley earned a degree in graphic design, worked as a model in the New York fashion world, and assisted artists there before hitting on the idea of combining his experiences to make textile-based graphic creations of his own. Inspired by aerial photography and topographic maps, he began stitching together scraps of his own and friends' old clothing into large-scale "painted" abstractions. His quilts are canvases with bold interpretations of maps that could, in fact, help the viewer find their bearings in the depicted locations.

PAULA SCHER

▶ *Israel,* 2007

Acrylic on canvas
92 x 65 in.

In her fiftieth year Scher, a partner in the prestigious New York design firm Pentagram, began making giant geographic paintings as a way to deal with an overload of information—from clients, the news, even her construction contractors. Somehow, it helped that in this sphere of her life, she was in control of the endless flow of data. Scher says of life in contemporary America, "You know everything, you know nothing."

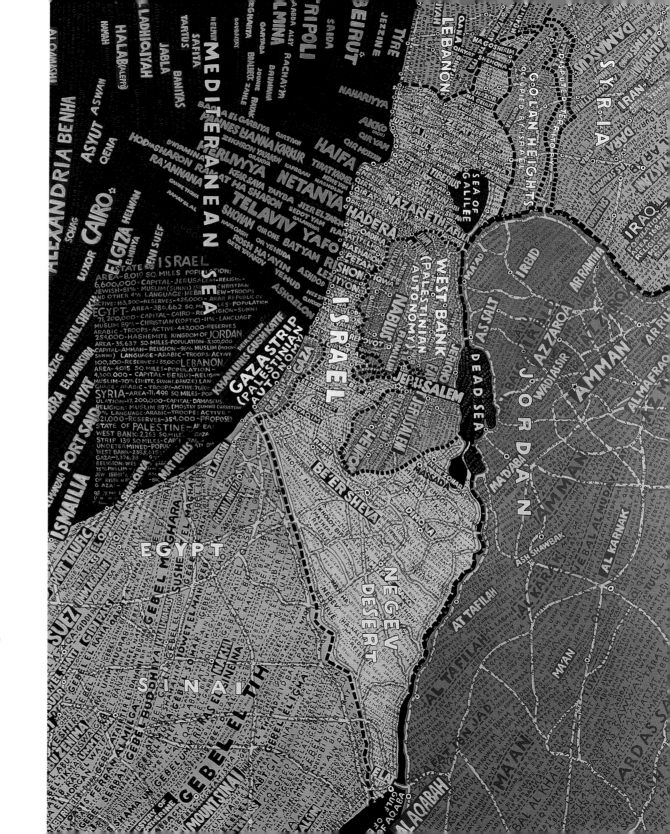

MARK R. SMITH

Undermining Paths (Green), 1991

Acrylic and graphite on inlaid linoleum panel
48 x 32 in.
Photo by John Maggiotto

Undermining Paths (Red), 1991

Acrylic and graphite on inlaid linoleum panel
48 x 32 in.
Photo by John Maggiotto

Smith addresses the conflict between human industry and the processes of nature, which, when viewed from afar, appear as an organic whole. In the green painting, lines incised into linoleum represent India's railway system, a vestige of England's colonial presence. The red painting maps roads alongside rivers that drain into the Amazon basin, evidence of deforestation. Amorphous shapes hovering over the maps came from transferring thick smears of paint from acetate sheets onto the painting surface. "In its creeping, fungus-like appearance," Smith says, "I was trying to mimic the incrementally accruing processes that result from webs of human activity."

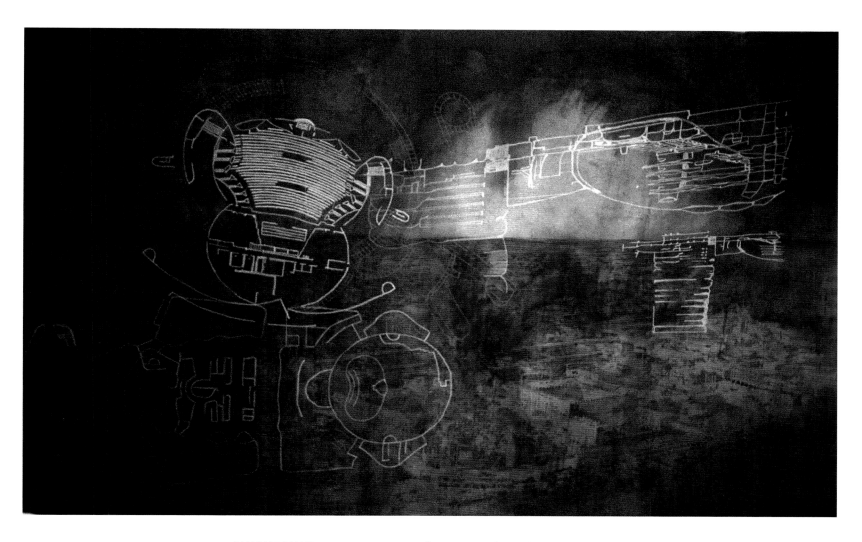

EAMON O'KANE

City XII (Stockholm), 1998

From *City Series*
Acrylic and mixed media on canvas
96 x 192 in.

Irish artist O'Kane drew with charcoal on raw canvas and then applied layers of translucent paint to produce a "Grand Tour" of European cityscapes. Each depicts a view of a city as seen from above (in this case, Stockholm). He has also created an intriguing work called *Regeneration,* a stop-motion animation of a dozen paintings based on aerial views of Blanchardstown, outside Dublin. The paintings track a period of ten years when the area changed from farmers' green fields bisected by hedgerows to the whites, tans, and grays of urban development, including one of the largest shopping centers in Ireland.

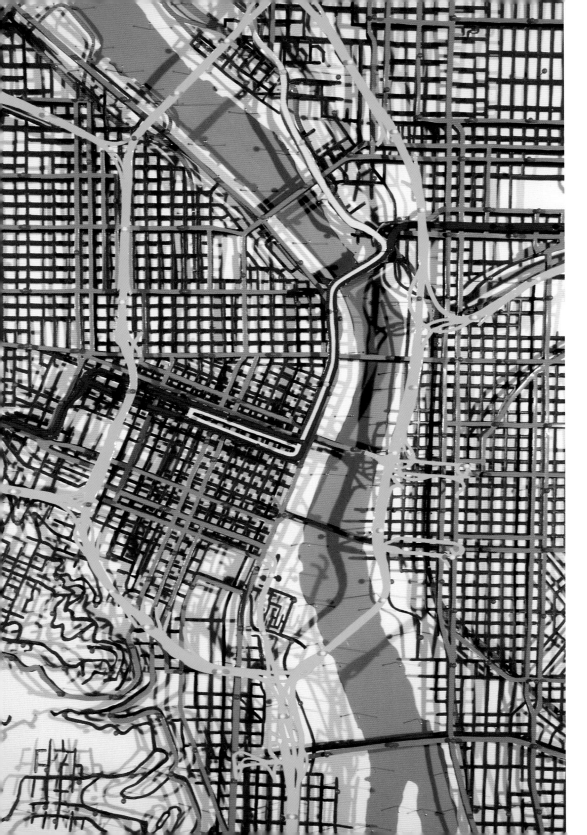

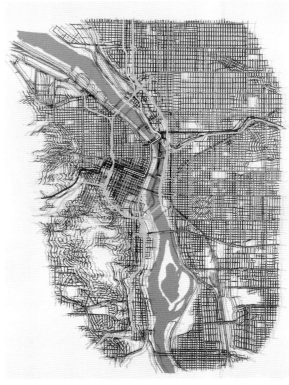

MATTHEW PICTON

Portland, 2007 (with detail)

Dura-Lar and enamel
66 x 50 x 3 in.
Collection of Second Story Interactive Studios, Portland, Oregon

Picton, a British-born artist living in Oregon, is inspired by
the inherent beauty of lines and forms that arise from natural
topography and built environments. His map of urban Portland uses
layering to create a 3-D story of a city's growth through its roadways.
Picton also explores roads at the micro level, tracing the miniature
byways in cracked sidewalks and alleys. Until reading the caption for
Cut Out Drawing, the viewer assumes that the mapping ratio is much
greater than one-to-one.

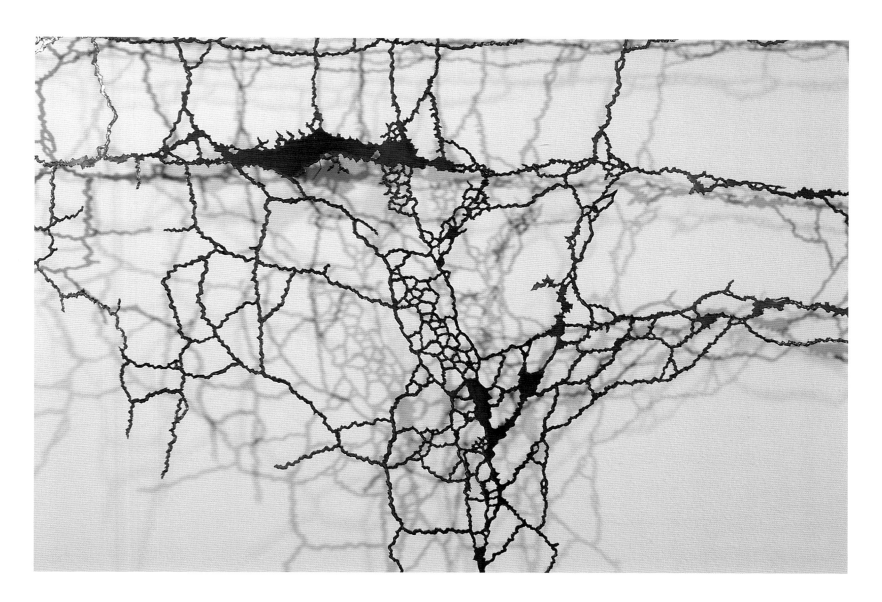

MATTHEW PICTON

Cut Out Drawing, Alley Way #2, Medford, OR, 2006

Dura-Lar and enamel
48 x 69 in.
Courtesy of Pulliam Deffenbaugh Gallery, Portland, Oregon

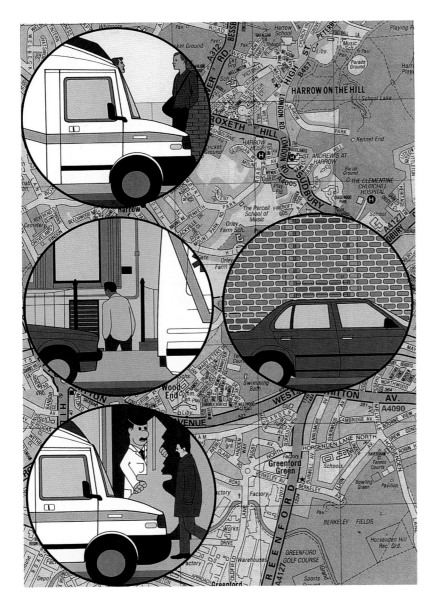

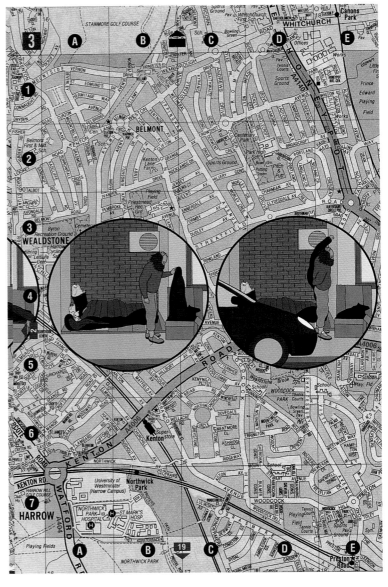

LARS ARRHENIUS

A–Z, 2002

From a series of ninety-six prints
Laminated C-prints
Overall installation: 165.75 x 98.5 in., each print 10 x 15.75 in.
Courtesy of Kinz, Tillou + Feigen, New York

Swedish artist Arrhenius tells tales of urbanites oblivious to their interconnectedness; the map is the unifier of countless individual story lines. In *A–Z*, narratives invade the pages of the classic London street guide of the same name. Lives circle around each other, but each reality is unique. Millions of existences keep the city humming despite their mundane anonymity. There is irony in the work's suggestion of a *Choose Your Own Adventure* format. As a gallery press release states, "Arrhenius draws attention to the fact that the world goes on, whether we participate in it or not."

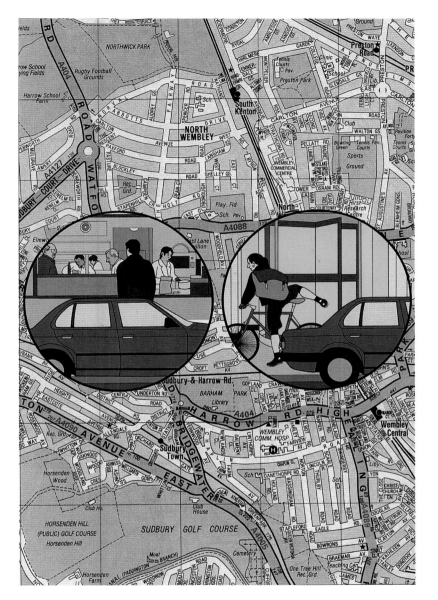
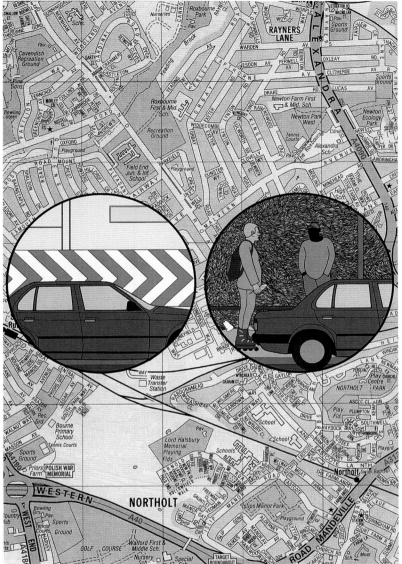

JOSH DORMAN

▲ *Tiny Lives: Beantown,* 2006 (with detail)

Ink and antique maps on panel
16 x 12 in.
Courtesy of the artist and Mary Ryan Gallery, New York

▶ *Four Fleurs,* 2008

38 x 42 in.
Ink, acrylic, and antique maps on panel
Courtesy of the artist and Mary Ryan Gallery, New York

"I am not exactly a landscape painter," Dorman says in his artistic statement. "My goal is not to depict the way light plays on treetops, but I do want to get inside to see the rings of the tree, explore the structure of roots and branches, understand the bark. I've been using maps to find my way." For Dorman, old sepia-colored maps are templates for investigating color and pattern; systems like biology, engineering, and aeronautics; and natural features of landscapes. "As if I am walking through nature with a magnifying glass and a telescope," he says, "I find cells, mushrooms, thunderheads, pebbles, cliffs, continents."

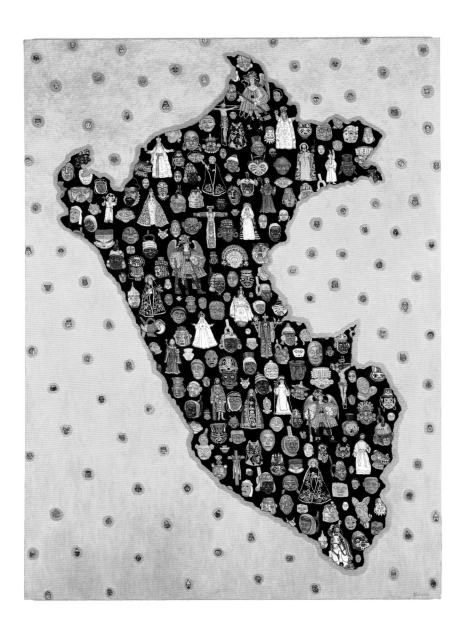

CHRISTA DICHGANS

◄ *Peru,* 2004

Oil on canvas
55 x 39 in.
Courtesy of Contemporary Fine Arts, Berlin
Photo by Jochen Littkemann

► *Europa,* 2005

Oil and collage on canvas
59 x 76.75 in.
Courtesy of Contemporary Fine Arts, Berlin
Photo by Jochen Littkemann

Dichgans, a German artist, crowded as many faces as possible into a group of paintings of various countries and continents. *Europa* is collaged with historical portraits, *Peru* is covered with painted spiritual icons, and *The Black Continent* features a plethora of African masks. India and the United States are unpeopled: *Indien* features bronze sculptures of traditional Indian art, and *Amerika* is covered in dollar bills.

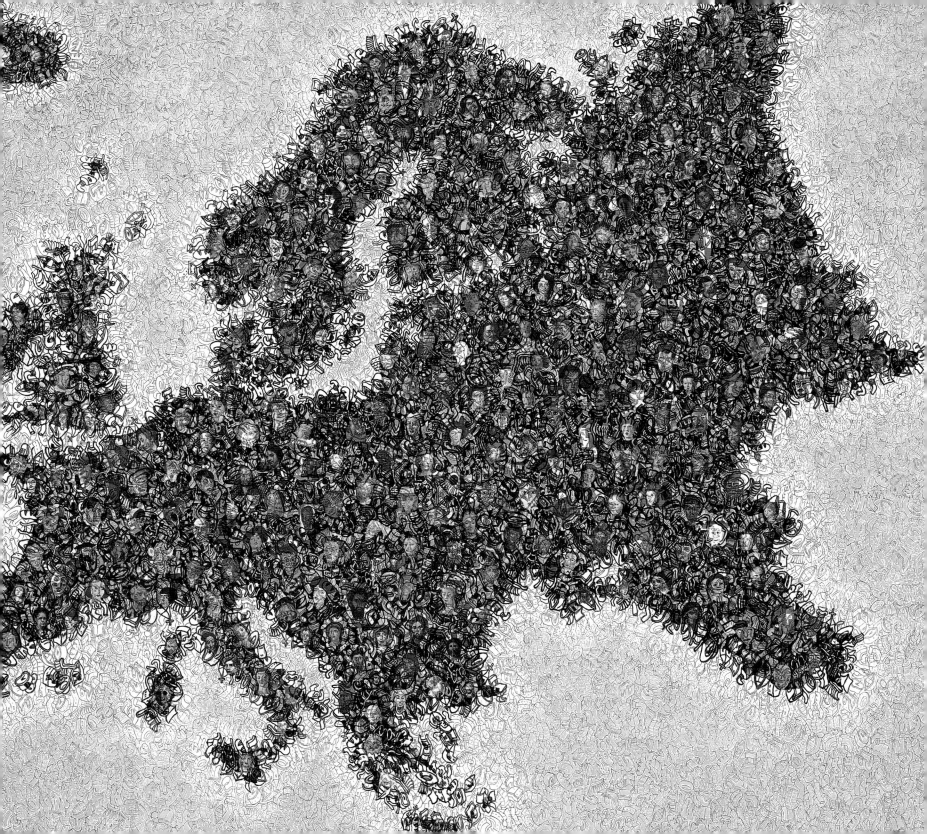

BRYONY GRAHAM

Rockaway Felix, You Are Here: Felixstowe, 2006

Temporary installation
Thirty thousand sticks of candy rock, fifteen
thousand seaside visitors
Photos by the artist

As part of an art festival in Felixstowe, on the southeast coast of England, Graham placed a giant "You Are Here" dot made up of thirty thousand sticks of "seaside rock" candy on a small shingle beach. Passersby were encouraged to help themselves to the peppermint-flavored sticks, which according to Graham drew attention to "the cultural quirkiness of seaside souvenirs." As people wandered away with pieces of rock in their pockets, the project became a literal realization of the philosophical aphorism, "Wherever you go, there you are."

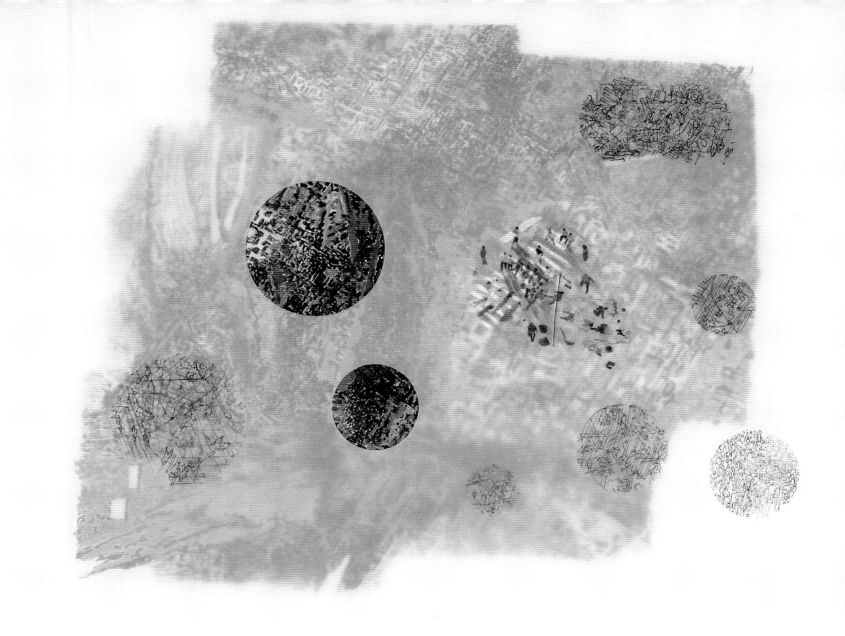

SIMONETTA MORO

Imaginary Map: Eyes on the City, 2007

Gouache, ink, pastel, and graphite on Mylar
24 x 36 in.
Collection of Confartigianato del Veneto Orientale, Portogruaro, Italy
Photo by Cibele Newman

Moro is an Italian artist born in Venice, a city of wanderers. She sees parallels between Venice and Manhattan, islands surrounded by water that are "like giant rafts ready to sail in the open sea." *Imaginary Map: Eyes on the City* depicts street scenes from the vantage point of the tenth floor of an office building in downtown Manhattan. Pedestrians intentionally appear distorted as they radiate into the streets, tangles of marks brought into focus by the oculus shapes. Moro says, "I see the city's neighborhoods as small islands, each with its own identity, loosely connected by the energy that emanates from its inhabitants."

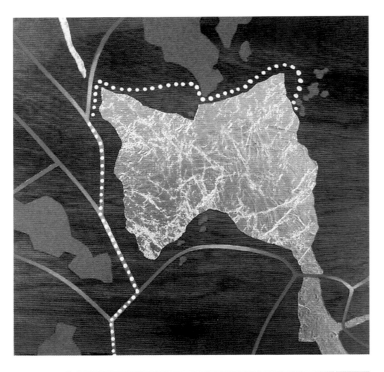

LEILA DAW

◀ *L to R*

Lake Trail

Jetty

Highway Topography

Lycian City

From the series *Map Icons,* 2006
Mixed media on panel
Each 8.5 x 8.5 in.
Courtesy of Atrium Gallery, St. Louis

The compass roses in these paintings are left intentionally blank, not just for aesthetic purposes but also to remind the viewer that maps are always subjective representations of the world. Daw asks, "How can we know where we are in the world, when what we're looking for determines what we see?"

JULIAN SCHNABEL

▶ *South Coast Prickly Point,* 2007

From the series *Navigation Drawings*
Oil on map mounted on linen
51 x 39 in.
Private collection
Courtesy of Sperone Westwater, New York

Schnabel's recent series of energetic assaults on maps is consistent with an artistic practice of showing how images and objects can be stripped of purpose through abstract manipulation. The artist's bold oil strokes obliterate maps' confident authority. These charts are, as they say, "Not to be used for navigation."

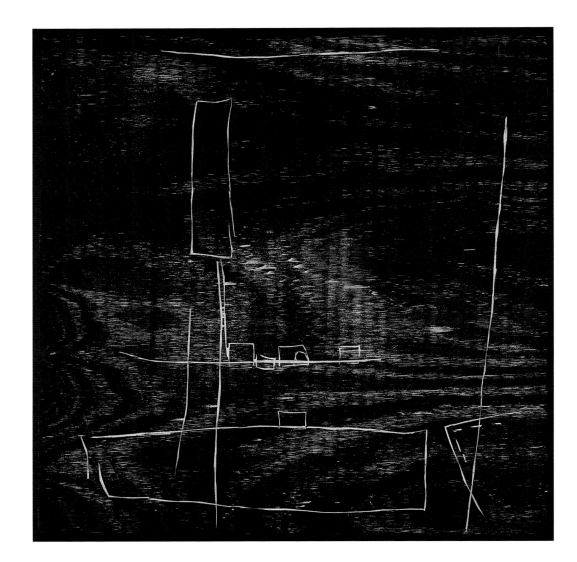

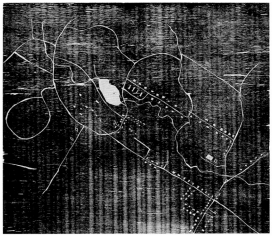

HIROKAZU KOSAKA

Selected prints from *Mappa Mundi,*
a 2007–8 residency at Seattle Art Museum

From the series *Mappa Mundi*
Woodblock prints on mulberry paper
Each 39 x 26 in.
Courtesy of Seattle Art Museum

Kosaka is a Los Angeles–based visual artist and designer of cross-cultural performance pieces. He also happens to be a Buddhist priest and master of Zen archery. He considers his art projects to be an active part of his "ministry," and throughout his career Kosaka has collaborated with and supported the efforts of many other artists. In recent years he has undertaken a series of collaborative mapping projects in various locales, called *Ruin Maps*. Kosaka invites participants—often Japanese American elders who were forcibly removed from their neighborhoods and interned during World War Two—to draw memory maps of prior communities. He enlarges

selected drawings, makes a woodcut print of each on mulberry paper, and displays them as a collection of shared and personal memories. For a Seattle Art Museum residency, Kosaka broadened the scope of his project, calling it *Mappa Mundi* and inviting participants of all backgrounds to share their memories and reflect on the city's changing neighborhoods. Museum visitors from all over the world—twenty-one countries in five continents—contributed maps. For Kosaka, the woodblock medium makes sense: "Cutting onto a surface of wood is similar, I think, to the way memories were ingrained in these people's minds."

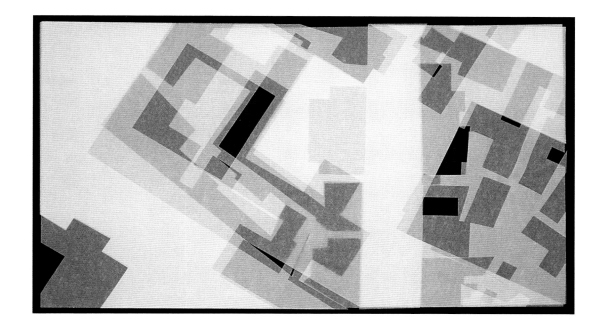

TINA ANDRIC

Urbanograph No. 5: Stuttgart, Kleiner Schlossplatz 1794–1855–1975–2005, 2004

From the series *Urbanographs*
Layered sketch paper
15 x 25.5 in.

Urbanograph No. 4: Stuttgart, Kleiner Schlossplatz 1794–1855–1975–2005, 2004

From the series *Urbanographs*
Layered sketch paper
15 x 25.5 in.

Andric is an artist, architect, and film scenographer in Stuttgart. Her series of *Urbanographs* depicts the structural changes of locations in Stuttgart, Germany, and Salzburg, Austria. Each shows a specific place at multiple periods, going back to medieval times, revealing "an urban palimpsest…of building and destroying, of continuity and change." Andric studied historic city plans and, using a sheet of paper for each, cut away the spaces of buildings standing at each time period. She then carefully layered the lacy cutouts atop a black desk to indicate three pieces of information: gray tones show structural overlaps, black areas indicate where buildings have always stood, and white spaces show where open spaces have persisted. At a glance we see the process of change in the urban landscape.

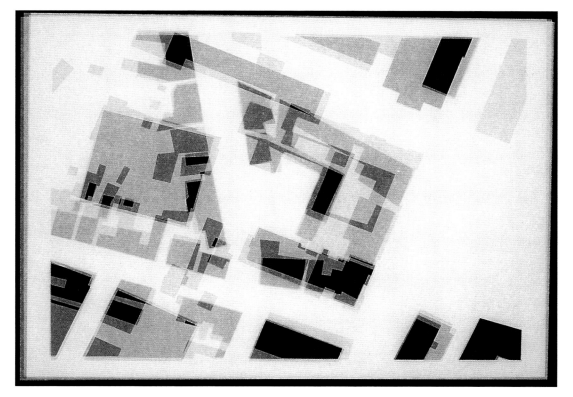

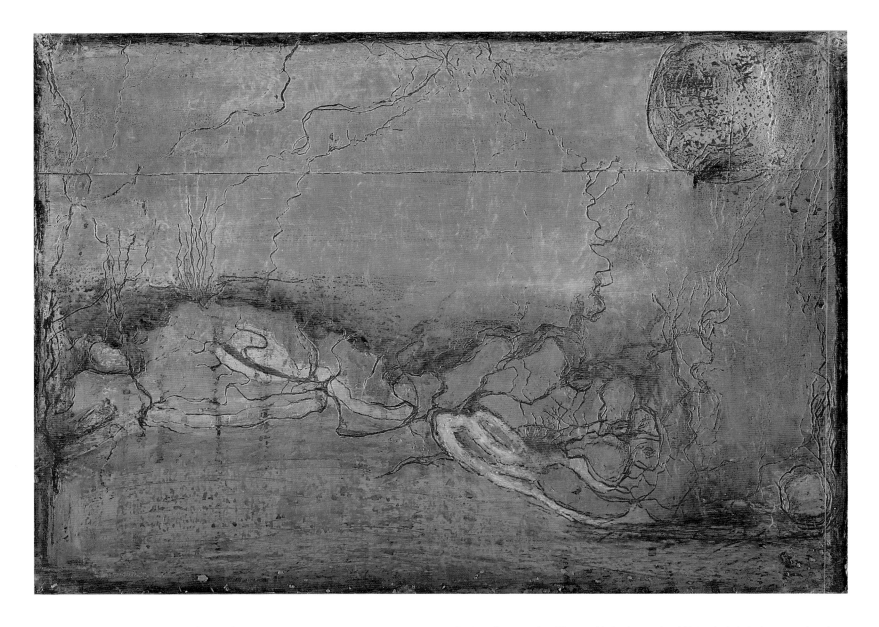

MARY ARMSTRONG

Mapping the Venetian Lagoon, Series 2, #7, 2007

Mixed media on paper
20 x 14 in.
Courtesy of Victoria Munroe Fine Art, Boston
Photo by Dennis Griggs

During a four-month residency at Venice International University in Italy, Armstrong found a book of fifteenth-century Venetian maps, which inspired a series of paintings depicting the natural beauty of the Adriatic coast and the fragility of the Venetian lagoon and its islands. In this piece, arterial lines delineate tributaries and tidal formations. Anatomical references remind viewers that modern life on the 118 Venetian islands is possible because of human interventions that have reshaped the largest wetland on the Mediterranean.

EQUADOR

ADRIANA VAREJÃO

Contingente (Contingent), 1998–2000

From an edition of one hundred
Unframed photograph
11 x 16 in.
Courtesy of the artist and Lehmann Maupin Gallery, New York

Born in Rio de Janeiro, where she lives and works, Varejão is one of Brazil's leading visual artists. Her paintings and sculptural wall hangings combine the decorative (e.g., canvases that simulate tiles) with the shock of the raw (sculpted flesh) to evince the pain and pleasure of her country's colonial history and the artistic process itself. For the photograph *Contingente*, Varejão locates herself on a blood-colored continuum connecting the world's equatorial regions.

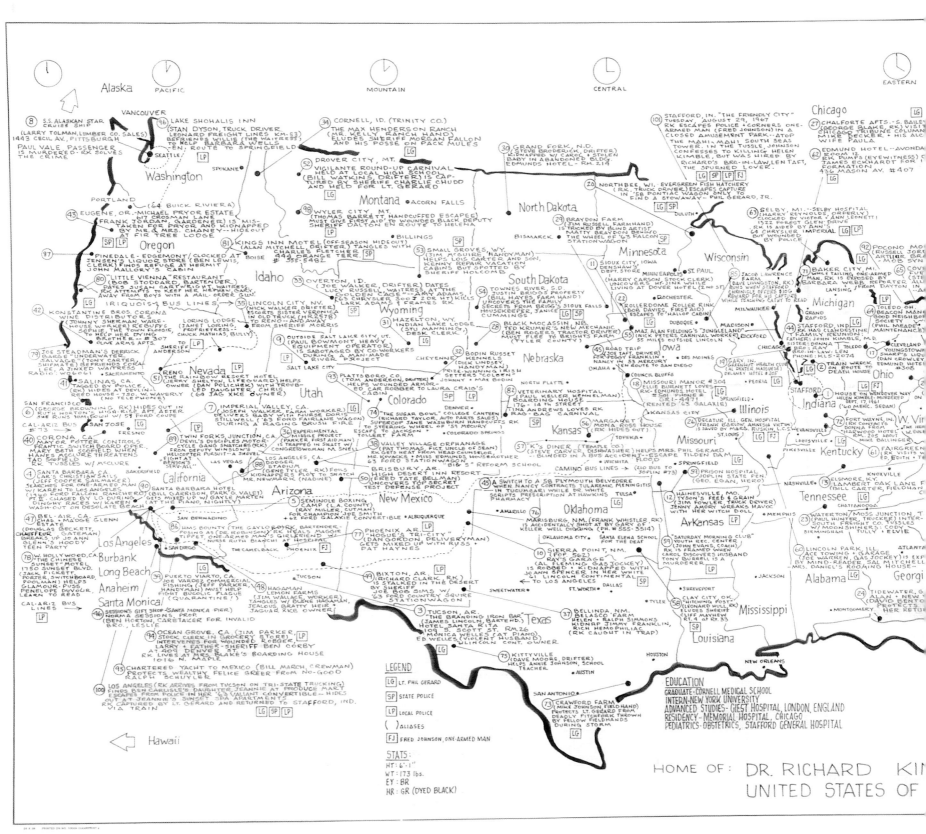

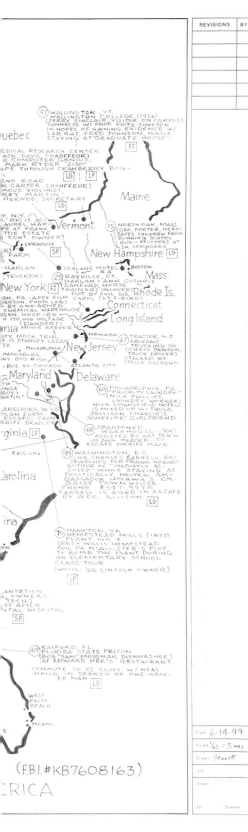

MARK BENNETT

◀ *Home of Richard Kimble (The Fugitive),* 1999

India ink and graphite on vellum
24 x 30 in.
Courtesy of Conner Contemporary Art, Washington, D.C.

Bennett creates blueprint architectural renderings of the homes of classic sitcom and film characters. Occasionally, he widens his scope to produce maps of entire television towns (such as Mayberry) and, in the case of *The Fugitive,* the entire country, so as to track the nail-biting peregrinations of Dr. Richard Kimble, endlessly searching for the one-armed man.

Following page

IBRAHIM MIRANDA

Vidas Disipadas (Metamorfosis), 2006–8

India ink, xylography, silk screen, and varnish on maps
98.5 x 138 in.

Miranda is a Cuban artist whose prints and paintings almost always include maps. He removes pages from atlases and aligns them as panels, onto which he layers imagery. Pictures of his own country appear throughout, most often as an abstract shape woven with other forms throughout the panels. "I try to create an unrecognizable microscopic animal that constantly mutates, a metaphor for sociopolitical and economic changes that Cuba as a country has constantly undergone in its most recent history," he says.

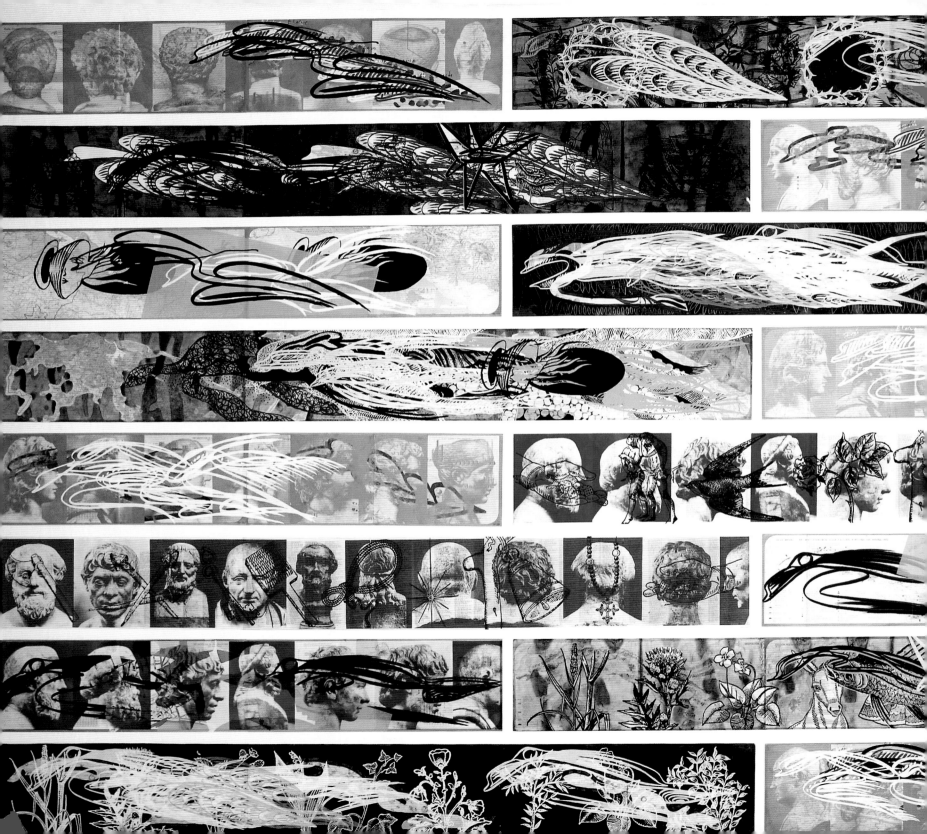

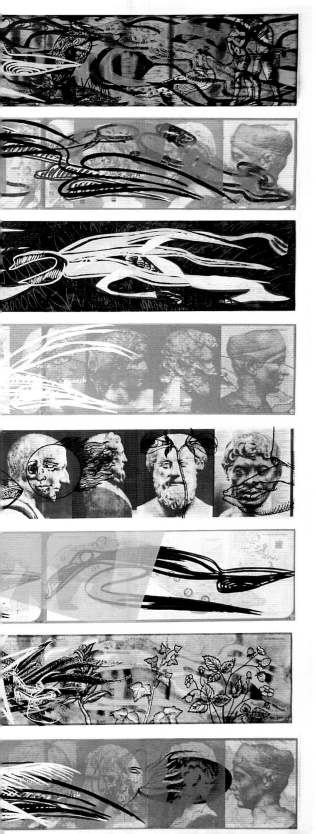

RAFAEL FERRER

▲ *Do This, Do That,* 2005

Gouache on paper
12.5 x 9.25 in.

Ferrer's paintings make plain his strong ties to the Caribbean region and, specifically, to his birthplace, Puerto Rico. He has repeated the shape of the island in many paintings as if to limn its every formal and emotional possibility. While geography is important to Ferrer, his art is also an attempt to disengage the Caribbean islands from what he sees as U.S. neglect and condescension, both economically and culturally. His work is not meant to be a political statement but calls attention to the lack of knowledge the U.S. populace has about the geography of others. (See also p. 205.)

Guillermo Kuitca Maps of Presence and Absence

The relationship between presence and absence is a major theme of Guillermo Kuitca's work. People are visibly absent from his paintings and drawings—or are they invisibly present? While human figures are never represented, the maps, diagrams, and objects in Kuitca's works suggest human activity, as if time has been momentarily suspended until someone arrives to impart meaning to these spaces. Although Kuitca's artworks are often described as desolate or empty, the places and things that they depict—beds, theaters, prisons, hospitals, cities, intersecting roadways—suggest human use and social activity. Kuitca removes the narrative of human presence to offer outlines and abstractions that are static, melancholy, and also, often, beautiful.

In the 1980s Kuitca moved away from an expressive, figural painting style and toward a more conceptual mode of working, creating paintings of architectural, geographic, and public spaces ready for habitation. Kuitca speaks of the changes in style and subject matter as a journey that took his work "from the bed to the apartment plan, the apartment plan to the city, then the city to a country, then the country as part of the world."[1]

At first glance, some of his paintings look like straightforward maps—but there is something amiss in Kuitca's cartography. In *Town of Thorns* (1991), Kuitca presents a lovely grid of white roads on a chocolate brown background. The scale is intimate—the town seems small, or perhaps Kuitca has selected a manageable portion—and we are drawn into an investigation of the quaint place-names: High Street, Cowgate, Princess Street Gardens. But the roads are spiked with thorns, making any imagined journey through the town perilous and dreamily bizarre.

Many of his other paintings and drawings are adorned with symbols of religion, danger, and death: crowns of thorns, the cross, hypodermic needles. The streets on some of his city maps are made up entirely of little painted bones; their straight lines and knobby ends lend themselves perfectly to the layout of streets and nodes of urban activity. It's not as if the roads are leading to doom; the presence of death and danger characterizes the journey itself.

> It is as if each [one of us] were part of a great master plan, one which, with a degree of desperation, I have done what I can to portray.
>
> Guillermo Kuitca (Argentinean, b. 1961)[2]

In the early 1990s, Kuitca began linking his use of the bed as a motif to more expansive investigations of geographic spaces. He painted maps on top of mattresses and exhibited these works as sculptural installations and paintings hung on walls. While maps are diagrammatic abstractions, on a reduced scale, of possible physical interactions with the world, Kuitca's empty beds call out to us with their bodily associations. But using these surfaces as actual beds would render the maps—tools for navigating bodies through space—unusable and invisible.

Kuitca sewed buttons on some of the mattresses to mark the sites of major cities, but located some names incorrectly or repeated them across the map. The repetition or mislocation of city names occurs in several of

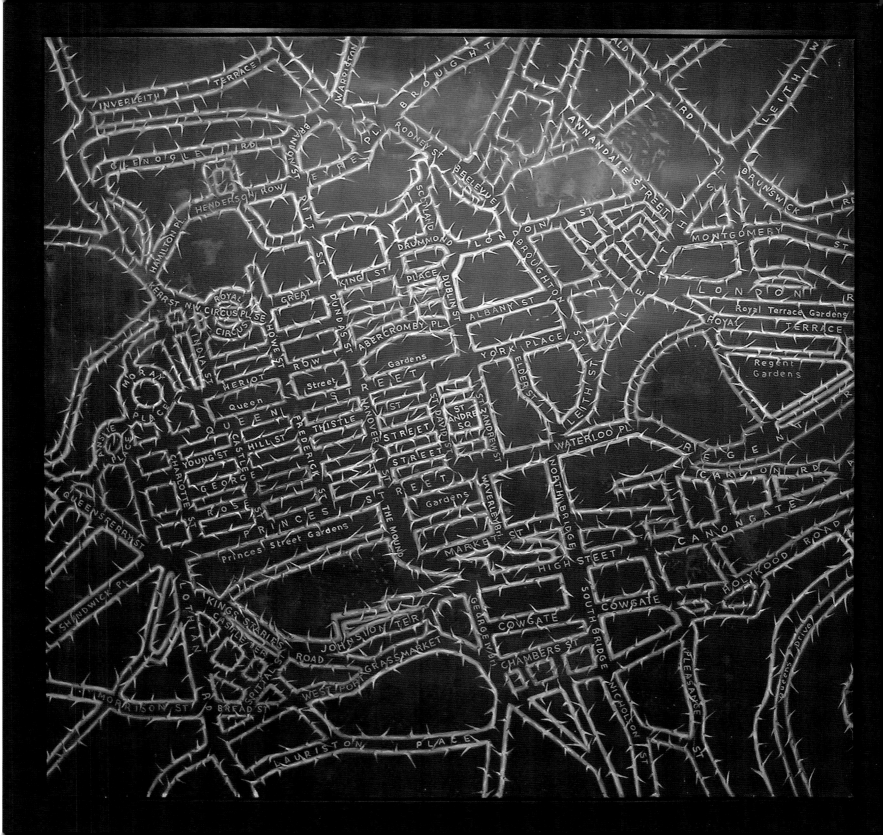

Preceding page

GUILLERMO KUITCA

Town of Thorns, 1991

Oil on canvas
77.75 x 80 in.
Private collection
Courtesy of the artist and Sperone Westwater,
New York

▲ *Untitled,* 1992

Acrylic on mattress with wood and bronze legs
Twenty beds, each 15.75 x 23.5 x 47.25 in.
Collection of Tate Modern, London
Courtesy of the artist and Sperone Westwater,
New York

Kuitca's maplike paintings on canvas as well; this strat-
egy suggests that there is an inevitable sameness to our
movements, or that we're fated to being dislocated
from reality. Or perhaps the arbitrariness calls atten-
tion to arbitrariness itself: Why are certain cities and
streets called what they are? And who had the power
to name them?

Kuitca, an Argentinean, is often asked how his
work has been affected by his youthful experiences
during his country's "dirty war" of 1976–83, a period
marked by the unpredictable actions of political lead-
ers, immigrants, exiles, and "the disappeared," people
who seemed to vanish from daily life. The ruling mili-

tary junta is purported to have kidnapped, tortured, or
killed tens of thousands of civilians, including dissidents
and innocent civilians. It was a time of instability and
uncertain movement, political awareness and fear.
While Kuitca declares that there is no overt political
message in his work, he stated, in 2000, "I have come to
understand that my obsession with being everywhere
and nowhere and trying not to be identified with a
particular point of view is a result of the political crisis
and historical events."[3]

Kuitca's obsession with presence and absence also
affected his domestic and professional choices. After
early success in his homeland, he chose not to show in

Buenos Aires for seventeen years. On the other hand, he remained a resolute resident of the Argentinean capital, refusing to follow the more typical path of relocating to New York or one of the European artistic centers as he became recognized internationally. "I wanted to play with the idea of exile," Kuitca has said. "For many years, I explored how to be present and absent in my own place at the same time."[4]

A sense of dislocation, or a longing to find oneself, runs through several of Kuitca's series of the last two decades. Diagrams and floor plans are common motifs. Kuitca paints plans of cemeteries, hospitals, stadiums, and prisons—spaces that suggest corporeal instability or transience—on monochrome backgrounds, underscoring the sense of displacement and anonymity.

We use floor plans as maps, conceptually orienting ourselves in relationship to real architectural structures and passageways, but plans and blueprints also have a fixed and powerful point of view. Looking at a plan, we are floating above the spaces, surveying all of the structures and passageways at once. Kuitca suggests a shifting relationship of the individual to the whole through the kinds of spaces that he paints: places where individuality is subsumed within institutional, social, or natural forces.

In another series of paintings, Kuitca removes architectural delineations to focus on outlines of furnishings found in places of ambiguous social or bodily activities. Kuitca treats these human-scale structures—corporate workstations, peep show cubicles, gambling tables—as

if they are neutral blueprints of shapes and abstracts them from direct associations with the individual goings-on that occur there.

The relationship of the singular to the accumulated whole is also a stylistic approach. While the overall look and subject matter vary throughout his work, a formal continuity is visible. Kuitca often presents singular shapes or lines that accumulate into a mass. Focus on one line or shape and these seem unique, even delicate; zoom out a bit and roads on a map are merely parts of

GUILLERMO KUITCA

San Juan de la Cruz, 1992

Mixed media on mattress
80 x 80 x 4 in.
Private collection
Courtesy of the artist and Sperone Westwater, New York

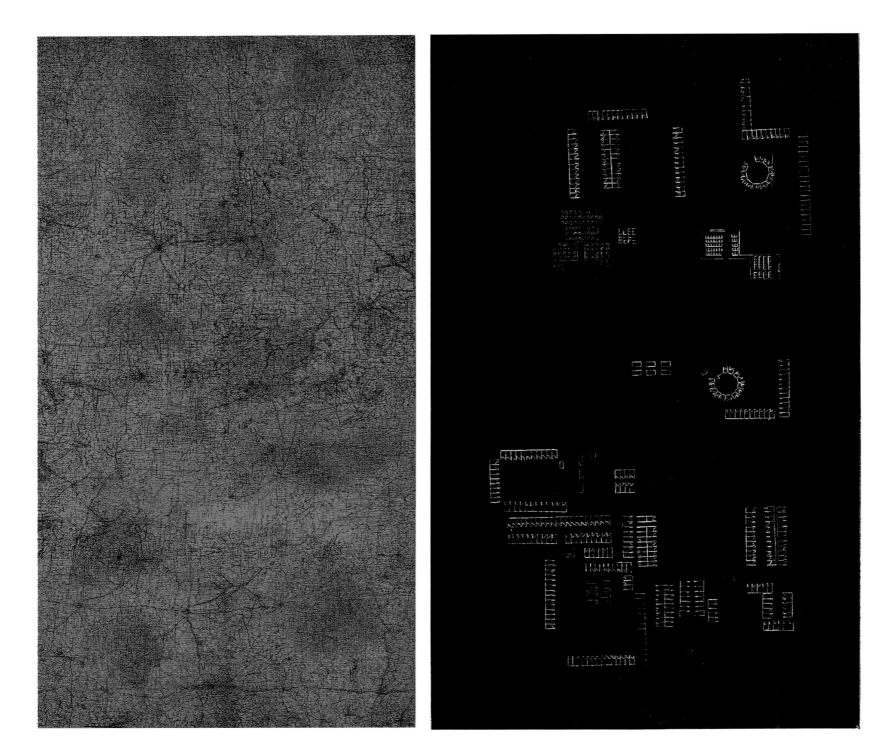

GUILLERMO KUITCA

◄ ◄ *Everything,* 2004

Mixed media on canvas
120 x 65 in.
Collection of Indianapolis Museum of Art
Courtesy of the artist and Sperone Westwater, New York

◄ *Untitled (Peep Show and Video Booths),* 1998

Oil and colored pencil on linen
42 x 25 in.
Courtesy of the artist and Sperone Westwater,
New York

a whole. Kuitca creates a sense of presence out of minimal means.

In a series of 2004 paintings titled *Everything,* threads and clots of paint spread irregularly across starkly contrasting monochrome backgrounds. The tracery can be read as maps of roads or highways without the place-names, but they can also be seen as internal networks of blood vessels or nerves. Here again, Kuitca is playing with fluctuating relationships—are we looking outside or inside? At our individual selves or our collective self? From above or within? Given the title of the paintings, the answer, perhaps, is simply "yes."

Referring to the possibility of multiple interpreta-tions, Kuitca has said that he doesn't see himself "as a creator of effect or a creator of reactions," and that he doesn't control what he calls "the potential" of the work. While the lack of a fixed goal or meaning may be unsettling, it can also place us firmly in the present. We are immersed in the here and now as we wander through Kuitca's empty spaces, undertaking with the artist "the kind of journey [that] implies that there is no home, no departure point, and no arrival point."[5] ◈

▲ *Zurich,* 2002

Mixed media on paper
Sheet: 8.5 x 11 in.
Private collection
Courtesy of the artist and Sperone Westwater,
New York

◄ *Untitled (Belt conveyors with unclaimed luggage),* 2000

Oil and pencil on canvas
80.5 x 79 in.
Private collection
Courtesy of the artist and Sperone Westwater,
New York

BODYS ISEK KINGELEZ

Kimbembele Ihunga, 1994 (details)

Paper, cardboard, polystyrene, plastic,
and other found materials
51 x 72.75 x 126 in.
Courtesy of the Contemporary African Art Collection
(C.A.A.C.—The Pigozzi Collection), Geneva

During the 1970s, when Kinshasa was an
exploding, chaotic city, Congolese (then Zairean)
artist Kingelez began developing his unique
"architectural modelism," a way to channel his
energies toward redemptive possibilities for
urban Africa. He began by creating maquettes for
elaborate community dwellings and progressed
to designing entire cities; the first one he built
(shown here) was *Kimbembele Ihunga,* named
after his native village. Kingelez imagines his
urban utopias as independent, self-determining
city-states without police or armies. Each ideal
metropolis is designed to promote lasting peace,
justice, and universal freedom. Kingelez wants
his art to serve a higher purpose, "to serve the
community that is being reborn to create a new
world, because the pleasures of our earthly world
depend on the people who live in it."

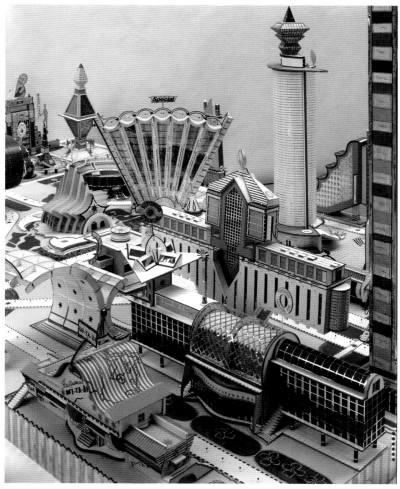

CHRIS KENNY

◀ ▲ *Observatory,* 2007

Construction with map pieces
16 x 16 x 3 in.
Courtesy of England & Co., London

◀ *The Norman Kingdom of Sicily,* 2007

Mixed media construction with map pieces
24 x 24 x 3 in.
Courtesy of England & Co., London

▲ *Map Circle (Akimiski Island),* 2007

Construction with map pieces
30 x 30 x 3 in.
Courtesy of England & Co., London

▶ *Mercato,* 2007

Construction with map pieces
14 x 14 x 3 in.
Courtesy of England & Co., London

Map fragments and pieces of found text coalesce into free-form maps with eye-catching depth in Kenny's crisp, clean assemblages. Organic forms and orderly geometric shapes float in shadow boxes as if each component were a prized, mounted specimen of color, form, and place. Kenny replaces the logic of cartography with "an absurd imaginative system." He uses cartographic forms cut from maps from around the world, which, he says, "float and interact in unlikely combinations that allow one's mind to ricochet back and forth between disparate locations and associations."

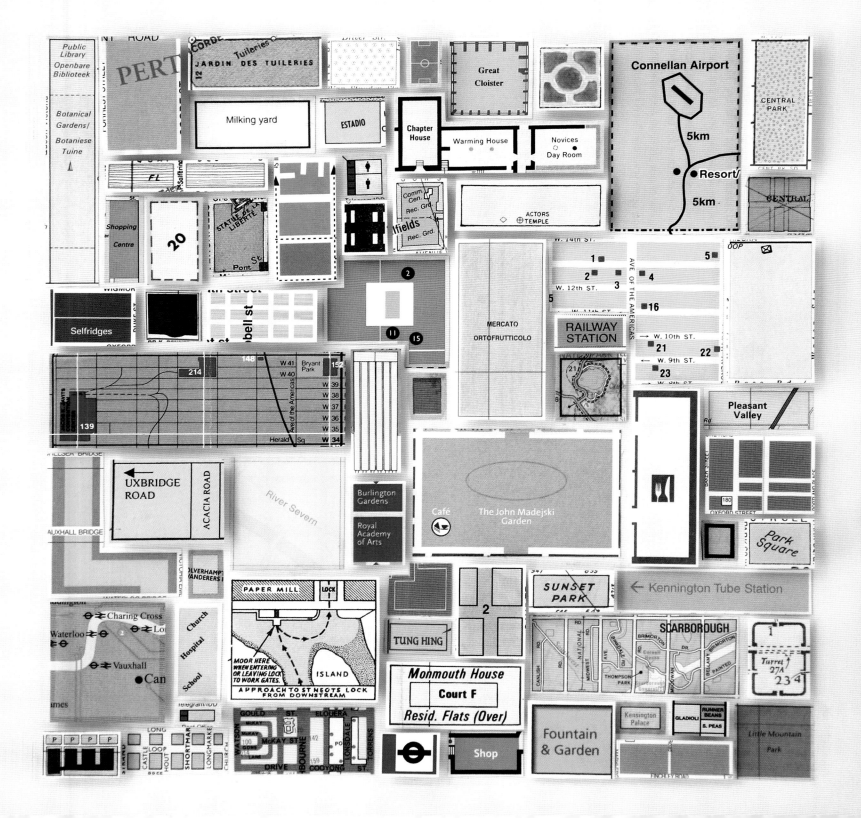

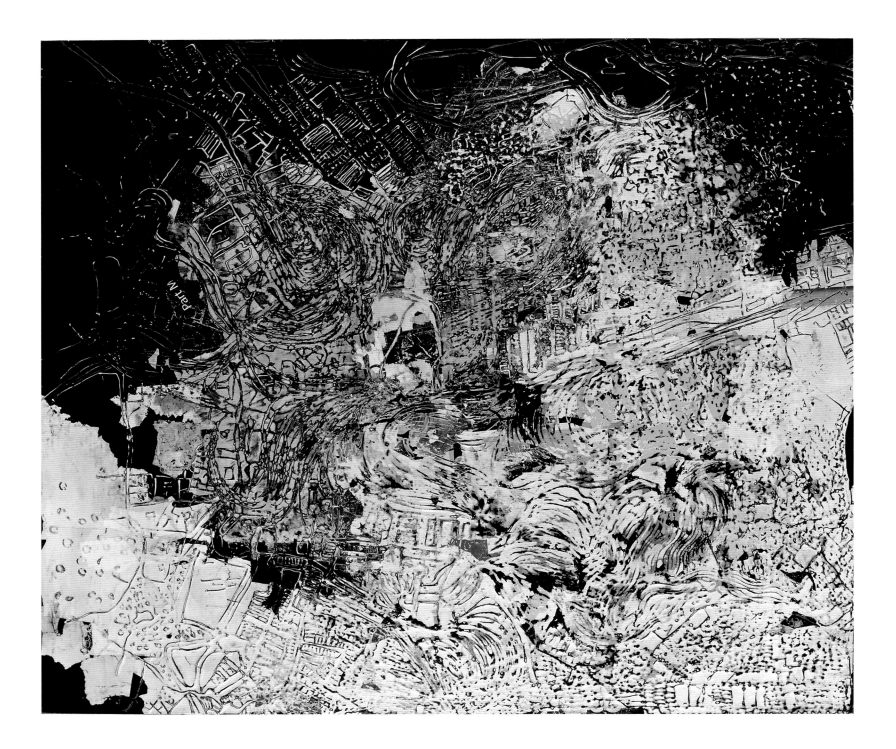

Part M

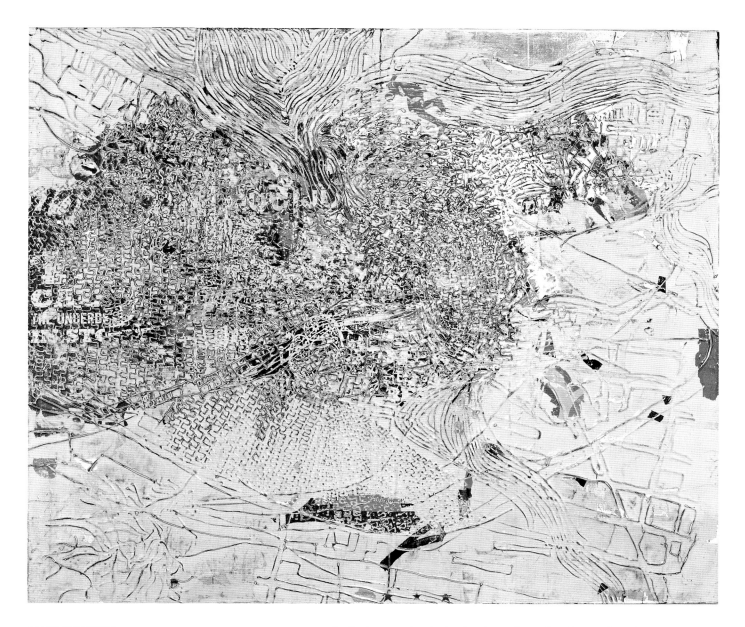

MARK BRADFORD

◀ *A Scaled Down Atlas for a Scaled Down Monarchy,* 2007

▲ *Spinning Man,* 2007

Mixed media and collage on canvas
Each 72 x 84 in.
Courtesy of Sikkema Jenkins & Co., New York

Bradford, an artist based in Los Angeles, works in video, photography, and installation, but is perhaps best known for giant-scale, mixed media canvases featuring Superman views of urban grids. He rubs, traces, bleaches, and sands paper fragments of street literature (newspapers, posters, flyers, etc.), layers these with raised byways made from strands of string, and incorporates oil-slick puddles of color that draw you into these visibly vibrant neighborhoods.

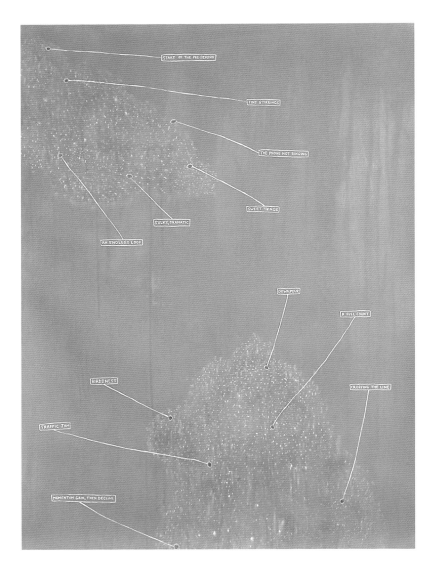

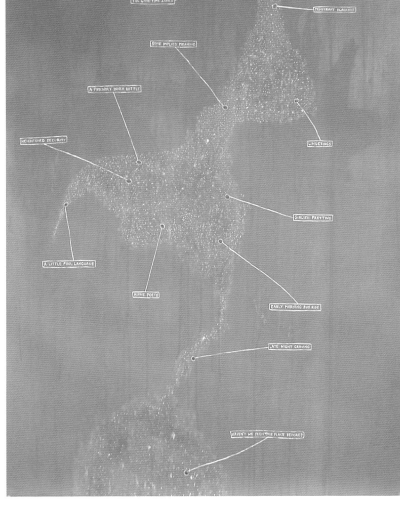

DAHLIA ELSAYED

▲ *Start of the Pre-Season,* 2005

Acrylic on paper
Diptych, each panel 46 x 34 in.

Elsayed's map paintings are illustrations of both internal and external geographies, charting the changing seasons, the weather, personal productivity, family stories, and fleeting emotions. Each work invariably features islands or coastlines. These mnemonic territories are fertile lands of personal narrative, giving form to observed moments in a day.

DARLENE CHARNECO

▶ *Petri Playgrounds,* 2006–7

Nails, resin, acrylic, enamel, and mixed media on panel
Nine pieces, each 12 x 12 in.

Charneco uses myriad computer-based implements—games (*SimCity*), multiuser realms (*AlphaWorld, Second Life*), and mapping technologies—to create utopias in petri dishes. Charneco hopes that perhaps, by showing what is possible, these microcosms will shake us out of what she sees as a dangerous myopia. "Aerial views never cease to amaze me, unmasking familiar places as parts of some large and complex organism," she says.

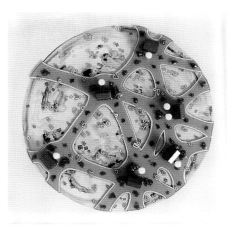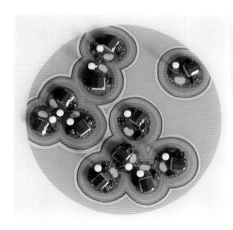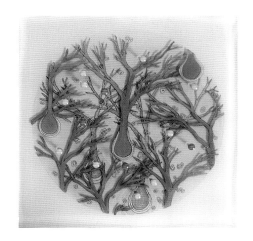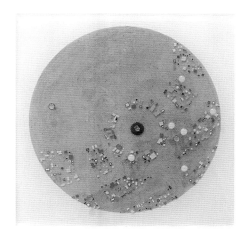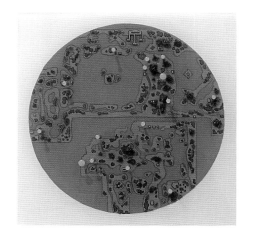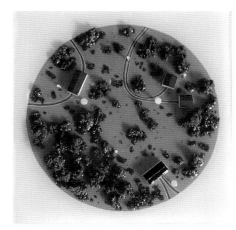

NATHAN CARTER

◄ *STAN KLR STAN BAC,* 2006

Wood, acrylic, and enamel paint
105.5 x 96 x 1.5 in.
Courtesy of the artist and Casey Kaplan, New York

Carter's works are a child's ideal science project; just consider the title of the piece at left. There are sparks flying between power towers, roller coasters and slides as gravitational follies, and spinning wheels for dabbling in hypnotism. A journey through these cacophonous lands promises both entertainment (pinball flippers) and an alluring bit of danger (a skull). "I am interested in maps that tell stories of chaotic events," Carter says. "I'm always collecting those map postcards for tourists with illustrations showing points of interest, but they are hopelessly optimistic. My maps are meant to be dystopic."

MICHAEL SLAGLE

► *Lakeland 3 (4th St & Quinmore),* 2007

Oil on canvas
26 x 26 in.

Lakeland 3 is based on a map of the neighborhood in Minnesota where Slagle grew up. The colors are those of houses he remembers. In his many map paintings, Slagle takes the language of maps—line, color, scale, shape, size—and bends them to convey his own cartographic visions of place. He writes, "What fascinates me, specifically as a painter, is the symbolic arrangement of these formal elements and how they translate as formal elements from a map to an abstract painting."

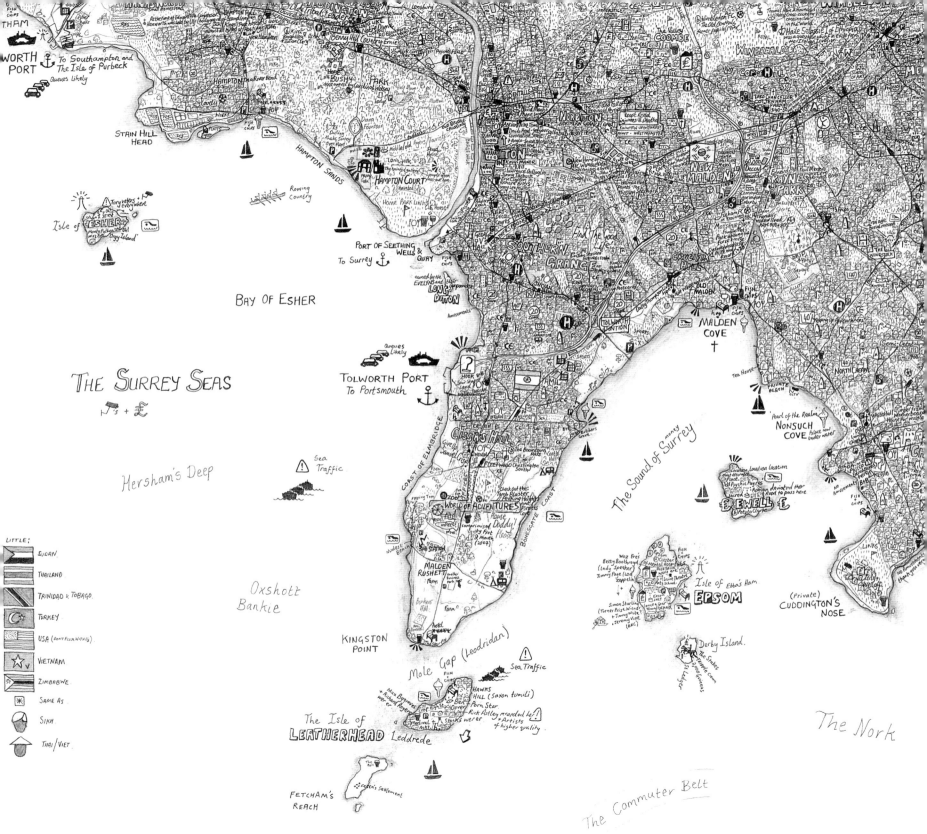

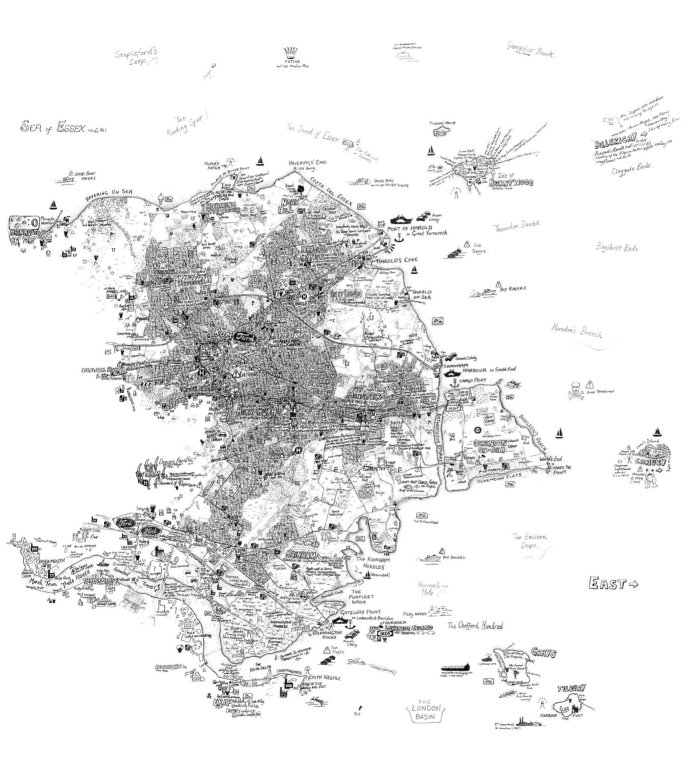

STEPHEN WALTER

◄ ◄ *The Island,* 2008 (detail)

Archival inkjet and screen print on paper
55 x 78.75 in.

◄ *Havering,* 2008

Archival inkjet and screen print on paper
33 x 31 in.

Walter, a lifelong Londoner, has created a series of drawings of the city's boroughs—from Hillingdon to Havering, west to east, and Barnet to Croydon, north to south—intricate beyond the scale of a book to convey. Each is packed with details of place: geography, history, etymology, sites of interest, built-up areas, green spaces, cultural institutions, myths, legends, trivia, and stereotypes—of the past, present, and future. Walter calls these maps "an intense exercise in cultural mapping merged with the realization of its own ridiculousness."

GREG COLSON

Oildale, 2006

Enamel, ink, and pencil on wood and metal
38 x 61 x 2 in.
Private collection, Aspen, CO

Oildale is one of a series of constructed city maps Colson began making in the mid-1980s from an array of discarded and store-bought elements: plastic pipe, metal tubing, curtain rods, ski poles, wood molding, lamp arms. These makeshift materials, with all their specific and independent associations, are fastened together to represent the highways and streets of an actual city (in this case, the California town where Colson was raised, though he says there is no personal, nostalgic aspect to the locations he chooses). "I see the constructed maps as a metaphor for how cities (and people) exist and develop according to a disparate mix of man-made and natural influences (social, economic, cultural, geological, climate and so on)," Colson writes. "This intersection of intention and accident is a central theme that runs through all of my art."

RAFAEL FERRER

Map for the Poets, 1974

Wood, lead, and copper wire
50 x 50 in.
Collection of Virginia Museum of Fine Arts

Before turning to painting in the late 1970s, Ferrer had already gained recognition for his combinations of unexpected materials—grease, ice, hay, neon lights—in temporary installations. This lyrical map, cobbled together from the simplest bits and pieces, could be an homage to the delicate structures of poetry or, equally, the suggestion that in a well-mapped world there is cartography for every person and purpose.

Following page

SATU NIKKU

In search of home 4, 2003

Tempera on canvas
27 x 30 in.
Photo by Harri Tuominen

Nikku, a Finnish painter, often overlays depictions of place with road networks and sometimes the outline of a human figure. To Nikku, the map is the modern equivalent of a labyrinth. As in her paintings, people today ponder a multitude of possibilities, find dead ends, encounter new experiences, or become completely lost before making their way out and into the next labyrinth. "Always," Nikku says, "in the background, the world keeps turning."

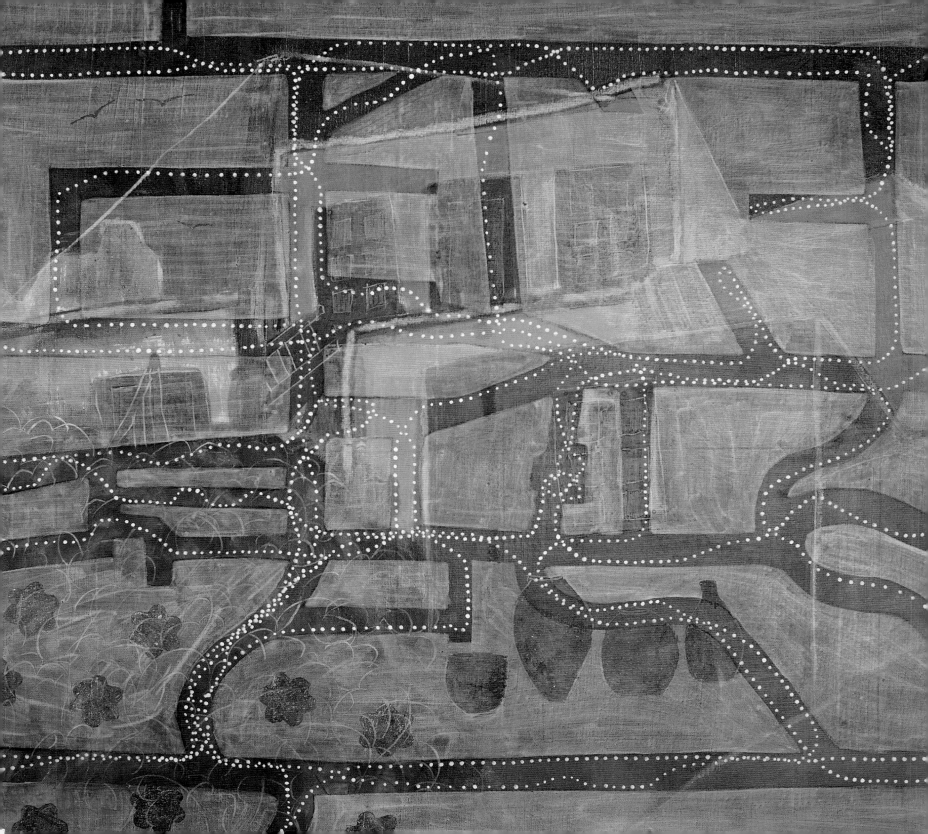

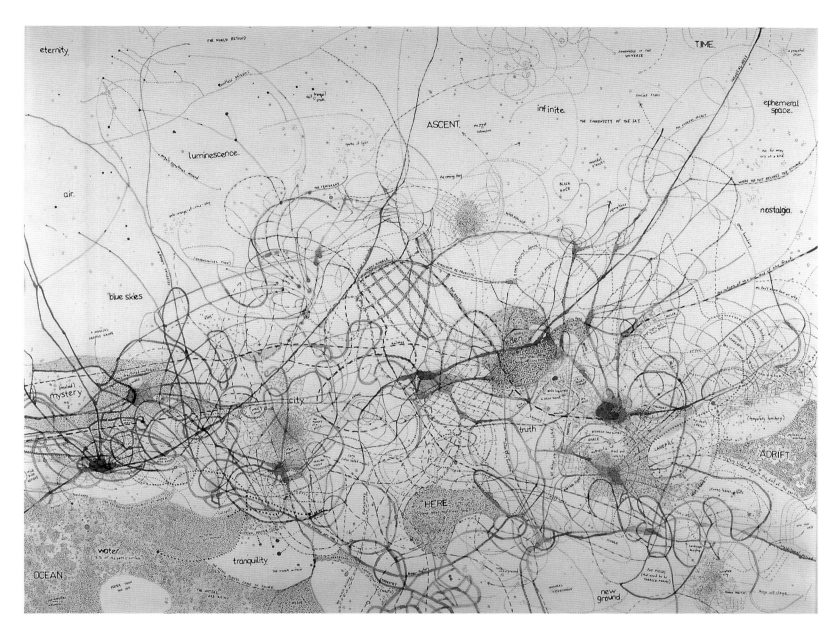

KAREY KESSLER

▲ *HERE (some green mysterious land),* 2007

Gouache and ink on paper
20 x 26 in.
Collection of Rebecca Turek
Photo by Gregory R. Staley

Kessler, a Seattle-based artist, says her map drawings are part cartography, part poetry. Sketching topographic shapes brings about associations with words, and these in turn suggest other elements from the visual vocabulary of maps. Kessler writes, "As much as I would like to, I cannot truly map a fleeting memory, a moment of dissolving time, or the spaces and gaps between spaces and gaps."

RICHARD STINE

▶ *Map Six (with Floor Plans)*, 2004

Acrylic on canvas
48 x 36 in.

Most of Stine's paintings, sculptures, and drawings over
the last dozen years have been map related. The work
shown here is one of his first map paintings, inspired by his
looking down on a flight from California to Washington
State. He says, "I love maps, the idea of maps, maps from
every angle—their gizmos, signals, symbols, and especially
their basic purpose: to show symbolically the possibilities
and how to get to them in reality. The premise couldn't be
better for art making."

REESE INMAN

▶ ▶ *Map I*, 2006

Acrylic on panel
24 x 24 in.
Photo by Peter Harris

Inman's maps unite man and machine, the technological
precision of computer algorithms with "the inflections
and irregularities of the human hand." Using a program
she created, Inman translates data into computer-designed
grids of dots that become the template for paintings. The
slight imprecision of the hand-applied paint droplets—"the
most basic unit of paint, much as a bit is the most basic
unit of digital information"—creates visual tension between
uniformity and individuality.

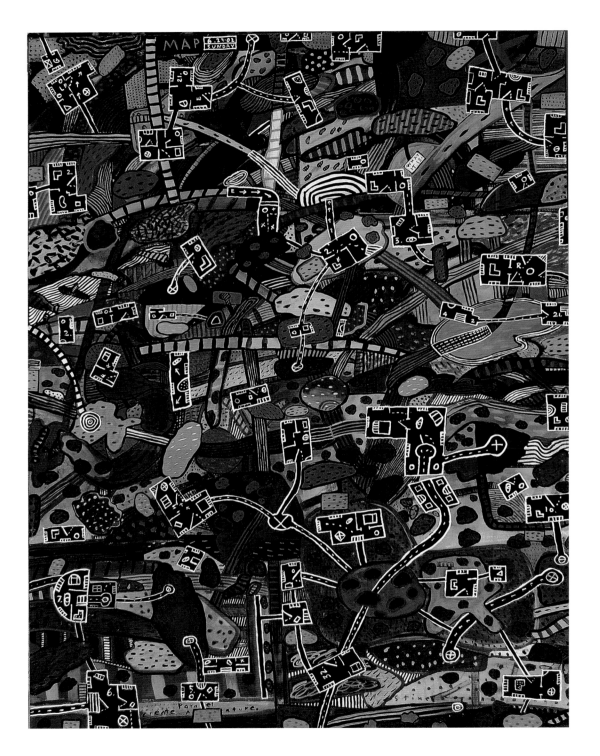

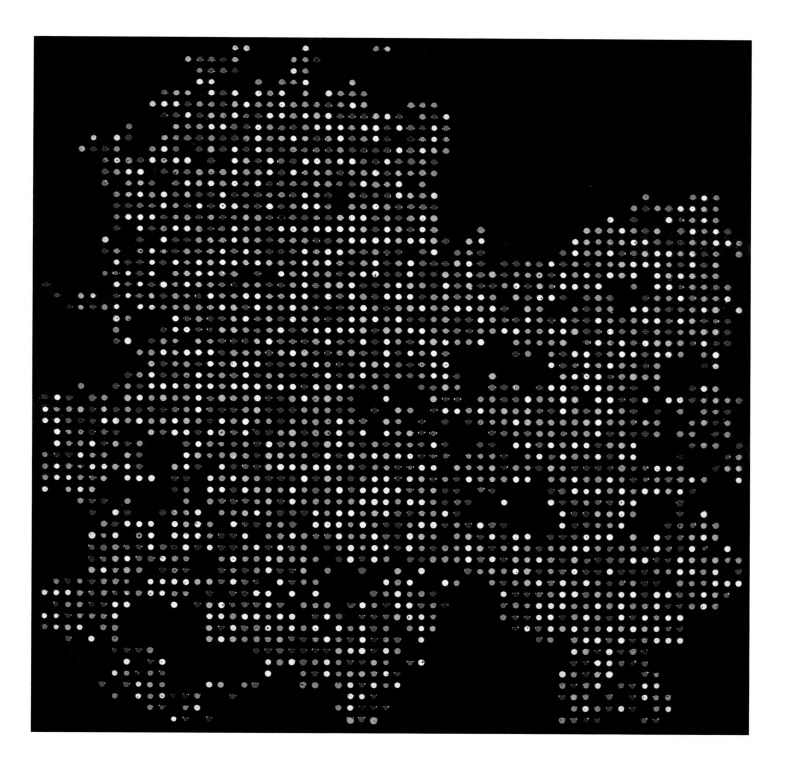

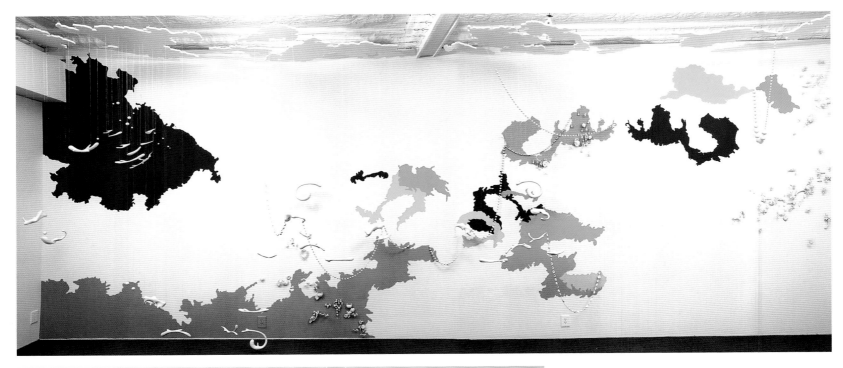

JEANNE QUINN

The Perfect World, 2007 (installation view, with details)

Porcelain, wire, paint, and plywood
11 x 28 x 4.5 ft.

In her work, Quinn attempts to create a new, perfect world. She explains, "The words decoration and decorum are rooted in the same Latin word, decorus: handsome and seemly. From this implication, decoration constructs the beautiful world in which we behave well. I believe this: when I see graceful ornament, it calms me, making me realize the order of the world." Using map forms as a background for decorative motifs, Quinn fashions peacefully arrayed utopias.

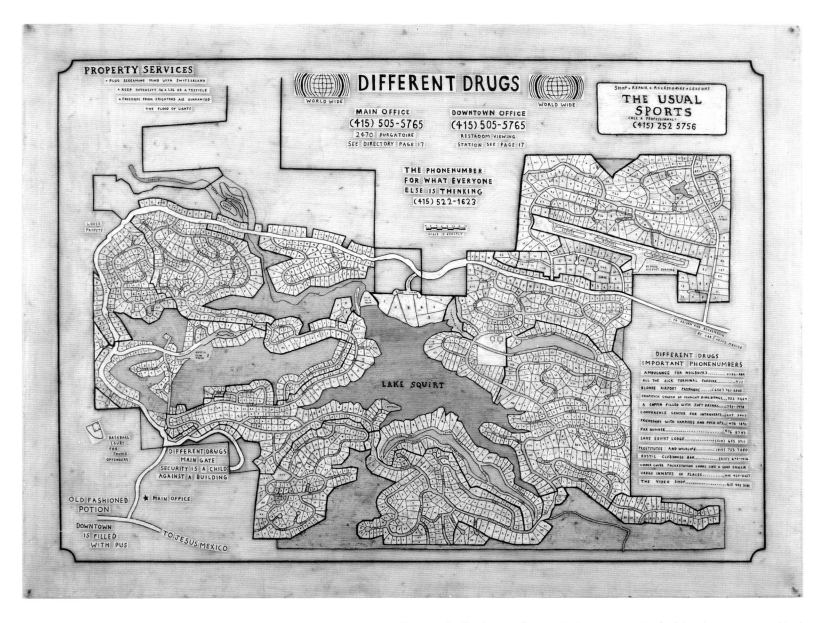

SIMON EVANS

Different Drugs, 2004

Mixed media on paper
19.75 x 26 in.
Collection of the San Francisco Museum of Modern Art
Courtesy of the artist and Jack Hanley Gallery, San Francisco
Photo by Donald Felton, Almac Camera

Evans uses familiar desk supplies—notebook paper, correction fluid, Scotch tape, pens—combined with watercolors to construct imaginative collages. The British artist was a professional skateboarder and writer before turning to art as a fitting way to portray visions simultaneously disjunctive, whimsical, satiric, provocative, and confessional. He did not attend art school, and sold his first work in a coffee shop where he worked, in San Francisco. Evans has mapped versions of heaven, an amusement park, and the world in unexpected and engaging ways.

MARK ANTHONY MULLIGAN

▶ *Minni Pearl Dale,* 1997

Acrylic and marker on joined
hollow-core doors
72 x 80 in.
Collection of David and Christine Clifford
Courtesy of Kentucky Folk Art Center,
Morehead

▶ ▶ *Quaker Park Hills,* 1997

Marker on paper
18 x 24 in.
Collection of Dale Fleishmann
Courtesy of Kentucky Folk Art Center,
Morehead

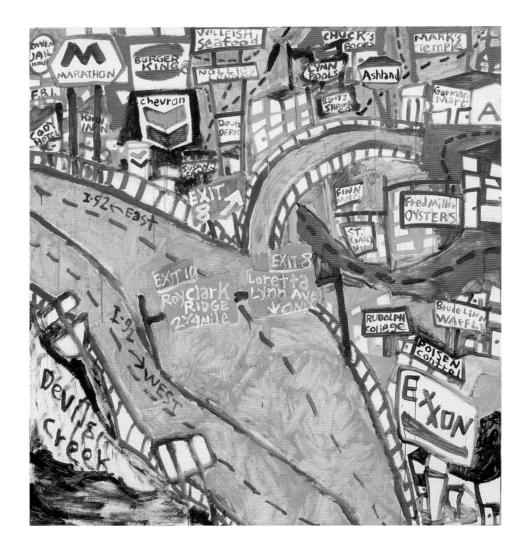

Mulligan is a self-taught artist, sidewalk singer, occasional open-mike performer, and a
familiar figure on the streets of his birthplace, Louisville, Kentucky. He travels by bus and
on foot throughout the city and is inordinately attuned to details of cityscapes, especially
signage and gas station logos. He creates acronyms for oil company names; for example,
Ashland stands for "Ask Him Love and Never Doubt" and Gulf means "God's Unique Love
Forever." Mulligan also invents amusing landmarks and street names. *Quaker Park Hills* (an
imaginary place, along with Rocky County and Judington) is filled with colorful byways,
from Dr. Stupid Boulevard to Starving Cow Place.

TITLE: QUAKER PARK HILLS (POP. 99,000 ITALIANS)
(OF ROCKY COUNTY, JUGINGTON)

RETAIL PRICE $74.99 + TAX

SUNOCO BOULEVARD

AVENUE

CHICKEN BUTT PLACE

ION ROAD

GARLIC STREET

LANE

ST. MIKE BOULEVARD

VAGENBURST LANE

MONKEY TRACE

WRENCH

MESS HALL CIRCLE

CUNNINGHAM BYPASS

FIRE MAN

GREENWOOD BOULEVARD

JUNCTION BOULEVARD

GREENWOOD STREET

DR. STUPID STREET

GREENWOOD TRACE

INDIAN ROAD

FIREMAN BLVD.

INDIAN LANE

MICHAEL ADAMS LANE

DR.

BRUCE

MICHAEL ADAMS LANE

GREENWOOD AVENUE

NDALE AVENUE

NOODLE RUN RD.

STOOL PIGEON PLACE

CUNNINGHAM LOOP

BYPASS

HOTEL

DEVILSIDE BYPASS

DELLICK ROAD

COLDWATER WAY

PARK AVENUE

GUN

NOODLE TOES BLVD.

STARVING COW

SUN DAT

NUN AVENUE

OLD ST

MOTEL

BISHOP DRIVE

BELIEVERS CAMP TRAIL

DONALD BOULEVARD

ST. MICKEY TRAIL

DR. PEPPER ALLEY

ADAMS

JUNCTION COURT

MICHAEL

NANCY COURT

MICHAEL ADAMS LANE

BRUCE LINN

CUNNINGHAM PLACE

JENNIFER CIRCLE

CHILEWOOD TERRACE

CUNNINGHAM BYPASS

TATER TALE SQUILLER COURT

FISHCREEK LANE

DELLICK RD.

MOONSHINE PLACE

PIG FEET CIRCLE

BAR-B-Q COURT

BIGFOOT HIWAY

MONA LISA TERRACE

WITCHES

NOODLE AVENUE

3 MILE LANE

8 MILE LANE

UNION STATION ROAD

ST. KATHY STEIN BOULEVARD

FEDERAL PARKWAY

DEAD FLY ALLEY

ST. PETES COURT

FRED MILLS DRIV

CHUCK SWANSON HIWAY

GORMAN ROAD

BEAN HEAD

FRIENDLY GHOST LANE

ASHLAND TRACE

ALBERTUS

BRUCE LINN ALLEY

MARVIN FINN

CASPER

TIDE LOOP AVENUE

PARKWAY

EDENSID LOOP

ELLIOTT DRIVE

ALPO ALLEY

SPOOKY DRIVE

MARATHON AVENUE

FAY STREET

ITALIAN ST.

MARY

MAN WAY

JELLYFISH AVENUE

ITALIAN ST.

FAY STREET

COOKIES AVENUE

DOTTED ALLEY

BIGFOOT

WET TOES

ONION LOOP TERRACE

HIWAY

AMOCO LANE

OATMEAL

ST. JANE HWY.

KLONDIKE BLVD.

WET SPOON BYPASS

MILLWOOD

ASHDALE CIRCLE

T-BONE MILE LANE

MILE MAKER STREET

TELLEY COURT

3 MILE LANE

5 MILE LANE

2 MILE LANE

MUD LOOP

CAPTAIN BRUCE TRAIL

SUSAN ALBERT COURT

LYNN CRALLE STREET

LYNN CRALLE STREET

HATFIELD COURT

TIDE LOOP

S MILE LANE

GASOLINE ALLEY

ST. LOLLYPOP COURT

ST. LOLLYPOP COURT

CASPER AVENUE

GREENTOWN COURT

SPOOKY DRIVE

4 MILE LANE

BON AIR TERRACE

ST. APOLOGY

DOG BUSTER PLACE

DERBY LANE

AMOCO

WET SPOON BYPASS LANE

DERBY LOOP

DOGI LANE

FUNCOOKIE LANE

NOODLEROCK STREET

IVORY TERRACE

ST. DUNK

ST. LUKE TRACE

MILEMAKER ST.

CHUCK SWANSON HIWAY

BARRY WAY

BEANDROP COURT

TIDE LOOP

CALORIES CIRCLE

HARVEY LOOP

FEVER ST.

DOTTSON PL.

HARVEY LOOP

SORRY CHARLIE

AVON COURT

ITALIAN BOULEVARD

BERGER DELL

CAPTAIN

HARD COPY COURT

MILLDUNE

MAPLE CRUMS

LIZA PHILLIPS

▲ *Inlet,* 2003

From an edition of five
Digital photograph
12 x 16 in.

▶ *Floodplain,* 2003

From an edition of five
Digital photograph
16 x 21 in.

For Phillips, one of the most compelling things about studying maps is their conceptual scale, and the imagination required to experience it. She is primarily a painter; her sand sculptures arose from a series of earlier airbrushed paintings based on U.S. Geological Survey relief maps of terrain. "These were very abstracted aerial landscape images, and I felt that I needed to bring my own hand into the process—to personalize the terrain as well as bring it into focus," Phillips says. She worked with a sandbox as her canvas, photographed her geographic formations, and applied color through digital overlay.

Dimension/Deletion Maps That Play with Cartographic Conventions

NORIKO AMBE

◀ *Flat File Globe Red Tank A,* 2007

Cut Yupo paper, metal cabinet, and Plexiglas
13 x 11 x 16 in.

▲ *Flat File Globe 3B, Red Version,* 2007 (detail)

Cut Yupo paper, metal cabinet
37 x 14 x 18 in.

Ambe, like Yuki Nakamura, is a Japanese-born artist living in the United States. Of her sculptural work she says, "I want to attain something sublime." Ambe cuts into paper to create negative forms representing herself, with undulating lines tracing her actions against streams of time. Subtle, natural distortions in the layers of paper convey the nuances of emotions, habits, and biorhythms.

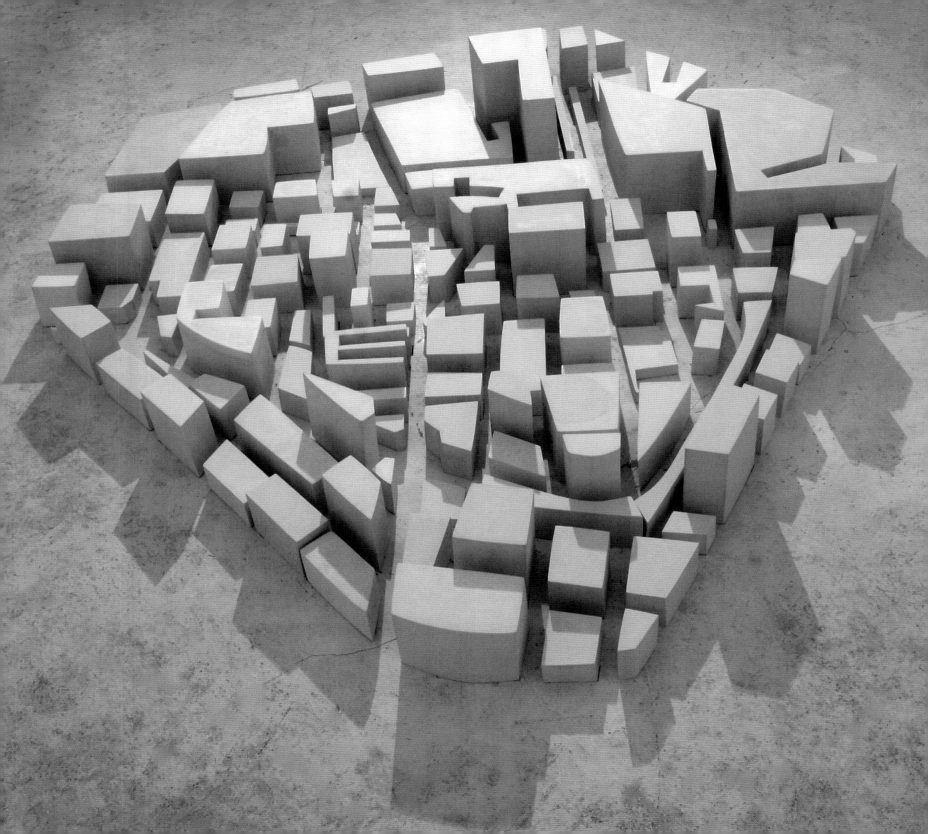

Preceding page

YUKI NAKAMURA

Fictional City, 2005

Residency project at Novara Arte Cultura, Novara, Italy
Plaster
8.5 x 76 x 67 in.
Courtesy of Howard House, Seattle
Photo by Riccardo Del Conte

Since moving from the relative isolation of southern Japan's Shikoku Island to Seattle, Nakamura has created sculptural installations reflecting on separations—those of geographic boundaries, cultural traditions, individual identity, internal and external worlds, and even artistic material (pushing the boundaries of ceramic, her preferred medium). Nakamura's *Fictional City* is a series of works that have been called "spatial puzzles," islands broken apart into monotone monoliths.

JONATHAN CALLAN
China in Japanese Prints, 2006

Paper
12.25 x 9 x 3.5 in.

Callan's altered books look as if they were decomposing, with maps as their destroying agents. A sculptor by training, Callan says he is exploring "the relationship of disembodied knowledge to embodied experience." To do so, he cuts, perforates, drills, scratches, and corrodes the surfaces of objects. Born and raised in England, Callan chooses to work most often with books in response to the way his country's literary culture has shaped its worldview; books (and, perhaps, maps) enable him to emphasize the inadequacies of language. Callan's works on paper occasionally feature maps as well; a piece called *No Legend,* of acrylic applied to a photograph, looks like a topographic map of great scale, made from filigreed metal impressed with fern fronds and lichen.

MARIELE NEUDECKER

The Air We Breathe Is Invisible, 1992–96

Photo album, glue, carved map of the English Channel, and glass
4.75 x 14 x 16.5 in.
Courtesy of Galerie Barbara Thumm, Berlin

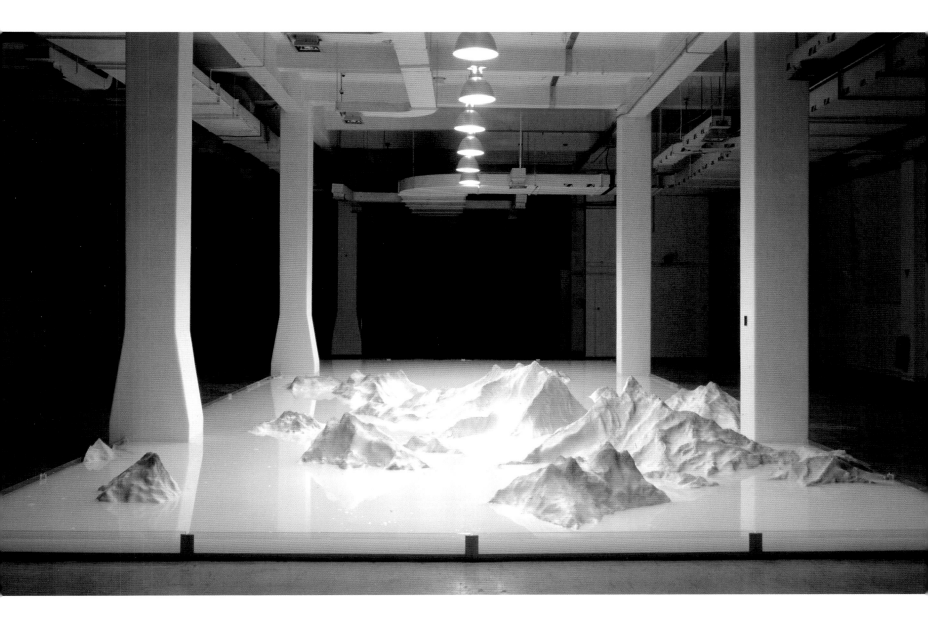

MARIELE NEUDECKER

Unrecallable Now, 1998

Installation views at Helsingor, Denmark, 2000 (left), and Melbourne Biennale, 1999 (right)
Glass and metal-frame tank, 18,000 liters of water, acrylic medium, and fiberglass
47 x 28 x 64 ft.
Courtesy of Galerie Barbara Thumm, Berlin

Neudecker creates atmospheric landscapes, often enclosed in glass cases. The elemental forms in her topographic sculptures—mountains, lakes, and forests cloaked in fog—are evocative and almost supernatural. Born in Germany, Neudecker has lived and worked in Britain for many years; her work can be seen as a modern coda to the Romantic traditions of both countries, as it invites viewers to reconsider notions of the natural world as the source of spiritual transcendence, cultural identity, and artistic inspiration.

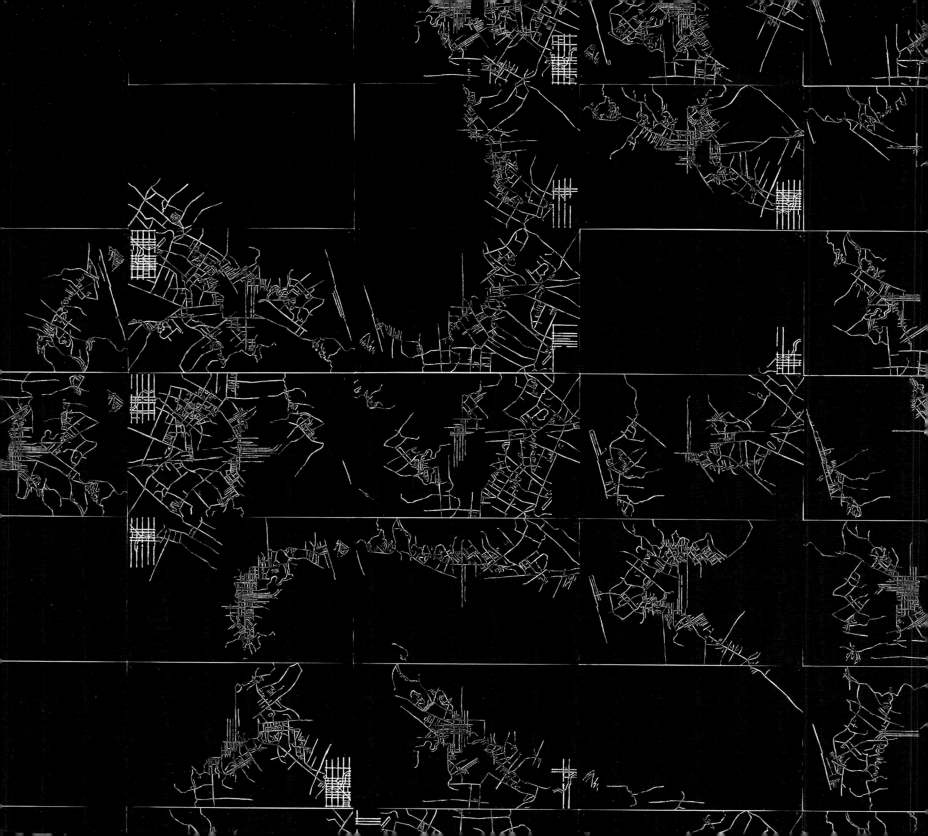

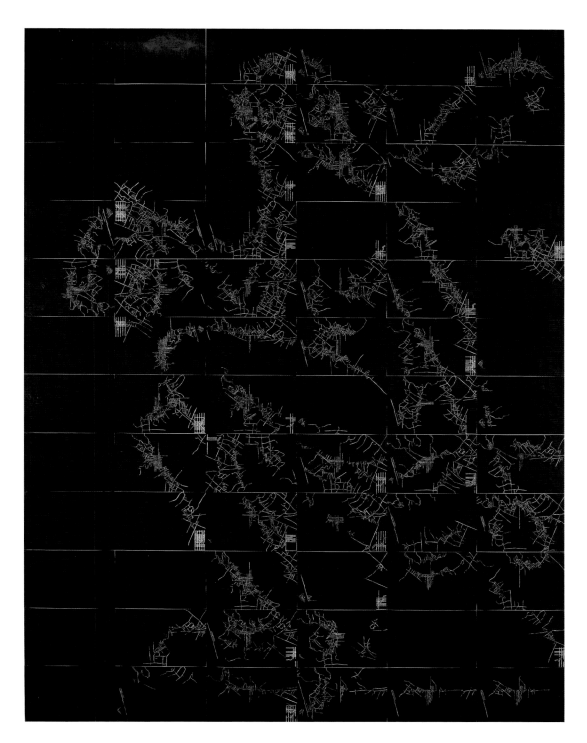

JOHN HURRELL

43° 30′49′S. "Allegoria della critica de l'arte" 172° 37′17′E.,
1985 (with detail on facing page)

Acrylic on offset-printed paper maps
12.5 x 9.5 ft.
Courtesy of the artist and the Museum of New Zealand
Te Papa Tongarewa, Wellington
Purchased 1989 with New Zealand Lottery Board funds

Hurrell explains that this piece is "appropriated" from
Allegory of Art Criticism, a 1981 painting by the Italian artist
Carlo Maria Mariani showing an angel sitting on a rock
with a severed head in one hand and a mirror in the other.
The image inspired Hurrell, a New Zealand artist, because
he was also working as an art critic at the time. The canvas
for Hurrell's version is a patchwork of maps of the city
of Christchurch, on which he superimposed the Mariani
image. He then retained the city streets underlying the
lines of the Mariani drawing while systematically blacking
out the rest of the maps. The latitude and longitude
coordinates in the title pinpoint the location of what was
then Christchurch's sole Italian restaurant, in honor of
Mariani. Hurrell has also made a series of works on single
maps, blacking out everything but the lines indicating
urban park pathways, thereby "discovering" what appear
to be mysterious hieroglyphs or newfound constellations
scattered across a night sky.

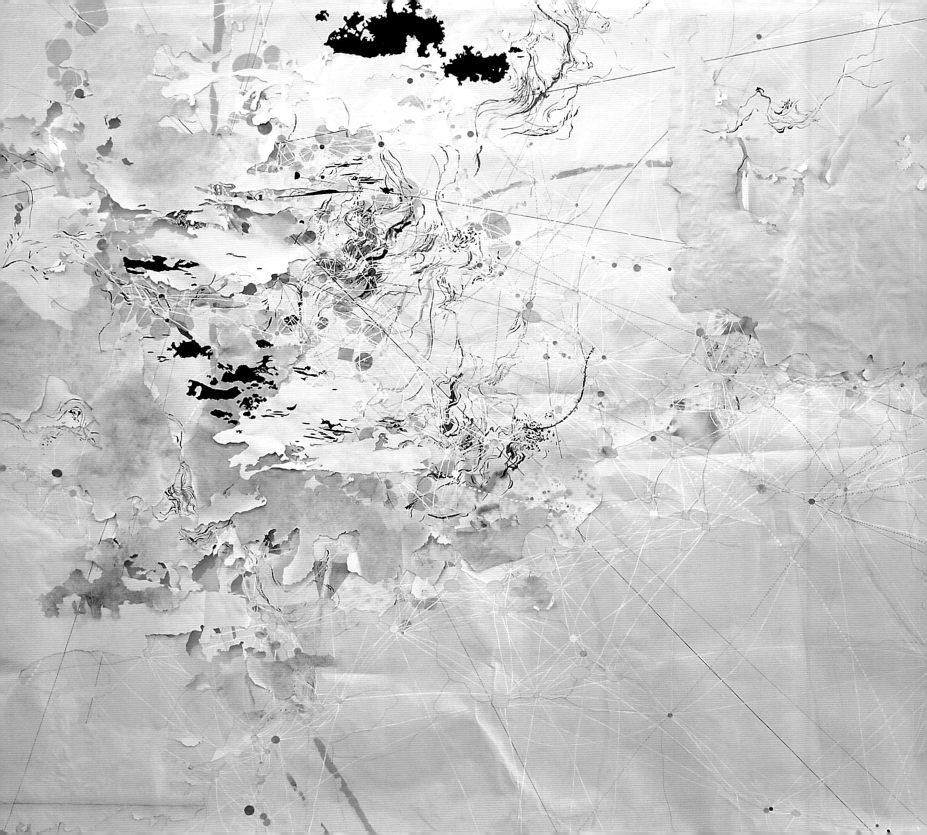

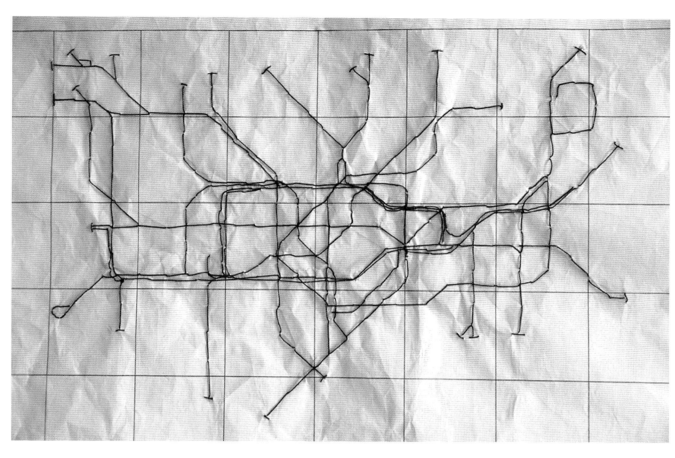

VAL BRITTON

◀ *Where could you have been, or where could I?* 2006

Ink, pencil, gouache, collage, and cutouts on paper
80 x 106 in.
Collection of Visa Inc.

Britton makes immersive collaged drawings that use the language of maps to navigate memory and imagination. The impetus for this body of work was her longing to connect to her father, now deceased, who was a cross-country truck driver hauling industrial machinery in an eighteen-wheeler. She writes, "Based on road maps of the U.S., routes my father often traveled, and an invented conglomeration, mutation, and fragmentation of those passageways, my works on paper help me piece together the past and make up the parts I cannot know."

SUSAN STOCKWELL

▲ *London Subway,* 2007

From the series *Line*
Red cotton stitched onto calligraphy rice paper
24.5 x 12 in.

Stockwell, a British artist, works in a variety of media, including sculpture, collage, drawing, and film. The map is a frequent theme in her paper-based work. During a residency in Taiwan, she exhibited a body of work based on the subway systems of Taipei and London, including large graphite drawings of spidery forms on Chinese rice paper, maps cut from paper bus-route guides mounted on glass, and map forms stitched onto calligraphy paper. Stockwell often finds direction in her choice of materials, including rubber tires and cardboard boxes. She has made maps of China and Taiwan from cut and stitched tea bags; a map of South America from stained coffee filters; a world map of delicate dressmaking pattern tissue, held together with pins; and a stuffed bovine-shaped map called *Mad Cow Country* made from Holstein-patterned fabric. Stockwell says she enjoys bringing out the hidden beauty of humble materials intended for other uses.

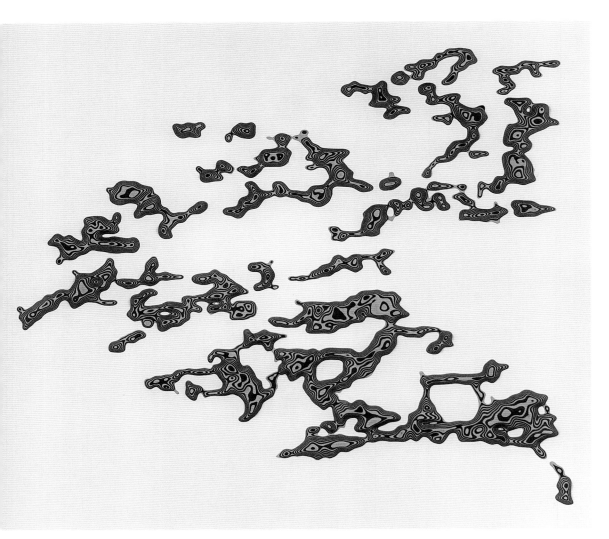

LEO SAUL BERK

Archipelago, 2005 (with detail)

Masonite and MDF
90 x 120 x 3 in.
Collection of Sarah and Richard Barton

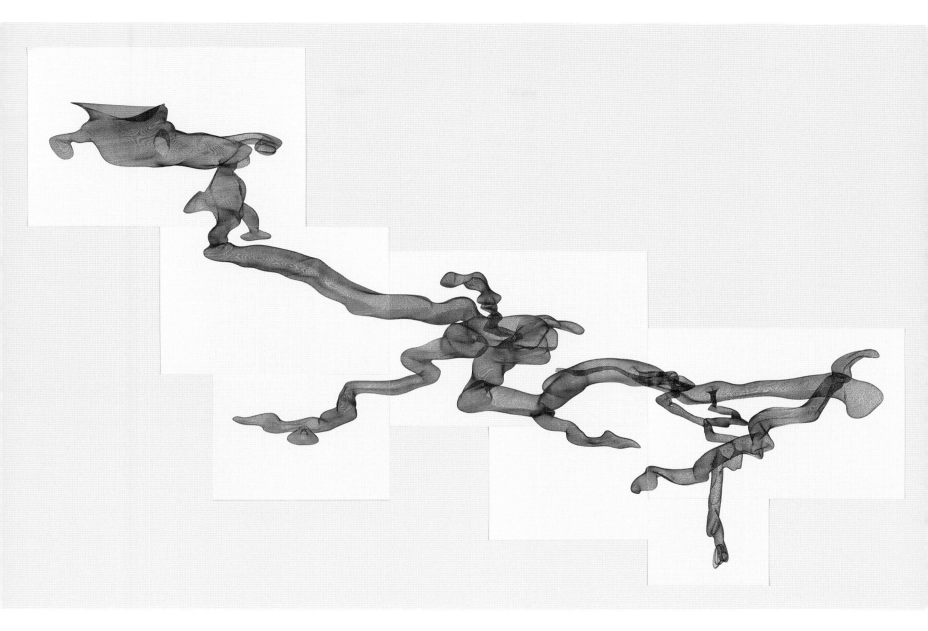

LEO SAUL BERK

Underworld Cave, 2007

Glitter pen on seven sheets of paper
90 x 140 in.
Courtesy of Lawrimore Project, Seattle

Berk uses 3-D modeling software to convert snapshots of natural objects—the bough of a tree, a cloud, or, at left, a pattern in the sand at Venice Beach—into topographic drawings and sculptures. More recently, he began producing 3-D representations of caves. Using a giant plotter he retrofitted from an electronic routing tool, Berk printed projections of the Quecreek mine in Pennsylvania, site of a flooding disaster, and Naj Tunich, a sacred Mayan cave in Guatemala (shown above). He is intrigued by our tendency to imbue caves with meaning. As examples, underground mining accidents capture a lot of media attention (as with Quecreek) even though many more deaths occur in surface mining, and the Mayans believed that Naj Tunich was the entrance to their underworld. Berk sees 3-D mapping as a way to both de- and remystify these unfamiliar spaces.

MICHAEL DRUKS

◀ *Flexible Geography (World),* 1971

Photograph (printed in 2002)
16 x 20.5 in.
Courtesy of England & Co., London

Druks, born and raised in Israel, came to Europe at the beginning
of the 1970s, and made this photograph not long thereafter. What
appears at first to be an uninflated vinyl beach globe is actually a
ball of crumpled maps, perhaps a comment on a time of increasing
global conflation, when a newly mobile Western society and
expanding air travel were creating new continental mash-ups.

LOS CARPINTEROS

▼ *Sandalia,* 2003–4

Gray-pigmented urethane rubber, clear urethane plastic
mixed with urethane rubber, certificate of authenticity
Each 12.75 x 5.75 x 2.5 in.
Editioned multiple published by Graphicstudio, University of South Florida, Tampa
Courtesy of Sean Kelly Gallery, New York

A duo of Havana-based artists—Marco Castillo and Dagoberto Rodríguez—work collectively
as Los Carpinteros (The Carpenters), tying themselves to a tradition of artisanship rather
than the culture of an ego-driven art world. They produce artistic "working drawings" (for
projects such as a roller coaster mattress or a brick home in the shape of a coffeepot) and
create sculptural objects that often subvert the relationship between object and function (for
example, breadboxes assembled in the shape of a missile, or flip-flops with relief maps of a
Havana neighborhood on the insoles).

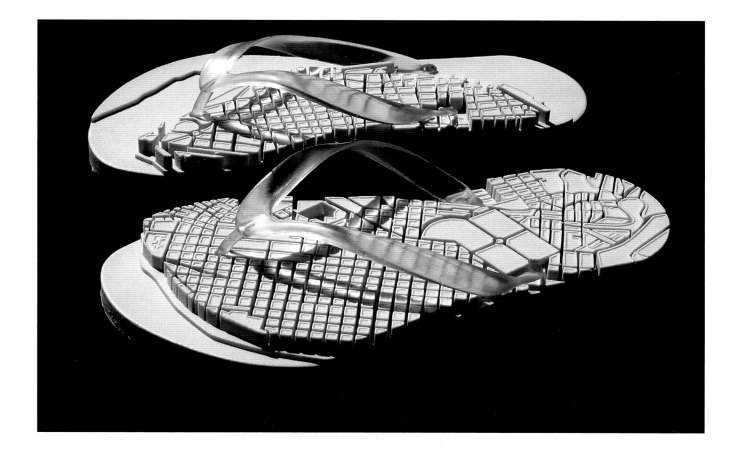

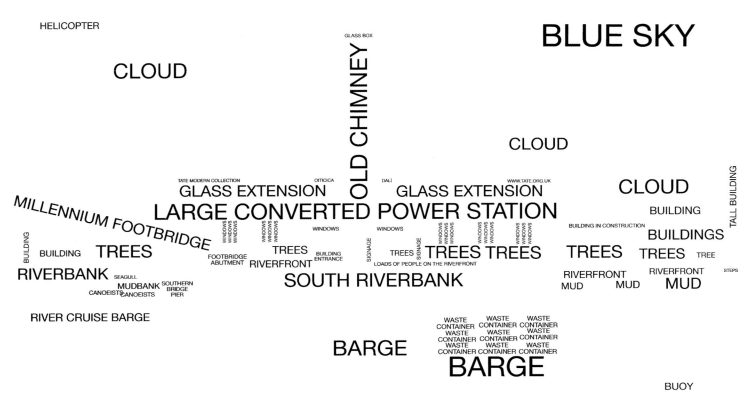

HELICOPTER
CLOUD
BLUE SKY
GLASS BOX
OLD CHIMNEY
CLOUD
CLOUD
TATE MODERN COLLECTION
OITICICA
DALÍ
WWW.TATE.ORG.UK
TALL BUILDING
GLASS EXTENSION
GLASS EXTENSION
BUILDING
MILLENNIUM FOOTBRIDGE
LARGE CONVERTED POWER STATION
BUILDING IN CONSTRUCTION
BUILDINGS
WINDOWS
WINDOWS
WINDOWS
TREES
TRES
TRES
WINDOWS
WINDOWS
WINDOWS
WINDOWS
WINDOWS
WINDOWS
WINDOWS
WINDOWS
WINDOWS
TREES
TREES
BUILDING
TREES
TREES
TREE
BUILDING
BUILDING
FOOTBRIDGE
ABUTMENT
BUILDING
ENTRANCE
SIGNAGE
SIGNAGE
TREES TREES
TREES
RIVERFRONT
RIVERFRONT
STEPS
RIVERBANK
SEAGULL
RIVERFRONT
LOADS OF PEOPLE ON THE RIVERFRONT
MUD
MUD
MUD
MUDBANK
SOUTHERN
BRIDGE
SOUTH RIVERBANK
CANOEISTS CANOEISTS
PIER
RIVER CRUISE BARGE
WASTE
CONTAINER
WASTE
CONTAINER
WASTE
CONTAINER
WASTE
CONTAINER
WASTE
CONTAINER
WASTE
CONTAINER
BARGE
WASTE
CONTAINER
WASTE
CONTAINER
WASTE
CONTAINER
BARGE
BUOY
RIVER CRUISE BARGE
I EAT RUBBISH! THIS DEVICE RESTORES VITALITY
TO THE THAMES BY COLLECTING 40 TONNES OF
RUBBISH EVERY YEAR THAT'S EQUIVALENT
TO 800,000 PLASTIC BOTTLES
RIVER THAMES
RIVER CLEANING BARGE

ALBERTO DUMAN

▲ *View of the Tate Modern, London,* 2007

From the series *Views of London*
Silk screen print
27.5 x 39.25 in.
Courtesy of England & Co., London

Duman, a conceptual and installation artist born in Italy, devised a series of seven typographic prints depicting landmarks of London, his adopted home. Duman took photographs of the sites and placed words on each image in order to completely replace the visual components with labels. The depth of the photographs is stripped away, leaving a flat plane of disembodied words—resulting in something much like a map. These are informative documents, but the details are not those of conventional maps, which would neglect to note a "white tarpaulin," a "large ornate building," or more than one "person taking a photograph." "Interpretational resources form a very essential part of the art-world structure," Duman has said. "The most common form of interpretation is one in which words explain images."

MARK ANDREW WEBBER

▶ *Amsterdam,* 2007

From the series *Where in the World*
Linocut print
33 x 38 in.

After returning from a trip to Amsterdam "to look around and get a feel for the place," Webber spent about one hundred hours, during a week, carving a map so inventive that the resulting print looks as if it were composed by a typesetter binging on a stack of font trays. "I like to show how crowded cities can be with multi-directional typography, so that wherever you look you see type." Amsterdam is part of an ongoing series that also includes maps of London and New York.

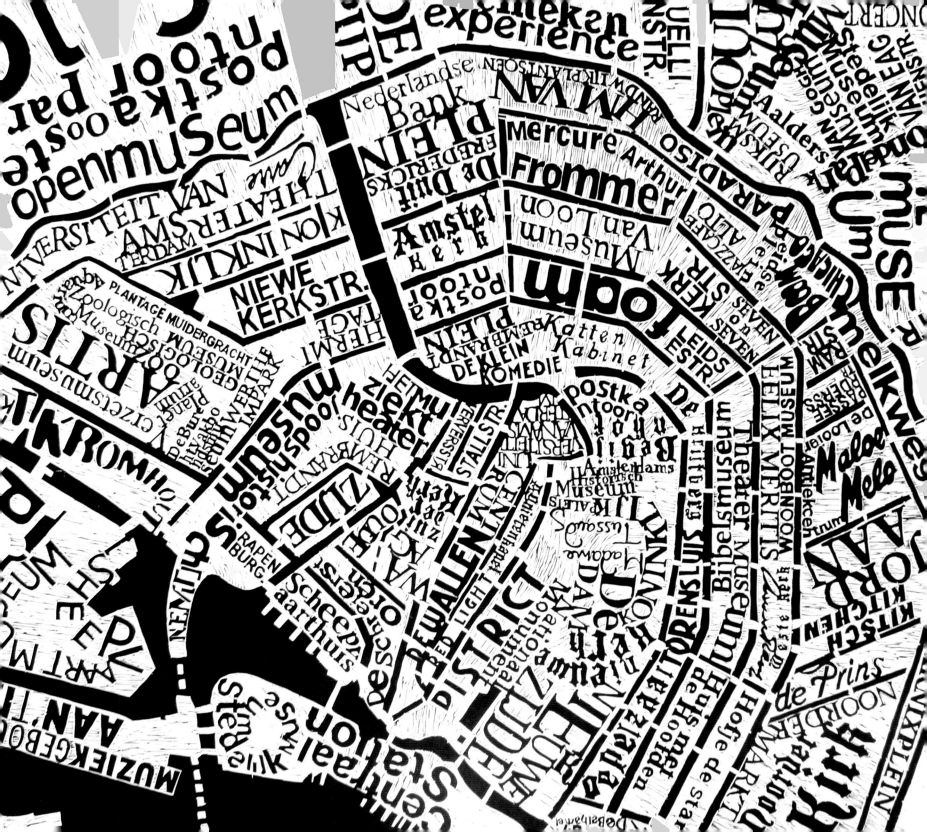

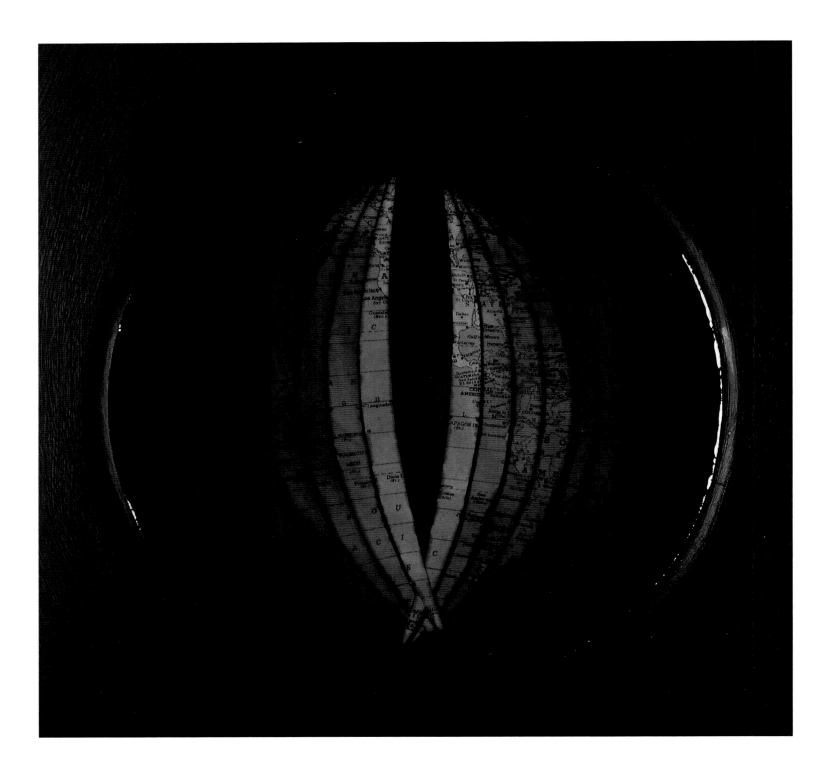

TIM MCMICHAEL

◀ *Shellac'd #2,* 2005

Resin, shellac, and map elements on MDF
6 x 6 in.
Collection of Roz Florez

▲ *Transformer,* 2005

Shellac on paper
22 x 30 in.
Collection of Mike Brod

McMichael says his map art comes from the need to document his place in a state of impermanence. He chooses elements from early-twentieth-century atlases, cuts them into decorative shapes, and fixes them in an amber of shellac and resin. "[Map components] are well thought out by man, but taken out of context they become organic drawings," McMichael says.

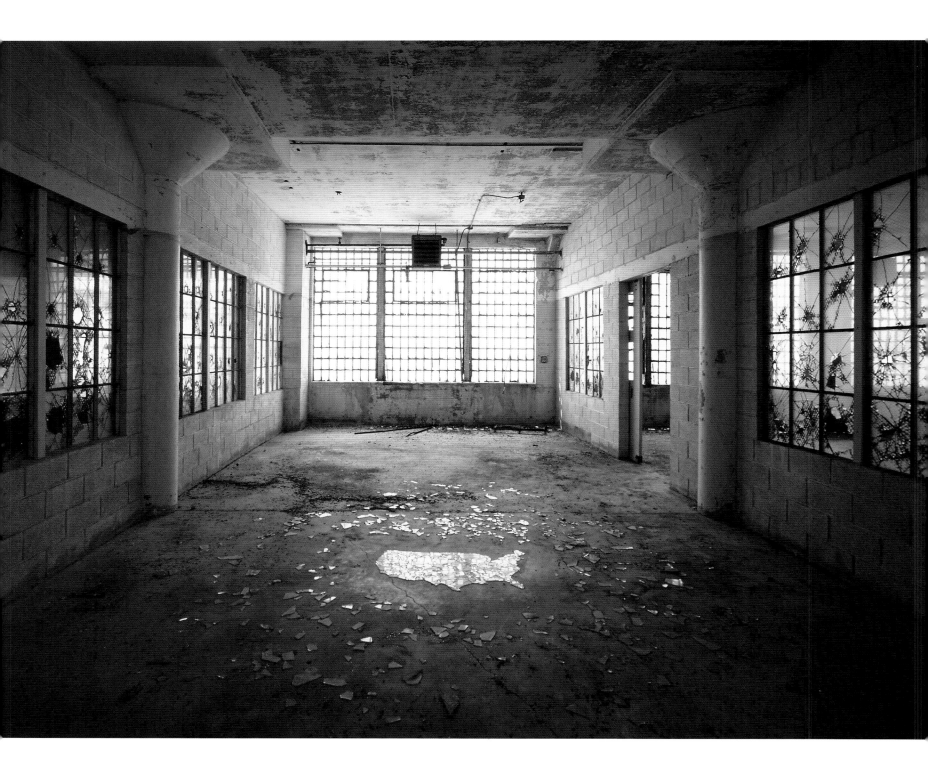

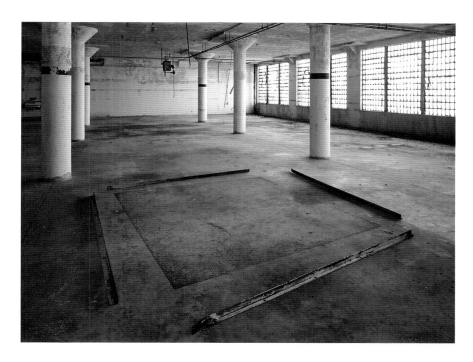

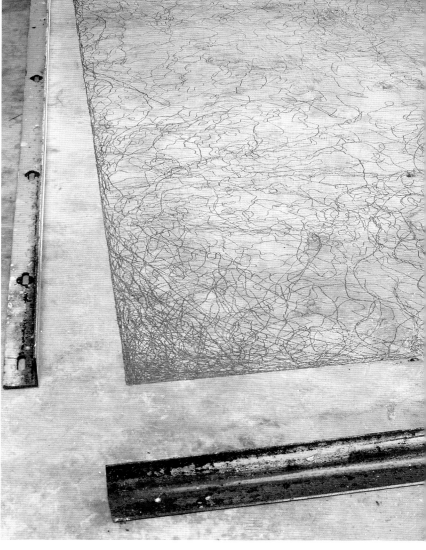

YUKINORI YANAGI

◀ *Broken Glass on Map,* 1996

Installation view, Alcatraz, San Francisco
Atlas map and broken glass
Photo by Ben Blackwell

Above and right

Wandering Position on Alcatraz, 1996

Installation view, Alcatraz, San Francisco
Ants, red crayon, and steel angle
Installation: approximately 108 x 122 in.
Photo by Ben Blackwell

Yanagi spent two weeks on Alcatraz in the spring of 1996, exploring the genius loci of the prison's deserted buildings. He had become intrigued by the infamous penitentiary, located on an island in San Francisco Bay, after learning about the imprisonment there of a Japanese American, Tomoya Kawakita, accused of treason against the United States after World War Two, and its occupation by Native Americans six years after the prison's closing in 1963. He was given access to the Industries Building's long, hauntingly lit spaces to conduct "field work" resulting in "sketches" made from materials at hand. "While there," he writes, "I constantly heard seagulls crying and Alcatraz's fog bells echoing desolately, in this starkly bare building ravaged by the ocean breeze."

For *Wandering Position on Alcatraz,* Yanagi placed ants inside a rectangle of metal braces and traced their paths in red crayon. This mapping exercise, which took days to complete, became a visual interpretation of entrapment, isolation, and social control. Yanagi's work often explores the transgression of boundaries, as also seen in his map of broken glass. For Alcatraz's inmates, committing a federal offense in any U.S. state had sharp consequences. The broken glass might also suggest escape attempts; there were fourteen in the prison's twenty-nine years of operation, involving thirty-six inmates. None were successful.

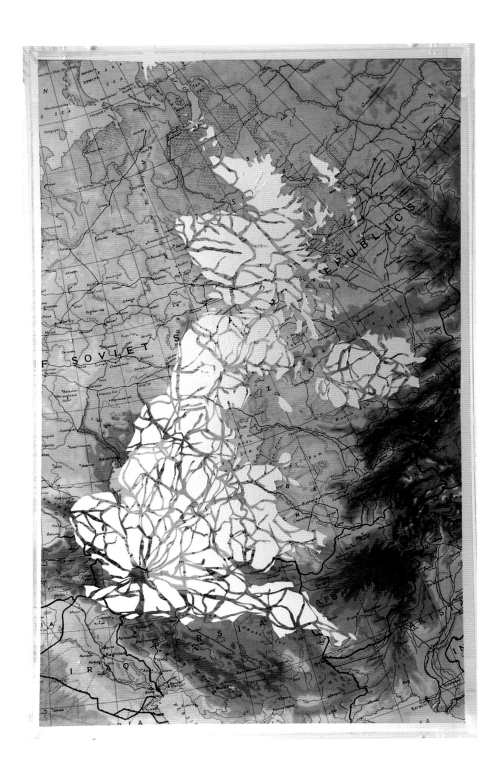

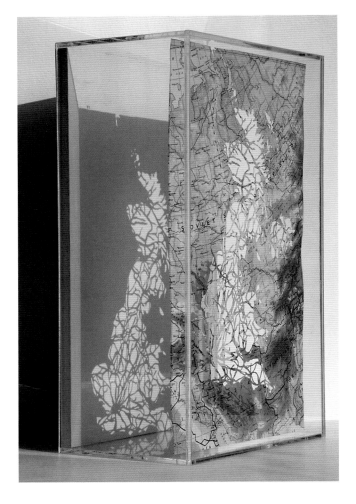

GEORGIA RUSSELL

Britain: March 2003 (Britain on Iraq), 2003 (with detail)

Cut map in acrylic case
13.75 x 8 x 5 in.
Collection of the Victoria and Albert Museum, London
Courtesy of England & Co., London

Russell might have been a surgeon, so adept is she with a scalpel. Instead, the Scottish artist cuts into maps, books, currency, and other found ephemera to create "membranes of memories." Her lacy images are mounted so that their shadows seem to turn negative spaces to positive.

EMMA JOHNSON

Matrix, 2007

Dissected Ordnance Survey map
35.5 x 39.5 in.

Johnson is a British artist whose
work centers on deconstruction,
transformation, and the ambiguity
of communication. In addition
to maps, Johnson often creates
larger sculptures using newspapers,
paperback books, letters, postcards,
and various other recycled materials.

JONATHAN PARSONS

◀ *Terminator Maquette,* 2007

Painted steel
16.5 x 8.75 x 6.25 in.
Collection of Jerwood Foundation, London
Photo courtesy of Jerwood Foundation

Map dissection is a recurrent practice in Parsons's work. He removes all but selected routes and finds therein intriguing visual elements. For example, in a piece titled *Zoned Out,* a bottle appears at the center of a map of the London Underground; in another piece, *My Beating Heart,* red and green forms emerge from two maps of east London (one of postal districts, the other of rail pricing zones). With *Terminator Maquette,* Parsons took this deconstruction a step further; he drew a 1991 intercity rail map, dissected it from sheet metal, and presented it as a self-supporting sculpture. Its title refers to the dividing line between night and day on the surface of a planet. "This sculpture is completely defined by its edges, where the [map] image and the object come to an end," says Parsons. "Its physical extremities are bounded by the termination of each depicted route."

JEFF WOODBURY

▶ *Ground Zero,* 1999 (detail)

Dissected map hanging in front of black square painted onto wall
32 x 31 in.

Woodbury began dissecting maps in 1998. "Tracing routes with a knife is similar to driving down a highway," he writes. "Most of what you're left with is the road itself and a narrow band of land on either side." He appreciates being able to extend the life of otherwise disposable, out-of-date maps by replacing their usefulness with aesthetic value. Among other map-inspired works, Woodbury has made "rubbermaps" from colorful squiggles of acrylic paint that remain flexible when dry, collages of burnt map fragments, tracings of spidery map organisms, and new works that combine layers of translucent map drawings on a lightbox (see next pages).

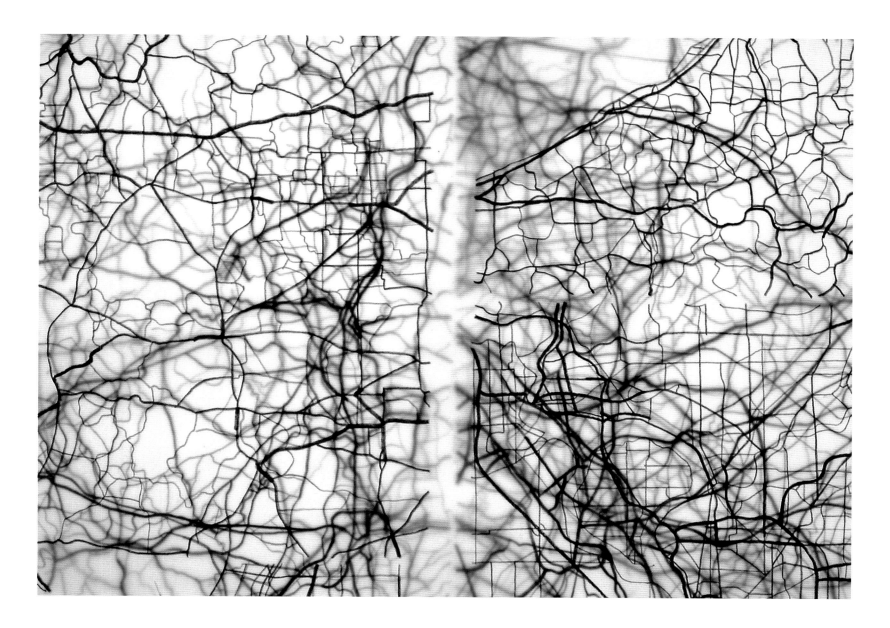

JEFF WOODBURY

◄ *City Hearts,* 1999

From the series *City Trace*
Graphite on tracing paper
13 x 10 in.

▲ *Atlas,* 2008 (detail)

Graphite on five layered sheets
of vellum, backlit
19 x 24 in.

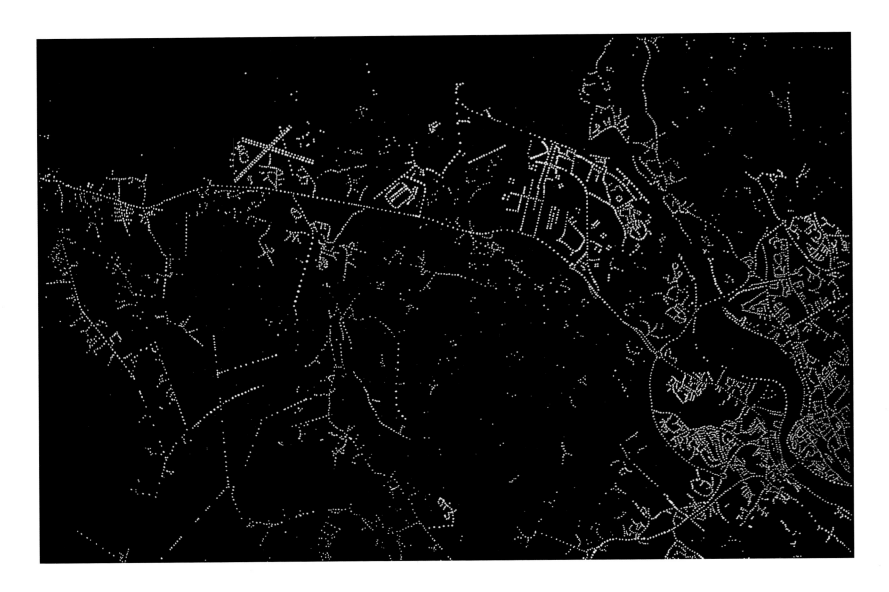

JASON WALLIS-JOHNSON

Derry, 2000

Acrylic lightbox and pierced carbon paper
14 x 10.25 x 3 in.
Courtesy of England & Co., London

Wallis-Johnson is a sculptor and visual artist whose map drawings
are illustrations of cartographic precision, whether in city plans of
great scale or in fragments of road systems and airport approaches.
Wallis-Johnson produces elaborate reversed maps by piercing
sheets of carbon paper with pinholes to outline roads, bridges, and
other elements of the built environment. Each sheet is mounted
in a lightbox; illumination seen through the pinpricks looks like the
twinkling lights of a city at night as seen from above.

KRISTIN BLY

legend 29, 2007

From the series *legend*
Oil on map
6 x 5.5 in.
Courtesy of the artist and JayJay,
Sacramento

To make his darkened *legend*
pieces, Bly eliminates from maps
all areas where characters or
numbers appear. "The works
are not intended to be hidden
messages of location and travel,
or topographic brainteasers," he
says. "Ultimately, these drawings
are meant to be somewhat
beautiful fields of color, pattern,
and shifting planes—albeit
a beauty derived from a
recipe intended to challenge
conventional notions of aesthetic
decision-making."

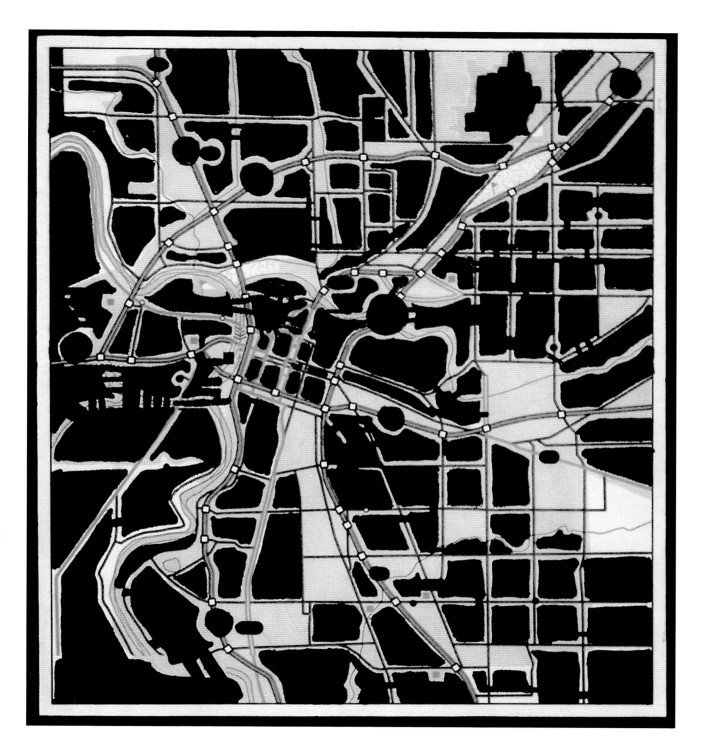

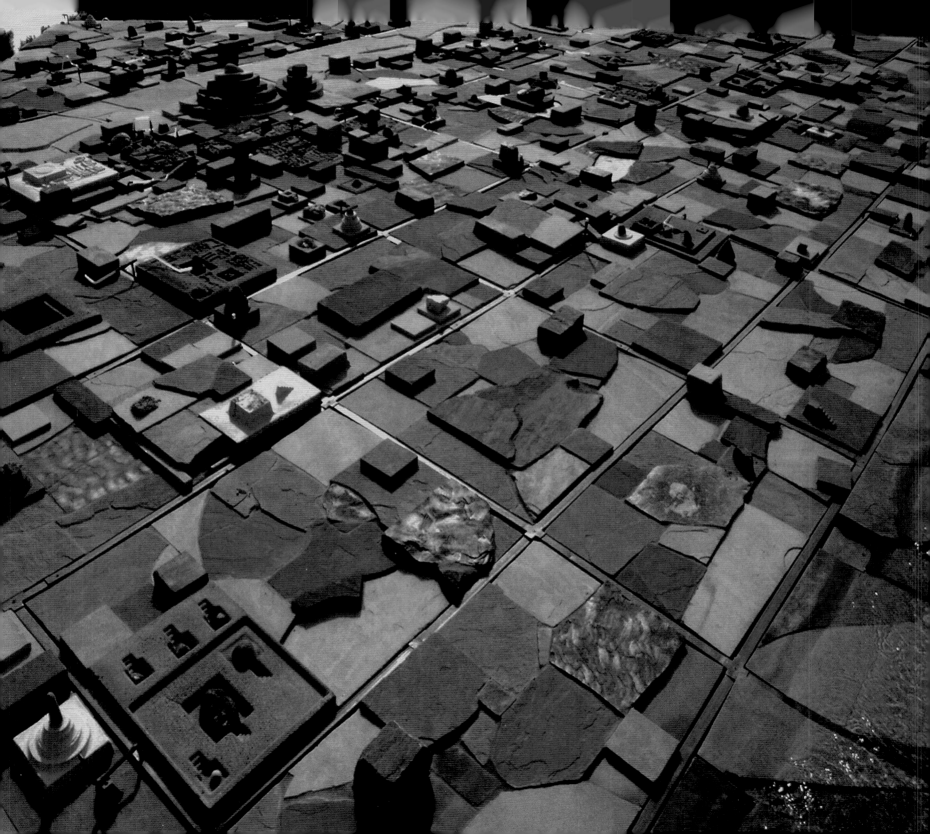

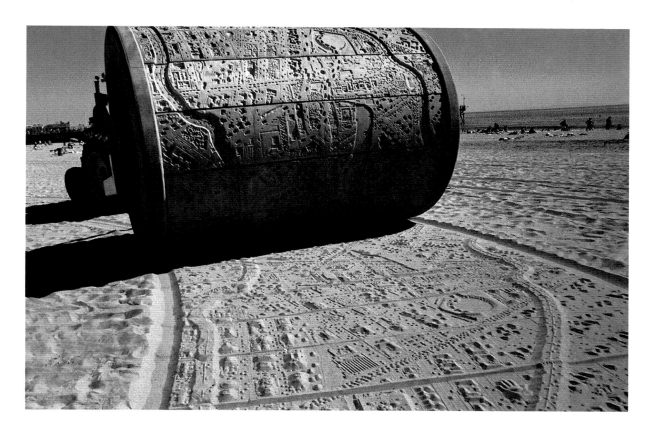

CARL CHENG

◄ *Tilted Landscape,* 1996

River-bottom rocks, flagstone, copper, concrete, wood, stone, and water

► *Santa Monica Art Tool,* 1988

Rolling stamp of drawn city map, printed onto beach sand

Cheng was born and raised in California and lives there still; he says that much of his work as an artist responds to coastal locations. Influenced by training in Bauhaus concepts at UCLA and the Folkwang Art School in Germany, he is interested in a "research and development" approach to art, continually experimenting with technologies and constructing his own mechanisms and tools for realizing inventive public art projects. One such innovation is the *Santa Monica Art Tool,* a giant roller pulled by city tractors that can print a map of Los Angeles in two-inch scale onto sand beaches. To plan it, Cheng flew over L.A. and conceptualized a map that reflects the characters of different sections of the sprawling city. He then used a vacuum molding machine to create a reversed 3-D cityscape with roadways, cars (and car accidents), buildings, crabs invading Beverly Hills, and "nuclear starfish" coming ashore. The

roller remains parked as a sculpture in the sand next to the Santa Monica Pier. "The thing I like best about it," Cheng has said, "is that everything about it is public. People eat their lunch on it, kids climb on it, people even sleep on it. And when it imprints, everyone can walk on L.A."

Tilted Landscape is a sculpture in front of the Tempe Public Library made of local flagstones and copper and inspired by aerial views of human encroachment on the Arizona desert. Cheng is a committed public artist. Rather than produce gallery art that emphasizes a certain signature style, he uses his art sensibilities to bring art to people in accessible environments, hoping in this way to contribute to society on a larger level.

Maya Lin Where Opposites Meet

When we see Maya Lin's topographic sculptures of 2006, we instantly recognize them in a visceral, intuitive way. Without consciously identifying them, we simply know that these are natural, organic forms: hill, lake, land. Lin's sculptures and installations are often large-scale and rhythmic, and our bodies relate to them empathetically—we feel their graceful presence and subtle power.

> I feel I exist on the boundaries. Somewhere
> between science and art, art and architecture,
> public and private, east and west. I am always trying
> to find a balance between these opposing forces,
> finding the place where opposites meet.[1]
>
> Maya Lin (American, b. 1959)

But these swelling, dipping, chunky, curvy, organic forms are created out of straight lines, right angles, and manufactured materials. Each evocative form is made out of a single man-made or processed material: plywood, wire, push pins, glass, paper. Lin's work often substantiates and harmonizes contradictions.

2 x 4 Landscape contains sixty-five thousand boards of various lengths, arranged into a unified mound that starts low, at the viewer's feet, and swells up from the floor, wave-like, to ten feet tall. The logical mind is fascinated by the complex construction process required to build this accretion of geometrically precise units. Is there a scaffold underneath, supporting the individual boards? (There is.) But looking at the undulating mass, it seems that there are unseen forces under the surface, shaping the rising mound.

Creating further pleasurable dissonance between what we see, what we know, and what we sense, Lin often bases the organic forms of her sculptures on rarely seen views or invisible landscapes. In her work since 1998, Lin has increasingly used geologic mapping, charting, and modeling systems as sources and methods for her work. These are technologies of data collection and analysis, but they are also tools for visual representation—showing us the lay of the land or water, when those forms are virtually impossible to experience in reality.

Lin states, "I am inspired by landscape, topography, and natural phenomena, but it's landscape from a 21st-century perspective, landscape through the lens of technology."[2] Lin takes these scientific models and re-presents their representations, offering us new frameworks for how to perceive organic forms.

For *Water Line* of 2006, Lin collected data from the sonar mapping of a site on the Mid-Atlantic Ridge, selecting an area of bedrock and land that rises from the sea floor to above sea level and becomes Bouvet Island. Her sculptural installation, lengths of wire that create a "line drawing" of this landform, allows us to simultaneously see views of what exists above and below the line where water meets air. Lin also conflates a variety of systems of representation, blending cutting-edge scientific modeling methods with the traditional artistic practice of line drawing, which records the contours

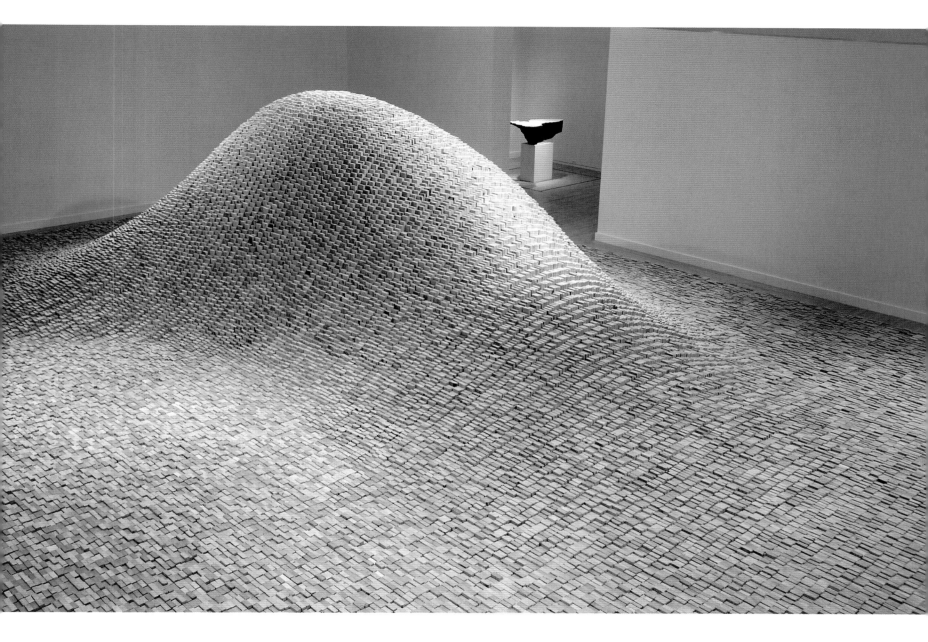

MAYA LIN

2 x 4 Landscape, 2006

Wood
Courtesy of Henry Art Gallery and PaceWildenstein
Photo by Colleen Chartier

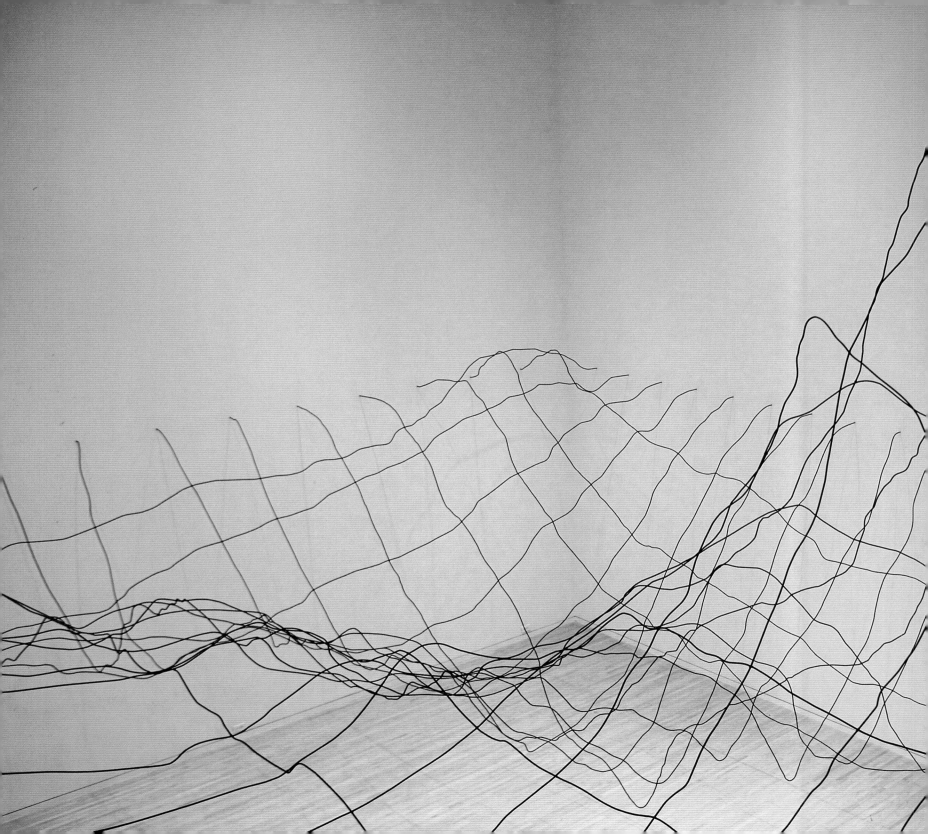

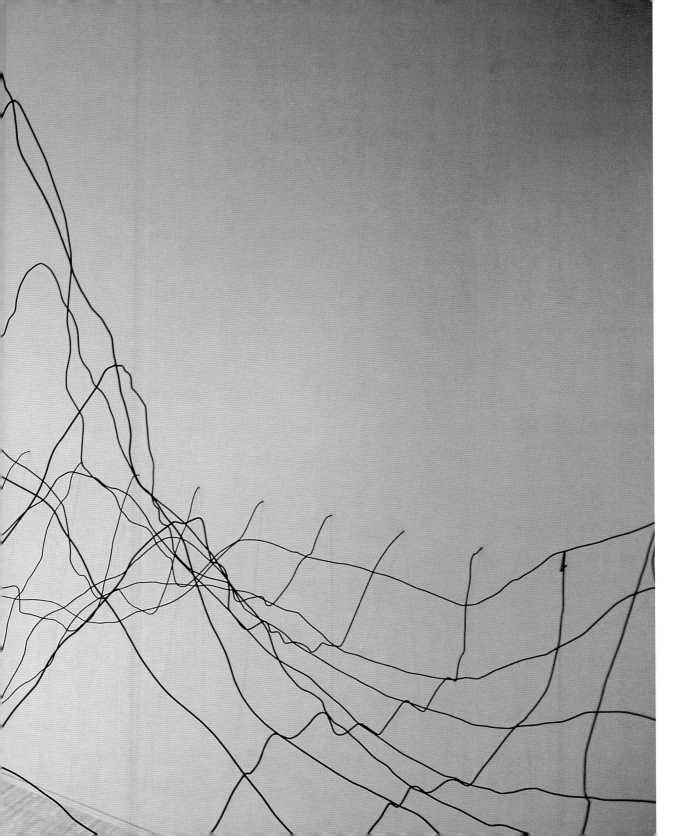

MAYA LIN

Water Line, 2006

Aluminum tubing and paint
Courtesy of Henry Art Gallery and
PaceWildenstein
Photo by Colleen Chartier

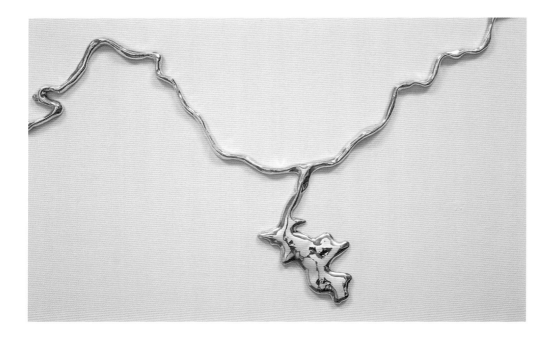

MAYA LIN

Silver River–Yangtze, 2007 (detail)

Cast silver
19 x 76 x .75 in.
Courtesy of Maya Lin Studio
and PaceWildenstein
Photo by Tom Powel

of forms. The act of line drawing engages the eye and hand in creating careful two-dimensional representations of what is seen from a fixed perspective. Lin's use of wire in a three-dimensional space inverts our relationship to positive and negative space; we can walk under and around these forms, as if we were within the land or looking up from underneath the sea bed. We experience, within the white walls of a gallery, impossible views of the original site in the Atlantic Ocean.

Lin's interest in creating works that are not static objects but phenomenological experiences that orient us to our surroundings has been part of her work since her crashing entry into the art world. In 1981, while a senior at Yale University, Lin's design for the Vietnam Veterans Memorial in Washington, D.C., was selected for realization and became one of the most debated and compelling works of public art in the twentieth century. Lin cut a deep slice out of the earth and paneled the earth wall with dark, polished granite,

into which the names of the fifty-eight thousand U.S. soldiers killed in the war were carved.

Visitors to the memorial can walk down into the space, run their fingertips along the thousands of names, and see their own reflections in the glossy surfaces. Lin underscored the emotional acts of remembering and paying tribute to the soldiers by creating an experience of mass and void, presence and absence. She also included a mapping gesture, bringing subtle attention to the location of the memorial within its historic site: the arms of the V-shaped form point outward to the Lincoln Memorial and the Washington Monument.

In the decades since, Lin has created other public works, architectural spaces, sculptural objects, and installations, all of which, according to Lin, "originates from a simple desire to make people aware of their surroundings, not just the physical world but also the psychological world we live in."[3]

Some of Lin's recent cartographic and topographic sculptures resonate with meanings about where we are and what can be lost. Sculptures in a 2006 series titled *Bodies of Water* appear at first to be upside-down islands or mountains made of stacked layers of thin plywood. They are based on inland seas, immense saltwater lakes surrounded by land. In reality, we would experience the original bodies of water by looking across their surfaces, perhaps noting the color of the water and the relationship of the water to the surrounding land. But,

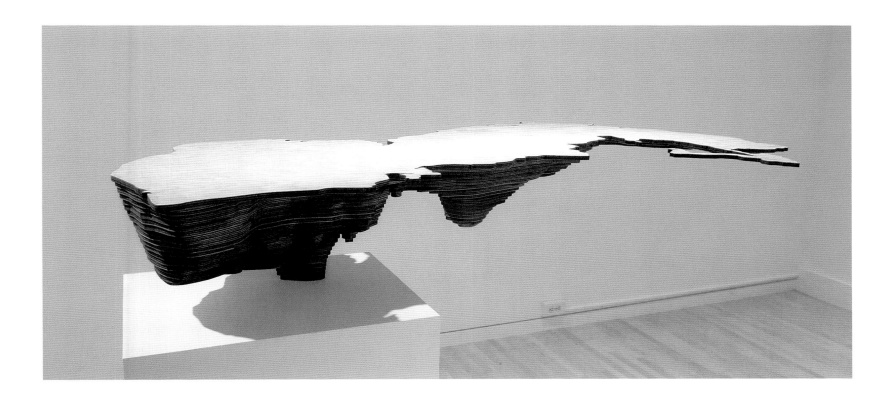

once again, Lin has tweaked our point of view. Water is a corporeal object—we see its flat surface, yes, but we also see its various depths and the complex contours where water meets earth.

The sheets of shaped plywood act like strata of the Earth. The resulting sculptures are both thin and solid, delicate and strong. They seem to balance precariously on their narrowest ends, an effect that Lin highlights by displaying them off-center, on narrow pedestals; portions of the sculptures extend into space with no visible support.

Through this interplay of balance and peril, strength and fragility, and through her ability to make the invisible visible, Lin quietly communicates an environmental message. These are not just any bodies of water, they are some of the most endangered bodies

in the world: the Caspian, Black, and Red seas. Lin has said, "I cannot remember a time when I was not concerned with environmental issues or when I did not feel humbled by the beauty of the natural world."[4] Her creations allow us to visualize unseen or overlooked natural forms and to make connections between what we see and what we can't. She creates intermediary objects. They are not nature; they are works of art, entirely constructed things that often call attention to this very act of mediation.

Lin's *Atlas Landscapes* series of 2006 makes use of actual atlases, those authoritative books that represent the Earth. An atlas is not a singular diagram of the land but a confident series of representations of data—flat, pictorial forms that break down a huge globe into smaller, manageable, and didactic segments. Lin is fully

MAYA LIN

Caspian Sea, 2006

Three works from the series *Bodies of Water: Caspian Sea, Red Sea, and Black Sea*
Baltic birch plywood
Courtesy of Henry Art Gallery and PaceWildenstein
Photo by Colleen Chartier

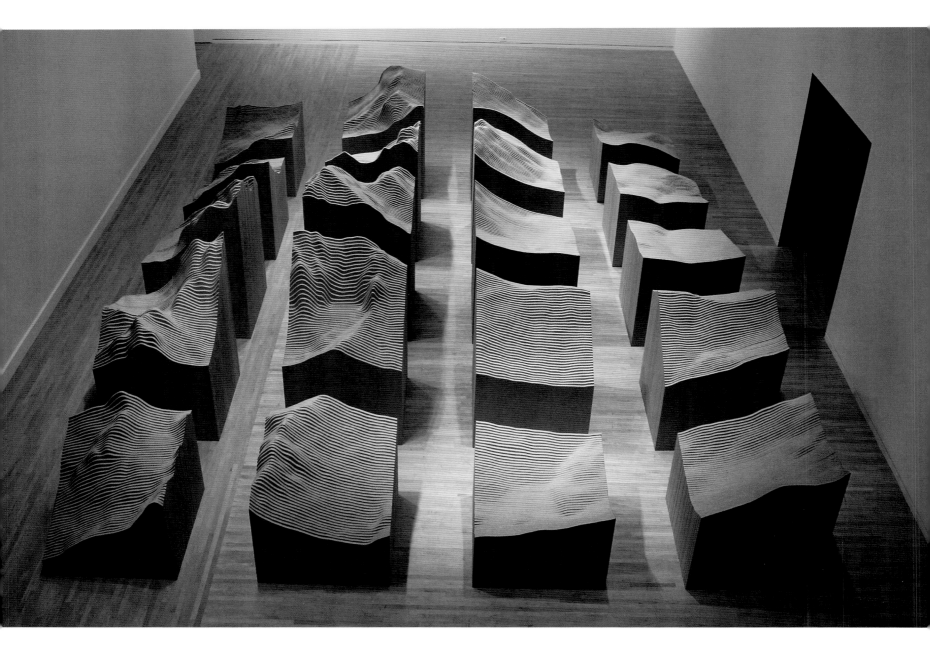

MAYA LIN

Blue Lake Pass, 2006

Duraflake particle board
Courtesy of Henry Art Gallery and PaceWildenstein
Photo by Colleen Chartier

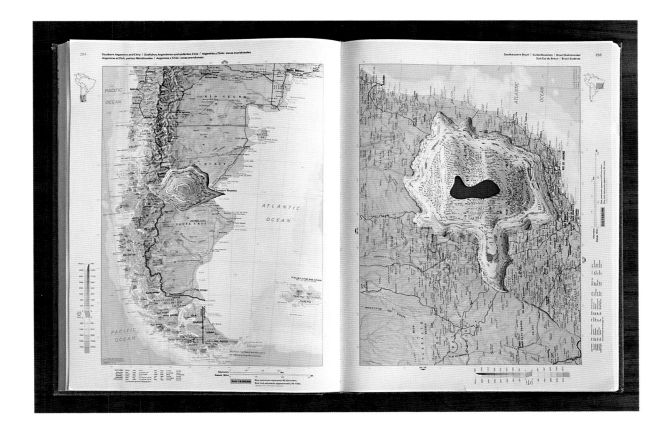

MAYA LIN

The Rand McNally New International Atlas,
2006

From the series *Atlas Landscapes*
Altered atlas
Courtesy of Maya Lin Studio and PaceWildenstein
Photo by Tom Powel

aware that maps "are inherently political—how we choose to present the world graphically will inevitably alter our perception of it."[5]

For these sculptures, Lin found used, outdated atlases and carved away layers of fact and location, creating new three-dimensional forms—tide pools, craters, lakes—by removing geographic references. Atlases and maps restrain our physical, experiential knowledge of the land in order to create functional clarity and legibility. Lin's interventions into atlases suggest a visceral confrontation of the difficulties of representing our location in the world.

In a way, all of Lin's topographic works are about construction and deduction. Her installations are complex fabrications, but they are also stripped-down, powerful forms created out of simple materials. Her work often hints at her processes—the units and layers are kept quite visible, and the diagrammatic feel suggests the scientific modeling and mapping systems that she employs. As we look at and move around her organic forms, we become aware of this interplay of building up and taking away. We add this awareness to the accumulation of perceptions—visual, intellectual, physical recognitions—that are fundamental to Lin's work. The quiet brilliance of her art emanates from Lin's capacity to immediately and lastingly engage us in forms that are both known and unique. ◈

Notes

INTRODUCTION

[1] Denis Wood, "Map Art," *Cartographic Perspectives: Journal of the North American Cartographic Information Society,* no. 53 (Winter 2006): 10.

[2] Edward S. Casey, *Earth-Mapping: Artists Reshaping Landscape* (Minneapolis: University of Minnesota Press, 2005), xvii.

[3] Nancy Holt, artist's statement on *Buried Poems,* October 7, 1992.

[4] Jan Dibbets, statement, undated/late 1960s, Documents of Conceptual Art, UbuWeb Papers, http://www.ubuweb.com/papers.

[5] Jean Baudrillard, *Simulations,* trans. Paul Foss, Paul Patton, Philip Beitchman (New York: Semiotext(e), 1983), 1.

[6] Donna the Buffalo, "No Place Like the Right Time," *Positive Friction* (Nashville: Sugar Hill Records, 2000).

[7] Lewis Carroll, *Sylvie and Bruno* (New York: Macmillan, 1893), 169; Jorge Luis Borges, "On Exactitude in Science," in *Collected Fictions,* trans. Andrew Hurley (New York: Viking, 1998), 325.

[8] Lola Dopico, "Cartographic Desires: The Map as a Symptom," in *Mapas, Cosmogonias e Puntos de Referencia* (Santiago de Compostela, Spain: Centro Galego de Arte Contemporánea/ Zunta De Galicia, 2007), 75.

[9] kanarinka, "Art-Machines, Body-Ovens, and Map-Recipes: Entries for a Psychogeographic Dictionary," *Cartographic Perspectives: Journal of the North American Cartographic Information Society,* no. 53 (Winter 2006): 25.

JOYCE KOZLOFF

[1] Montalvoarts.org, Joyce Kozloff residency information, Montalvo Arts Center.

[2] Eleanor Munro, "Exterior and Interior Cartographies," essay to accompany 2006 exhibition, Olin Art Gallery, http://www2. kenyon.edu/artgallery/exhibitions/0607/photo%20link%20 kozloff.html.

[3] Vicki Goldberg, "An Interview with Joyce and Max Kozloff," *Art Journal* 59, no. 3 (Fall 2000): 96.

[4] Robert Kushner, "Gunsmoke," in *Boys' Art,* by Joyce Kozloff (New York: Distributed Art Publishers, 2003), 6–7.

[5] Kozloff, *Boys' Art,* 5.

[6] Ibid.

[7] Goldberg, "Interview with Joyce and Max Kozloff," 96.

LANDON MACKENZIE

[1] Landon Mackenzie, quoted in Charlotte Townsend-Gault, "Landon Claims and the Saskatchewan of the Mind," in *Landon Mackenzie, Saskatchewan Paintings,* exhibition catalog (Vancouver: Contemporary Art Gallery, 1996).

[2] Landon Mackenzie, artist's statement, Faculty of Fine Arts Gallery, http://www.fofagallery.concordia.ca.

[3] Landon Mackenzie, interview with the author, April 6, 2008.

[4] Mackenzie, artist's statement.

[5] Mackenzie, quoted in Townsend-Gault, "Landon Claims."

[6] Mackenzie, author interview.

[7] Mackenzie, author interview.

[8] Mackenzie, artist's statement.

INGRID CALAME

[1] Ingrid Calame, interview with the author, March 20, 2008.

[2] Jamescohan.com, "Ingrid Calame" (video), James Cohan Gallery.

[3] Pepe Karmel, "Field Notes," in *Constellations,* exhibition catalog (New York: James Cohan Gallery, 2007), 36.

[4] Ibid.

[5] Ibid., 42–43.

[6] Jamescohan.com, "Ingrid Calame."

[7] Ibid.

GUILLERMO KUITCA

[1] Kathryn Hixson, "No Home at All," *New Art Examiner* 27 (February 2000): 42.

[2] Kristen M. Jones, "Guillermo Kuitca at Sperone Westwater," *Artforum,* May 1996, 100.

[3] Ibid., 44.

[4] Hilarie M. Sheets, "Surprise Breaks Out of the Box (or Cube)," *New York Times,* June 3, 2007.

[5] Hixson, "No Home," 44.

MAYA LIN

[1] Maya Lin, *Boundaries* (New York: Simon & Schuster, 2000), 2:7.

[2] Ibid., 12:6–7.

[3] Ibid., 2:3.

[4] Richard Andrews, "Outside In: Maya Lin's Systematic Landscapes," in *Systematic Landscapes,* exhibition catalog (Seattle: Henry Art Gallery, 2006), 61.

[5] Lin, *Boundaries,* 6:27.

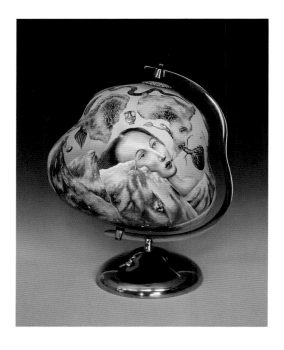

KURT WEISER

Continental Drift, 2005

Porcelain and bronze
20 x 24 in.

Weiser makes meticulous paintings on china vessels and, more recently, globes with vessel-like curves on elegant bronze stands. These often feature Edenic images of women, creatures, and vegetation. Around the circumference of the globe at left he shows continents drifting out of the mouths of Eves as the world is created—or, possibly, re-created.

Resources

SELECTED EXHIBITIONS AND CATALOGS

An Atlas of Radical Cartography. Edited by Lize Mogel and Alexis Bhogat. Los Angeles: Journal of Aesthetics and Protest Press, 2008. Published in conjunction with the exhibition "An Atlas," curated by Lize Mogel and Alexis Bhogat, Gallery 400, University of Illinois at Chicago, 2007–8.

Artists and Maps: Cartography as a Means of Knowing. Essay by Linda Brady Tesner, curator. Published in conjunction with an exhibition at the Ronna and Eric Hoffman Gallery of Contemporary Art, Lewis & Clark College, Portland, Oregon, 2003.

Artists' Maps. Essay by Janet Kardon, curator. Published in conjunction with an exhibition at the Philadelphia College of Art, 1977.

"Atlas Mapping," an exhibition at Kunsthaus Bregenz, Austria, coproduced with the O.K. Centre for Contemporary Art, Linz, Austria, 1998.

"Cartography 101," an exhibition at Johnsonese Gallery, Chicago, 2005.

(C)artography: Map Making as Art Form. Essays by Mic Moroney, William Laffan, and Professor William J. Smyth. Published in conjunction with an exhibition at Crawford Art Gallery, Cork, Ireland, 2007.

"Charting Maps: The Topography of Contemporary Art," an exhibition curated by Carrie Scott at Hedreen Gallery, Lee Center for the Arts, Seattle, 2007.

"International Waters," an exhibition curated by Soo Kim and Jessica Silverman at Steven Wolf Fine Arts, San Francisco, 2006.

"L(A)TTITUDES," an exhibition at Ann Loeb Bronfman Gallery, Morris Cafritz Center for the Arts, Washington, D.C., 2008.

"Legends Altered: Map as Method and Medium," an exhibition at Carrie Secrist Gallery, Chicago, 2008.

Mapping. Essay by Robert Storr, curator. New York: Museum of Modern Art, in association with Harry N. Abrams, 1994. Published in conjunction with an exhibition shown at the Museum of Modern Art, New York, 1994.

"Mapping: A Response to MOMA," an exhibition curated by Peter Fend at American Fine Arts, New York, 1995.

"Mapping the Self," an exhibition curated by Tricia Van Eck at the Museum of Contemporary Art, Chicago, 2007–8.

"On the Map: Artists Inspired by Maps," an exhibition at North House Gallery, Essex, U.K., 2006.

"Personal Geographies: Contemporary Artists Make Maps," an exhibition curated by Joanna Lindenbaum at Times Square Gallery, Hunter College, New York, 2006.

"Terra Incognita," an exhibition curated by Jacqueline Doughty at Gertrude Contemporary Art Spaces, Melbourne, 2006.

The Map Is Not the Territory. Essay by Jane England, curator. Published in conjunction with an exhibition at England & Co., London, 2001.

The Map Is Not the Territory II. Essay by Jane England, curator. Published in conjunction with an exhibition at England & Co., London, 2002.

The Map Is Not the Territory III. Essay by Jane England, curator. Published in conjunction with an exhibition at England & Co., London, 2003.

"There's No Place Like Here," an exhibition at University Art Gallery, Sonoma State University, Sonoma, CA, 2007.

Topographies. Essays by Karen Moss, curator, and Steve Dietz, Jeannene Przyblyski, and Noah Snyder. Published in conjunction with an exhibition at the San Francisco Art Institute, San Francisco, 2004.

"Uncharted Territory: Subjective Mapping by Artists and Cartographers," an exhibition at Julie Saul Gallery, New York, 2004.

"Urban Legends: The City in Maps," an exhibition organized by CitySpace at Oaklandish Gallery, Oakland, CA, 2004.

World Views: Maps & Art. Essays by Robert Silverman, curator, and Yi-Fu Tuan. Published in conjunction with an exhibition at the Frederick R. Weisman Art Museum, University of Minnesota, Minneapolis, 1999.

Zoom +/-. Published in conjunction with an exhibition curated by Doug Beube and Sherry Frumkin at Arena 1, Santa Monica Art Studios, Santa Monica, CA, 2007.

"zoomandscale," an exhibition at the Institute for Art and Architecture, Vienna, 2008.

MAGAZINE AND JOURNAL ARTICLES

Cosgrove, Denis. "Maps, Mapping, Modernity: Art and Cartography in the Twentieth Century." *Imago Mundi: The International Journal for the History of Cartography* 57, no. 1 (February 2005): 35–54.

Krygier, John, and Denis Wood, editors. *Art and Mapping,* a special issue of *Cartographic Perspectives: Journal of the North American Cartographic Information Society* 53 (Winter 2006).

Wood, Denis. "Memory, Love, Distortion, Power: What Is a Map?" *Orion* 13, no. 2 (Spring 1994): 24–33.

BOOKS

Casey, Edward S. *Artists Reshaping Landscape.* Minneapolis: University of Minnesota Press, 2005.

Lippard, Lucy. *Overlay: Contemporary Art and the Age of Prehistory from 1983.* New York: New Press, 1983.

Long, Richard. *Five, six pick up sticks/Seven, eight lay them straight.* London: Anthony d'Offay Gallery, 1980.

Smith, Roberta. *4 Artists and the Map: Image/Process/Data/Place.* Lawrence, KS: Spencer Museum of Art, 1981.

ONLINE

The Map Room: A Weblog about Maps. Jonathan Crowe, author. http://www.mcwetboy.net/maproom/.

Moon River: Night Traveling, Day Dreaming, while Mapping My Escapisms, Tracing Love. http://moonriver.blogspot.com/.

Strange Maps: Collecting Cartographic Curiosa. Frank J. Jacobs, author. http://strangemaps.wordpress.com/.

Acknowledgments

Limitations of space prohibit me from thanking the individuals who provided images for the book, including artists, collectors, and gallery and museum representatives. For their willing help in sending digital files, artistic statements, and permission forms I extend my warm gratitude. It has been a pleasure to have the support of all who enabled me to produce this book.

For extra help in locating and obtaining artworks, I am grateful to Stefano Catalano, Bellevue Arts Museum; Peter Gordon-Stables, England & Co., London; Ellie Grace, Haunch of Venison, London; Penny Hoile, Gallerie Australis, Adelaide, Australia; Jessica Mastro and Jennifer Burbank, Sperone Westwater, New York; Paula Mazzotta, VAGA, New York; Sique Spence, Lehmann Maupin Gallery, New York; Adrian Swain, Artistic Director & Curator, Kentucky Folk Art Center; and Gerard Vermeulen, The Richard Long Newsletter.

In addition, I wholeheartedly thank Denis Wood, for his generosity in planting the seed for this book long ago, sharing his resources, and reviewing the introduction; Gayle Clemans, for contributing the essays and her grace; Jane Jeszeck, for another outstanding design and production effort; Clare Jacobson, editor, for patience and advocacy; Steve Roth, for an extra editing eye; Dorothy Ball and Becca Casbon, for copyediting skill; Maryann Jordan and Pam McClusky of the Seattle Art Museum, for their support; Margaret Levi and Bob Kaplan, for sharing their passion for Australian aboriginal art; Jane England, gallerist, whose exhibitions and connections led me to many British and European artists; and Kathy Cowell and the staff and board members of the Helen R. Whiteley Center on San Juan Island, Washington, for providing a writing retreat like no other. And, in all ways, John and Avery Fulford.

—Katharine Harmon

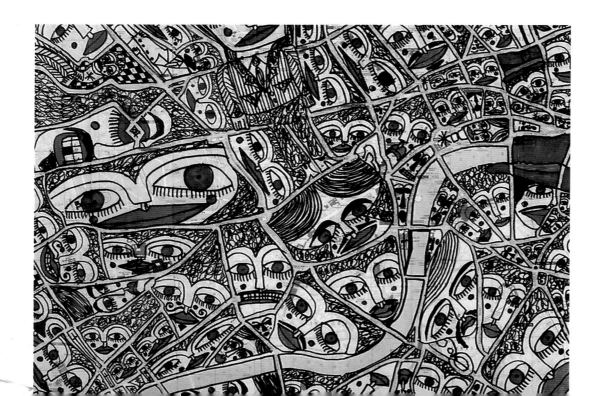

DAMIAN LE BAS

Romeville (London), 2007 (detail)

Pen on printed map
22.5 x 34 in.
Photo by Delaine Le Bas

Gypsies in the United Kingdom, called "Travellers," differ from those in the rest of Europe. Travellers are descendants of the Roma people; Irish, Welsh, and Scottish Tinkers; and the old Canting Crew of London—a mixture of Huguenots, Roma, and London vagabonds. The Cant word for London is "Romeville." Le Bas created *Romeville* to show the underground network of Travellers in London. Members of his family used to travel from Ireland to London in the nineteenth and early twentieth centuries. His work was exhibited as part of the first Roma pavilion at the 2007 Venice Biennale.